STREETBONERS

STREETBONERS

STREETBONERS

STREETBONERS

STREETBONERS

STREET BONERS

STREETBONERS

STREET BONERS

9/17

Also by Gavin McInnes

The Vice Guide to Sex and Drugs and Rock and Roll

DOs & DON'Ts: 10 Years of Vice Magazine's Street Fashion Critiques

FROM THE CREATOR OF VICE MAGAZINE AND DOs & DON'Ts

STREET BONERS
1,764 Hipster Fashion Jokes
by Gavin McInnes

With commentary from Chloë Sevigny, Debbie Harry, Fred Armisen, and many, many more ...

GRAND CENTRAL
PUBLISHING

Grand Central Publishing
Hachette Book Group
237 Park Avenue
New York, NY 10017

www.HachetteBookGroup.com

Printed in the United States of America

First Edition: May 2010
10 9 8 7 6 5 4 3 2 1
RRD-C

Grand Central Publishing is a division of Hachette Book Group, Inc.
The **Grand Central Publishing** name and logo is a trademark of Hachette Book Group, Inc., which
sounds pretty Juggalo to me but, whatever. None of my beeswax.

LCCN: 2009932228
ISBN 978-0-446-54635-5

**This book is dedicated
to Judi's dog, Boner.**
May he rest in peace
(if he dies).

"Pure, undiluted genius."

"a riot."

"Damn near impossible to put down."

"What I would do if there were no standards and practices on TV."

"An obvious idea executed in the purest way possible resulting in sublime, box-cutter sharp, multilayered social commentary."

"Hot Book."

"A priceless compendium of fashion quasi-advice doled out in withering, spot-on blurbs."

"I bought 50 copies for my friends."

"I couldn't put it down."

"The fact that I once read about my own hairy asshole in there was just icing on the cake."

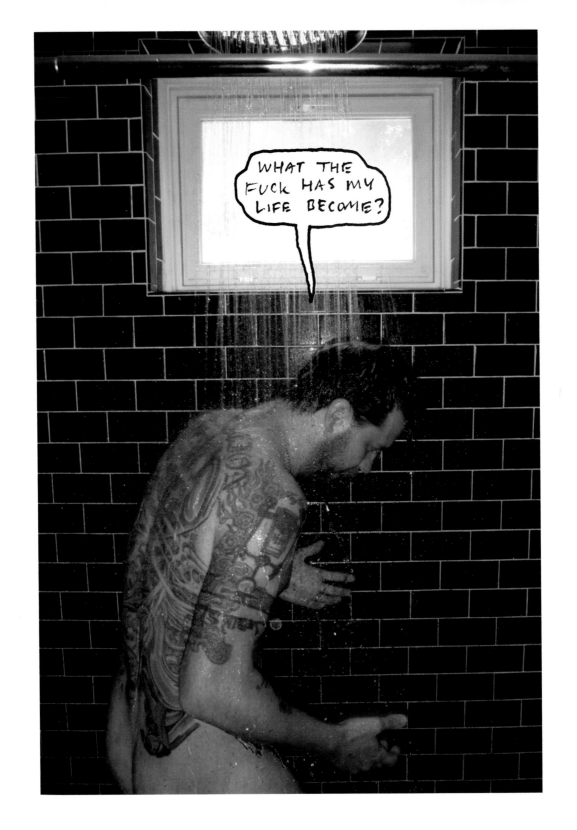

INTERVIEW WITH THE AUTHOR

When Gavin wrote the first DOs & DON'Ts back in 1994, he had no idea it would be his fucking job for the rest of his life. Huh? You pay your rent by making fun of people's pants? That's retarded. I sat down with him to ask a few questions about this strange vocation because it looks weird to just start out a book with pictures and have no intro text.

What the fuck is with your ridiculous tattoos?
Isn't that obvious? It's a skullhead cyber-jellyfish eating Fidel Castro and Chiang Kai-shek with the words "Destruction Creates" at the top. Get it?

Nope. I don't get tattoos.
Well, I'm of two minds with them, when it comes to girls at least. On the one hand, I feel like certain tattoos kind of separate "us" from "them," and I don't think I've ever met a person with a funny tattoo I didn't like. However, when a girl totally splatters her chest, like the Hipster Grifter, I don't know. It doesn't seem very feminine. Have you ever fucked a girl like that? When the lights are dim, she looks like she fell in a mud puddle. It feels traitorous to criticize them but it's true.

I have actually fucked a girl with tons of tattoos, and it was exactly like that.
I know.

What's with the kittens? Can you explain the ratings system?
Well, the DOs & DON'Ts always felt a little too "all or nothing." There's some people who have a great look going but they blow it with a straw fedora or something. That outfit that would be an eight got pulled down to a six but he's not a DO or a DON'T.

So, the ratings are just about the outfits and not the person's physical features, right?
I've discussed this for hours with all sorts of intellectuals and sociobiologists, and the answer is: It's an art, not a science. Yes, ideally it is only about the clothes but it looks weird to give the hottest woman in the world a four just because she wore Uggs. I do my best to keep it fashion-based but my dick is only human.
There's dozens of other questions that arise when you try to figure out the ratings system. Do you see a ten once a lifetime, or do you look over the past month and use those people as a median ensuring you saw an equal amount of tens, nines, eights, sevens, sixes, fives, fours, threes, twos, and ones? High school teachers do this when they make sure a certain percentage always fails, but I'm not a teacher. I'm a student. So I just throw the crystals on the table and try to read the vibes.

Oy. Let's move on: Where do you get the pictures?
You, oy! What kind of boring question is that? Why does everyone want to know the process? It's like watching a chick put on her makeup.

I think people see hundreds of pictures in a book and the first thing they think is, "Where do these come from?" I'm sure you get asked this a lot.
I do but it's not interesting. Most of them I take myself. Well, what I do is, I go out with a pretty, young girl who doesn't look threatening and tell her who to photograph because it sketches people out to have an old man like me ask for their picture. After that, there's a group of half a dozen photographers who submit photos regularly.

Do you ever get sued?
Nope. When you're in public there's "a reasonable expectation of being photographed." It's also pretty clear the book is satire. You're not really a coke dealer or a rapist or a dead slut — it's a joke. I've been slapped and assaulted a few times, however. The funniest one was when some gay dude who I made a DON'T walked up to me and gave me a raspberry. Like, he went *ppppphhh!* in my face. It was really loud, and it gave me a real jolt because I wasn't expecting it at all.

I heard a lot of rumors about why you left *Vice*.
Yeah, me too. The strangest one was that I left to do commercials.

Why did you sell your shares and get out?
It was time. Everything I thought ruled, my partners thought reeked and vice versa. That's why we went with "Creative Differences."

And what do you do now?
Besides Street Boner books? I made a comedy sketch movie called *Gavin McInnes is a Fucking Asshole*. I also did a documentary about the Movie Watching World Championships called *A Million in the Morning*. Then there's StreetCarnage.com, a website I do with Derrick Beckles. We're both also pitching TV all the time, which is a lot like throwing piles of shit at a wall hoping something sticks.

What if it doesn't stick?
You tape it there. Dude, these quetions are dull, dull, dull.

All right, what's a good question?
Well, you can't really discuss a jokebook without wrecking it. It's like sex or defining what's cool — which I do later on in the book.

Did you invent hipsters?
There's nothing sadder than seeing Ronnie James Dio and Gene Simmons trip over themselves trying to take credit for that heavy metal hand gesture with the two middle fingers down. Who cares who made it up? I made up hipsters about as much as Al Gore invented the Internet.
I will say, the aptly named DOs & DON'Ts had a big part in defining what these people look like. It was two pics a day for 15 years distributed in almost every major city in the world. Eventually, that's going to make some-thing a "Thing." Can we stop talking about hipsters now?

Are you a hipster?
Assuming a hipster is "a young enthusiast of contemporary, alternative, pop culture," I would have to say "no" because I'm "old."

What's with the ironic moustache?
I have no chin whatsoever, so I'm forced to sculpt one out of chin hair. Once you do that, you're left with limit-ed options: You can do a full beard, a chin beard, or a goatee. I did the goatee for a while but it seemed too normal. I needed more pieces of flair, so I grew the moustache to get out of the jock zone. I had no other choice.

Does your wife get bummed out when she sees you talk about hot chicks?
Well, I had been doing this for over a decade before I met her, so she was pretty much used to it. Besides, it's not like I literally long for the ten kitteners. It's more of a Benny Hill thing like, "Ello, ello, ello!"

Do you think it's weird you're interviewing yourself?
Sort of, I mean, I jerk you off almost every day, and I wash your body in the shower. You fuck my wife, and I spoon-feed you. It's definitely weird but it's the only way I can ensure I get asked exactly what I want to be asked.

I don't even think it's going that well despite the fact that I'm you.
I think it's going smashingly well. If you want to see a bad interview, check out this one I did with an art mag-azine called *SOMA*. They canned it after seeing my answers (and, most likely, the questions — the guy was free-lance) but it would be a crime if this was never published.

SOMA: The 90s ushered in the widest bifurcation of fashion: the gay community became both more formal and louder, the flintily end days of grunge nuanced aloofness, revival fashion became paying homage rather than posing, Harajuku trends were ordered through the internet and catalogue magazines to New York, London, Paris and LA, garbed Oriental and African expatriates tessellated prints subsumed in rich colors reflected the chang-ing physiognomy in fashion and urban centers. In the cacophony of street fashion, Gavin McInnes's obsession with street fashion filled the desideratum for a critic, and he has become iconoclastic for his endeavor. McInnes's street fashion critiques antedate all others, and all others are in some way or another derivative of his. Only his exceptional record for being right matches his temerity.
Why do you think street fashion critiques became so influential in the mid 90s, yours the most influential arguably?

Gavin McInnes: Temerity? Bifurcation? Desideratum!? Dude, what is with that intro? Did somebody buy you a thesaurus for Halloween? I haven't heard words like those since University. "The changing physiognomy in fash-ion"? Is this how artists get by the part where everyone thinks they're full of shit — they make up a language? You're like a bunch of fucking lawyers.
To answer what I think your question might be, I'd like to say: Who says street fashion critiques had this big

surge in the 90s? Where is that documented as a fact? You think there was this big zenith in street fashion critiques because you were reading DOs & DON'Ts back then and starting to give a shit about how you looked. There was nothing special about this time, and making fashion jokes has been going on since before there were clothes.

Also, my street fashion critiques were / are popular because my level of wit tends to be reserved for serious shit, like politics and social commentary. To do highbrow jokes about lowbrow stuff like shoes and socks is the hook that keeps it on most people's radar. It has nothing to do with the epoch.

Chameleon by Woody Allen is about a man who immediately transforms to suite his surroundings. Can someone do that wearing the exact same thing?
Too good. You use huge words to try to sound smart and then you spell *suit* wrong. And it's *Zelig*, not *Chameleon*. Ha. This is why it's always best to just be yourself and not try to be some Christopher Hitchens intellectual. How old are you, 23?

When does character trump actual attire?
Jesus, this is not easy. First I have to translate each question into English, then I have to try to answer it honestly. I'm going to assume you mean, "Is there a point where someone is so amazing, it doesn't matter what they wear?" If that is the case, the answer is: Of course.
Fashion, like art, is just kidding. To take it seriously is to miss the point. When I say I want to kill men that wear sandals, I am being hyperbolic. I actually could care less, obviously. The real impetus behind style and dressing well is, "I know none of this matters but I'm stepping into the fray and giving it a go anyway. How's this?" Fashion is like a board game or a dance. You want to do a good job because it's fun and it shows you're happy to be here but as soon as you take it seriously, the bubble pops. Some of my best friends are bad dressers. I just think it's lame and wish they'd try harder because it's fun to do that.

What is style analogous to? What does it tell us about someone?
I think you just wanted to use the word *analogous*. As I said earlier, it is "analogous" to, say, the board game Risk or even Operation. You are participating in this thing called society and fucking around with the parameters (great, now I'm talking like you people). Style is about someone who knows the rules and can tweak them a bit to reflect his or her personality. She's never going to wear Juicy Couture but she might be funny enough to wear Rocawear with a Balenciaga bag. Sometimes she blows it and her friends point it out and everyone has a laugh.

Who are some women and men who dress poorly but pull it off?
There's a New York artist named Spencer Sweeney who always wears overalls and, like, Japanese clogs. I don't know if it's his confidence or his art career but nobody can fuck with him. It's a mystery how he does it but if I tried it, I'd look like a gay farmer who sells ice cream to construction workers. Sarah Silverman is a woman who couldn't dress her way out of a wet paper bag but somehow she makes it work. Who else? Um, I wouldn't say notorious 92-year-old night owl Zelda Kaplan "dresses poorly" but she dresses "really fucking insanely," and she always manages to pull it off.

What things are common in any fashion faux pas?
Basically, attraction is built on recognizing our differences. Women want men to be masculine, and men want women to be feminine. That's why flip-flops are such a crime. What if someone slaps your girl? How are you supposed to fight now or even chase him with your little rubber soles? And why do men have to be so comfy all the time? In New York, the summer uniform is cargo shorts and wife beaters. They look like Thai street vendors. Men dressing like they're still in dorms is not masculine, and women don't like it.

Similarly, there seems to be a huge contingent of females who think it's empowering to walk around in sweatpants with short hair and no makeup. This "throwing in the towel" look ignores the part where women are more attractive than men and should take advantage of it. We're only of courting age for about 10 years or so. To ignore that and say you're over it is like refusing to play musical chairs with the rest of us because it's "gay."

Q: Why are women so clueless to what man want and like in fashion?
Why'd you stick a *Q* on there all of a sudden? And "to what man want"? What are you, a cave person? Dude, you come at this interview with a tidal wave of synonyms, and you can't even pluralize *man*. Is this what public school education has come to?
The fundamental problem with your question is women are NOT "so clueless." In fact, they usually know more about making us find them attractive than we do. Don't believe me? Turn the page.

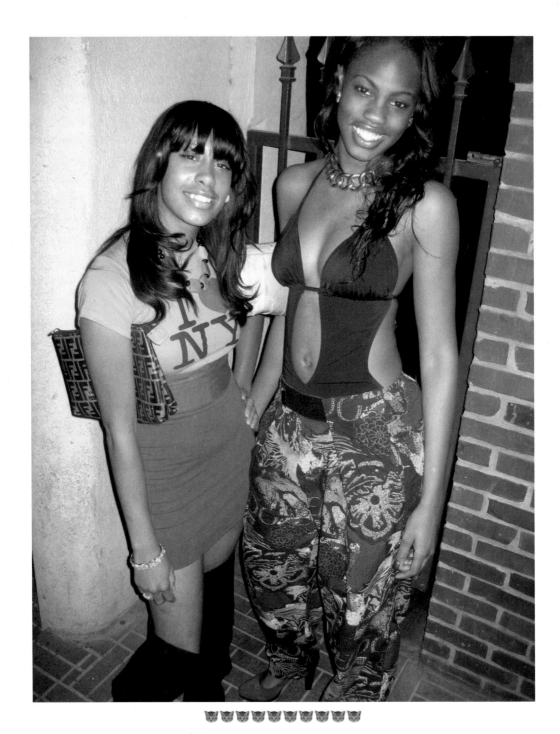

I know you're already on your way to the tattoo shop with this photo in your hand but are you ready for the real nail in the Perfect Coffin? This picture's from motherfucking Nashville!

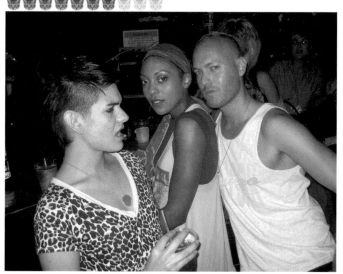

Luckily, by the time you get to that point where you're saying, "Does it really matter what gender blows me?" you're so fucking wasted, you won't be able to get it up. Whoever came up with this design deserves the Nobel Penis Prize.

Ever since Amy Winehouse got out of rehab, she's been getting, like, zero sleep.

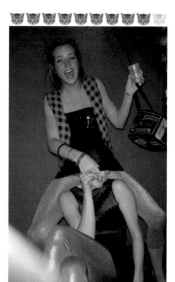

Hat designers are pushing the envelope so far these days, it's hard to know what a hat is anymore.

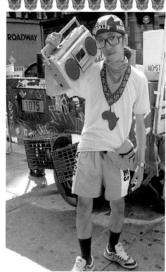

If you're at a block party waiting for the magic to happen, he's every noun in this sentence but the first one.

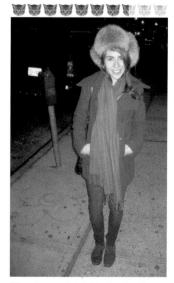

When shoes match tights, it makes the girl look like she's smokily swirling out of a genie bottle, warily wondering if one of your wishes is going to include you coming back in the bottle.

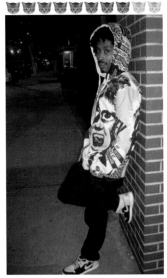

"Waiting" is the most rigorous workout you can give an outfit. It's like boot camp for your shoes.

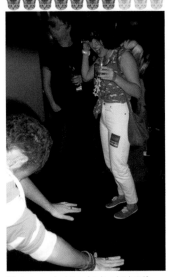

We know we insist on heels a lot but if you're good enough at, say, a Jimmy Buffett-look, you can skip the stilettos, and we'll still worship you.

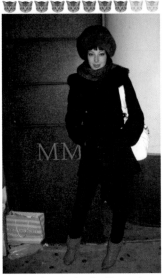

When you look like Angelica Houston in *Crimes and Misdemeanors*, you are destined to be a mistress for life. Go find yourself a wiseguy and at least get some free shit out of the deal.

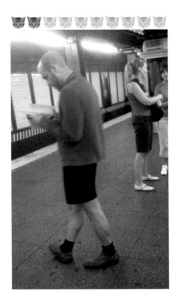

Judging by the Kierkegaard book, this high-IQ low-life has spent so long in academia, he's figured out clothes don't matter and nor does getting laid, ever.

Where jocks see a ridiculous, fat gaylord, we see a brother in arms checking up on a party crammed with eye-scorching tens.

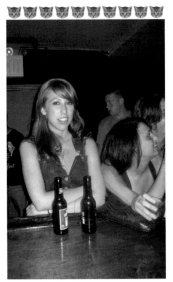

If you can deprogram your dick from *Baywatch* propaganda, you will see there are piles of potential wives right under your nose who nobody's paying attention to.

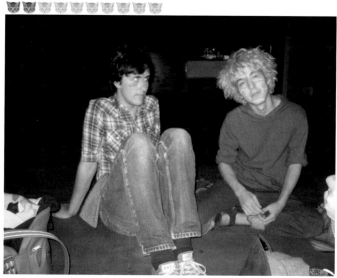

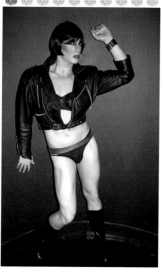

"Stop the Violence" is great in the rap community but there's certain parts of the suburbs where no violence can have disastrous side effects.

This guy is determined to get his body super-buff by the summer, like Chyna-buff.

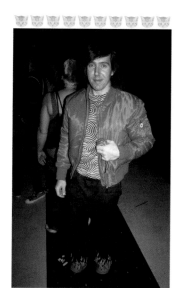

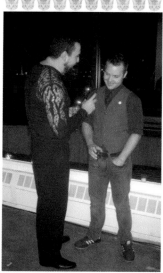

"The Disco Skier From Hell" sounds like a shitty joke a MILF would make, not an actual guy.

Tribal tattoo sweaters are a great way to look like a Greek meathead without having to suffer through 30 hours of needles.

This is the History of Cool: Black people party while white people carefully document it.

More on p.140

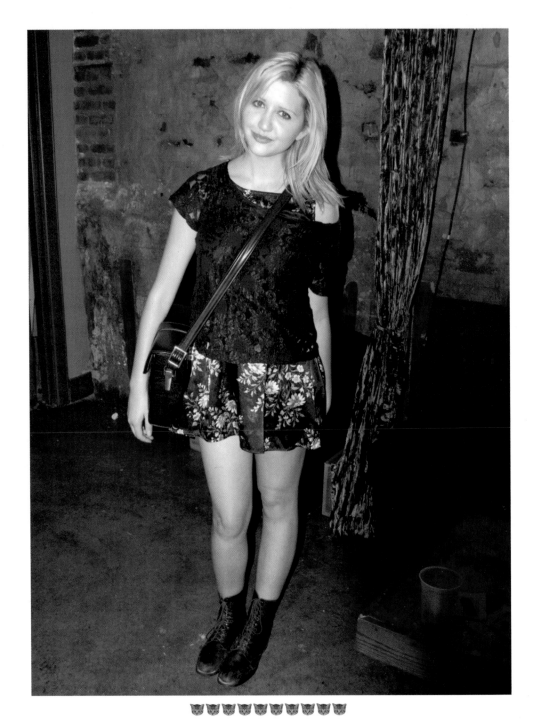

She looks like someone stuck my grandmother's brain into a babe machine.

Talk about the laughingstock of the patent office; it's a purse holder you put above urinals.

Hey Bruce Lee Wayne, Robin called. You forgot to take your belt off.

We were so happy when little Timmy came out of his coma after 20 years but we were kind of shocked to see him pick up exactly where he left off.

Is this one of those Halloween costumes that you stick your legs in and pretend a girl is dancing with you, or is his belt buckle made out of mail-order bride?

He's a jock dressed as a guido dressed as Mystery dressed as a flapper dressed as Fred Astaire on St. Mark's Place.

People who really, really, really want you to know they travel need to go back to where they don't come from.

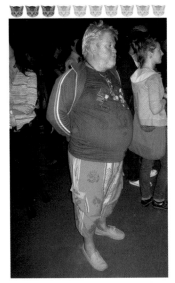

This isn't a beer belly. It's a gas tank for a Fat Piece of Shit Machine.

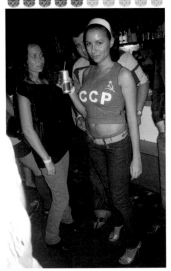

This actually sums up Russia perfectly: It should be beautiful, and it's difficult to say exactly what's wrong with it but it just ... sucks.

Ripped knees in jeans look great but when you get a slit in something as synthetic as spandex, it brings in a TMI factor that's not unlike catching your mom take a shit.

We know what you're going through, guy. Going up to girls from scratch is the WORST. Here's a tip: Pretend they have shitty tits.

This looks like a picture from *Intervention* where you hear he used to be the life of the party and everyone liked him, and you can't believe it because he's fat now and lives in a puddle.

The only accessory cooler than a white cane is a blind friend.

Stop snitching.

"Hi, I shoot exotic fish and sell them to Japanese tourists, then I get stoned and listen to music with my friends. What's your job?"

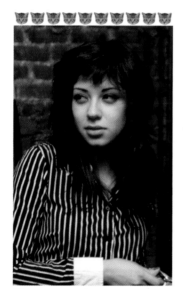

When guys wear striped shirts they look like every other gel-haired rapist at the club but when girls do it they become dick-melting cartoons that make kidnapping seem like a viable option.

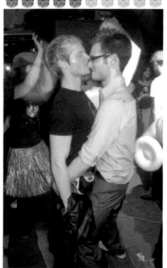

Homophobic is a gay word because you're not "scared" of this. You just have no file in your brain for "showing Brian what a nasty little fucking whore he is."

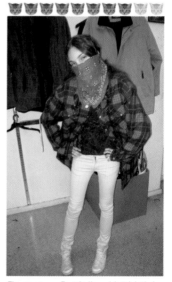

The same way East Indian girls trick their parents into thinking facial piercings are traditional, Muslim girls are convincing their parents this is just an evolution of the burqa.

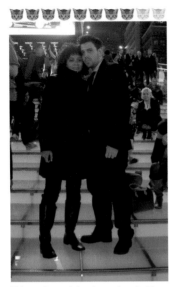

This guy is one haircut away from looking like a gorgeous homo.

This woman (?) has said, "Oh dahwling, how fah-h-h-bulous," so many times, it's actually changed the shape of her face.

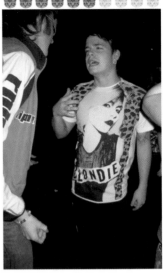

If you listen carefully you can hear a guy who sounds exactly like Patton Oswalt explaining Blondie to a 20-year-old Canadian who doesn't care.

When men do drag in comedy shows, you're supposed to laugh but when they're not kidding, you're supposed to not laugh. That's hilarious.

People are listening to music with such shitty compression these days, hits like Roxette's "Listen to Your Heart" are coming out with all the *H*s as *F*s.

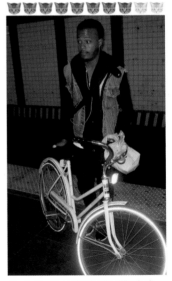

Hey buddy, nice old lady bike. Why don't you get a track bike like we ... like we ... whoooa ... look out! Coming through! Whoooa ... shit! Whaaaa! Fuck! ... <KKKRSPKKgssh> ... CRASH ... bkksh!

Fuck you, you motherfucking piece of shit dictator who was supposed to be dead but apparently isn't but will be soon if I ever see you out on the streets, you fucking dipshit fuckhead goddamned asshole motherfucker of a fucking cocksucking piece of shit monster.

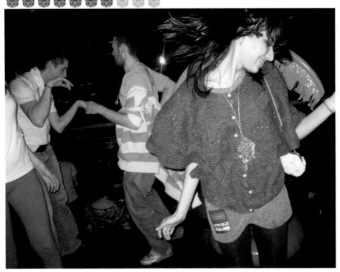

When you see a girl like this dancing by herself, you ask yourself, "How can she be alone?" Then you see her options.

Sorry, but having a shirt that's 23 percent too big is like having a dick that's 32 percent too small: It just doesn't feel right.

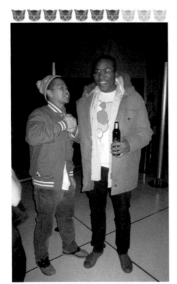

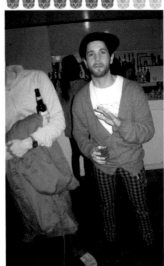

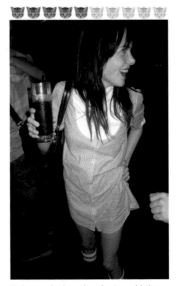

New York may look goofy to you but in a city of rats and death, you have to dress like a cartoon kid or your whole life becomes a Cannibal Corpse album cover.

It's like this guy *knew* the cruel world of digital lighting would turn his drink into a vodka cranberry and his hat into an oversized golfing Kangol with an errant pom-pom.

Unless you're in a play about an old-timey lumberjack who sleepwalks, you may want to tone down the theatrics. You look like a fucking hand puppet.

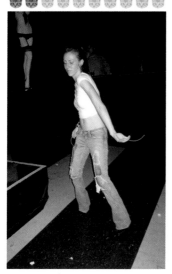

What's worse than having to watch some-one who's dancing like nobody's watching?

Chicks with big feet feel like Daffy Duck in junior high but when heels come into play, the small-footed girls look like weird chickadees while the gangly girls blossom into swans.

Long hair went from hippie-only fare to the stuff of rockers, nerds, European immigrants, male models, and guys into magic. Why don't they just change the name to "shitty-guy hat"?

This picture is from Montreal where racism has been abolished. Man, do the souris ever dancent when the chats sont partis, eh?

Back in New York where les chats still call the shots.

A girl without her heels is like Green Lantern without his ring. All you have is a guy in a green bathing suit, incapable of giving anybody a boner.

Dude, are you kidding me? Seriously? Do you want to make us barf? Native American jewelry is such an obvious scam to get girls to talk to you, it makes guys who carry a puppy look like Lemmy.

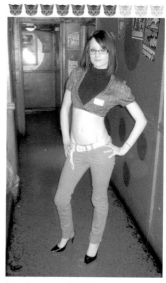

Have you ever had perfectly pure cocaine before? You can eat with it, fuck on it, sleep after it, and it glistens in the light like a prism. The only thing it doesn't do is fall from the sky — thank God.

I don't care how retarded she looks, if this guy is not a fag hag's best buddy, he's basically a Jedi who convinced her all the other guys are not the droids she's looking for.

I want a woman that's 50 percent ticket girl from indie movie theater and 50 percent slut from the 60s. Wait, no I don't.

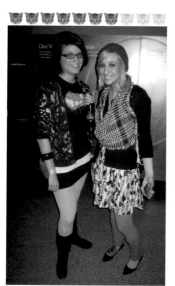

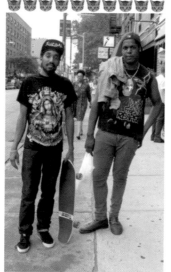

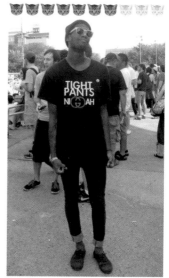

Remember the No. 1 rule of accessorizing: Before you leave the house pour one garage sale all over your body.

Comparing New York to LA is like asking if Agnostic Front could beat up Devendra Banhart. (They could.)

What started out as a stupid joke from A-Ron's buddy has become the biggest fight within the black community since Oprah said rap sucks.

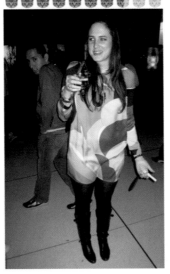

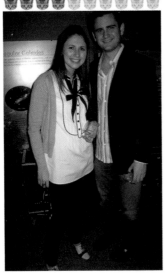

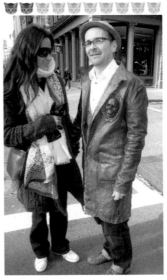

And thus, hotchickswithdouchebags.com was born.

If this girl was a joint, she'd give me the munchies so bad that I'd have to eat her out.

When rich nerds go shopping, clothes grow anthropomorphic cysts that whisper, "Please ... help ... me."

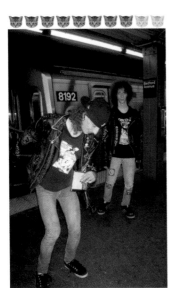

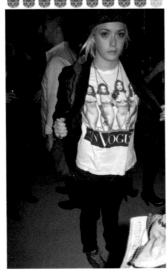

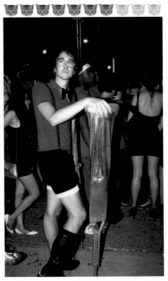

The best thing about DRI fans is they care about moshing the way most people care about Africa.

When fair-skinned blondes wear too much eye makeup they look like Parisian nymphs who stayed up with you all night getting hammered and stealing dumb trinkets from bars.

While everyone outside of New York and LA sees this guy as a "fag with a broken leg," we see a valiant weirdo overcoming adversity and paying his respects to the party.

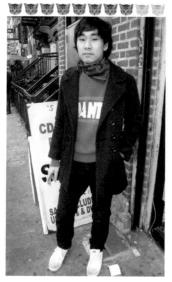

This kind of look says, "I will let you down, I will be a loser, I will bore the shit out of you, then, just when you're about to give up on me, I will crush New England and win the Super Bowl."

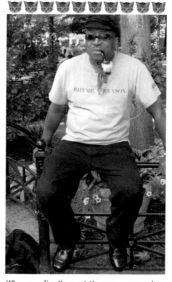

When you finally meet the one person who knows everything in the world, it's surprising how many of his responses are "I think you already know the answer to that question."

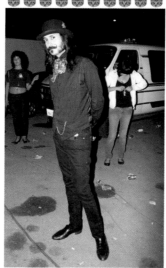

These two are in charge of the Regrets Department at the National Institute of Threesomes.

Adding winter socks to your summer shoe equation is so fucking weird and intense that I now know how anal feels.

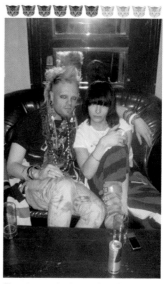

Old-timey is hard as shit to pull off. One sneaker and you're toast ...

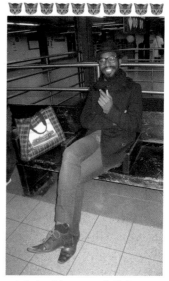

... but when it happens perfectly from head to toe, it's like going back in time but without the short lifespan and terrible food.

If this guy is running some kind of drug ring or even just murdering people for money, I'd like to say to the police, as a taxpayer, "Let it go."

Fat, bald guys with huge record collections and childless spinsters with blogs love to bitch about "hipsters" but seriously folks, who would you rather fuck?

Ugh, that stage when college students discover "fashion is an urban myth" is about as hard on the eyes as their political theories are on the ears.

If a British guy shows up at your school, don't even try to compete. Just hang on to him like cymothoa exigua* and eat out his scraps.

*That's a bug that eats a fish's tongue and then becomes the tongue and then steals all its food.

Blue and yellow go really well together. So do attractive women and boners. Wait, that sounds like my ideal scenario is being surrounded by attractive women and boners.

It sucks to have big tits when you're punk because you become the Mama figure of the scene and all the damaged kids in mohawks come cry on your shoulder for hours. True Fact.

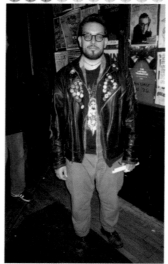

It would suck to have your head cryogenically frozen and then wake up to find they used the body of the guy who hands out flyers at CBGBs.

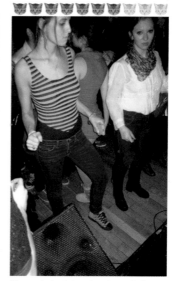

You can hate on American Apparel all you want but I went to high school when girls dressed like the one in the white, and it was a Victorian bummer.

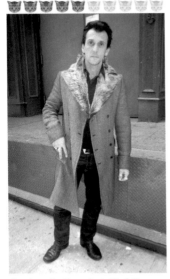

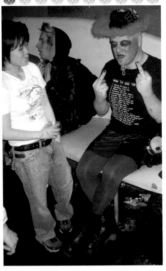

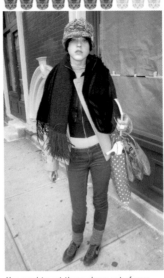

Somehow, the "loan sharks" in SoHo aren't as intimidating as the ones in Little Italy.

Um, there's no need to give us the finger. Our eyeballs already told us you said, "Fuck off."

You need to get those shoes out of your bag and onto your feet and then get out of my dreams and into my car.

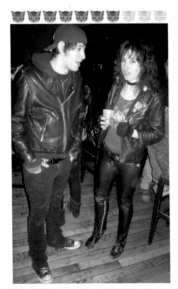

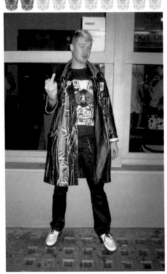

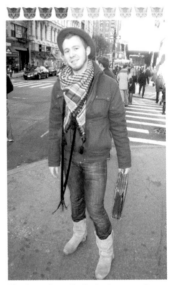

People think it's weird that Sid found a freak like Nancy but New York is filled with these balls-to-the-wall Jewy broads who want you to know YOU are the star of the show and everyone else in the band is a piece of corn in your shit.

This guy looks like the logo for Punk Cheerios.

Here's a palette tip: Try to stay away from Earth-toned orange when you're Earth-toned orange.

I know you bombed Pearl Harbor and you have biker boots on with a cigarette in your mouth but I'm sorry, I'm just not seeing it.

Of all the things baseball has to offer, he chose the graphic design used to represent the sport on children's pajamas.

The only thing cuter than a happy hobo is a disappointed dandy.

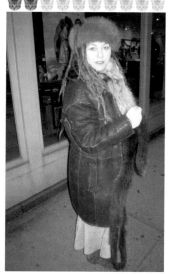

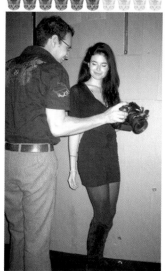

Africans love gold but hate the cold and when they move to New York, the former always overcomes the latter.

When you're young, you're like, "I'm going to be single forever," but trust me, it's not a good look.

Do all these dorks in LA with the silkscreened everything know how much they look like one of the "winners" from that VH1 show *The Pick-Up Artist*?

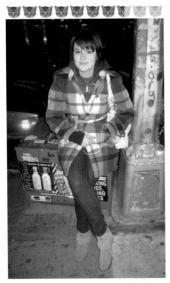

Finally, my little brain and my big brain are willing to agree on something.

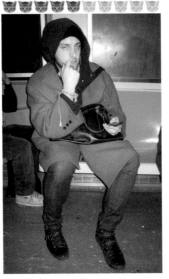

The only thing worse than your big brother and your mom ganging up on you is when they both become the same person.

If this guy is going for "Time Traveling Events Coordinator in a Bitchy Mood," he nailed it!

Wearing a keffiyeh is a great way to say, "FUCK GEORGE BUSH." Unfortunately, it's also a great way to say, "Fuck Jews, gays, rape victims, and infidels like me."

Peter Bagge cartoons look so believable on paper, but when you see them in real life, you realize he's not really that good at drawing.

Ever since Terry Richardson started going to bars again, he's become a total asshole.

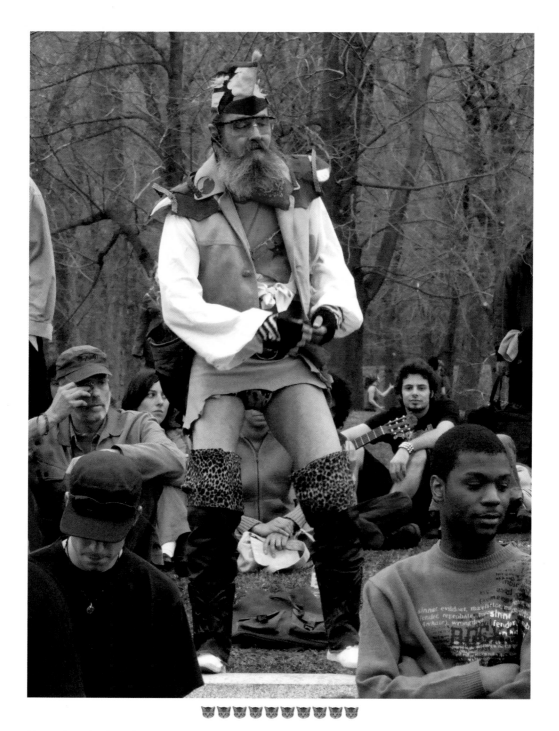

Voyagers from other planets have no idea what a bum-out their balls are. Look around you, Jean-François 3000; your leopard nuts are the End of Days.

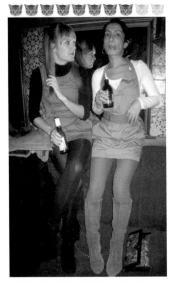

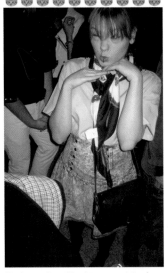

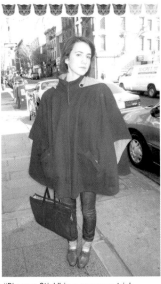

Next time I'm having a bad acid trip, please talk me down by saying, "It's Smiths night. Girls are wearing their best outfits and drinking beer. They're making funny faces. You have $140 in your wallet, and nobody knows you still have a bag left over."

You know when this picture was taken? Who cares? Thanks to places like TG170, New York girls are timeless Boner Machines that represent the best of every decade.

"Pig on a Stick" is a gross eye-trick boomer moms from Long Island try to pull on us but when a normal-shaped girl goes huge on top and small on bottom, it looks more like a cool lollipop.

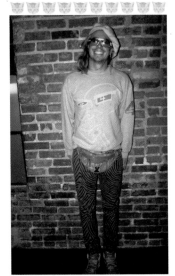

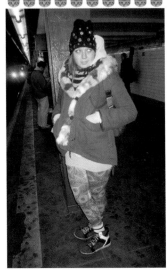

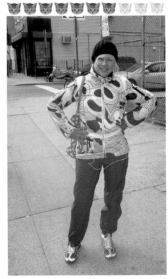

The Zany Colors thing works in LA where everything's clean but here in New York you just look like a bag of dirty candy ...

... Houston, please disregard that last call.

Wait, Houston, are you still there? We do have a problem after all.

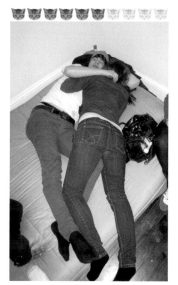

If there was ever a book written about Canadian house parties, it would be called *Socks*.

Montreal is both freezing and filled with thrift stores. What did you THINK was going to happen?

I tried to resist this guy but he's like taking a gay pill! Sorry, God.

A Fag Hag's life is nonstop laughs but if she doesn't watch the clock carefully, she'll be staring at her watch in 10 years saying, "Hey, where the fuck did my ovaries go?"

Don't ever pay a lesbian money to suck your bag. She will outsmart you.

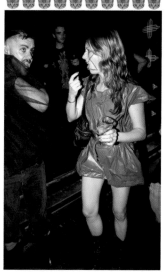

Not to get too Woodsy Owl on you but, as the New York Dolls said, "Trash, go pick it up. Don't throw your love away."

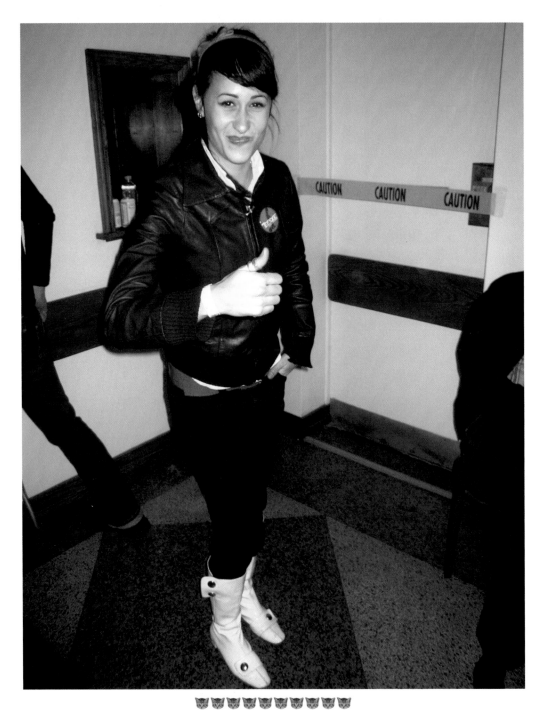

🐱🐱🐱🐱🐱🐱🐱🐱🐱🐱🐱

Sorry to pull another double whammy like we did with the Nashville girls, but this jokey-faced nine is more than just a cute European rocker in 60s boots. She's also the keyboardist for the Staggers.

What is it with people under 25 and sitting? They sit everywhere. They also hug the shit out of each other every 10 minutes. I guess that's life before you learn about dogshit and sex.

It's amazing how many kittens get taken away when you don't let your shoes grow up and hang out with the rest of you.

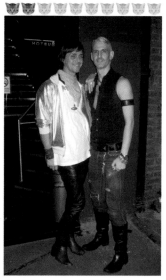

It's kind of worrying that Richard Branson is spending so much money on SpaceShipOne because the last thing outer space needs is more fags.

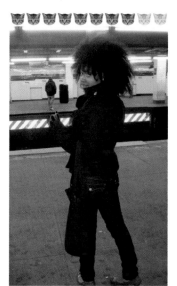

You can always tell which girls grew up with big sisters because their shit is just too perfect to be DIY.

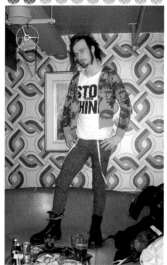

Just a tip: If you're an ugly, old, British techno punk who nobody's considering fucking, you may want to avoid a shirt that says "Stop and Think" and was made by H&M to support AIDS awareness.

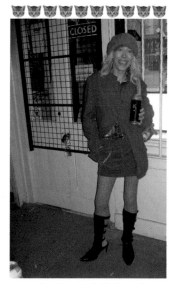

I guess if you're going to the Fancy Dress Ball as a crackhead's tampon, this is a ten.

This guy's posture is so fucking good, he looks like a pen.

This dance is called "Leo Fitzpatrick as a Tiny Skinhead From a Chucky Movie Using His Gigantic Shoulders to Be Incredibly Sarcastic."

English girls are basically the Asians of the Caucasian world.

Punk was way better before they all became obsessed with *Dumb and Dumber.*

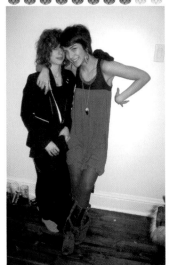

It must have been fun to be Uday Hussein at his peak and have women offer themselves to you, petrified you'll kill their husbands if you disapprove.

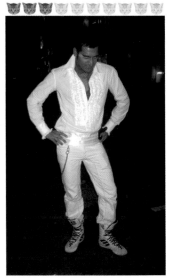

When people were voting on what Elvis era to use for his stamp, almost nobody voted for the three months he spent in a K-hole.

A bunch of buddies on 50cc mopeds is so much more badass and fun than real bikers, it makes the Ching-a-Lings look like the Jonas Brothers.

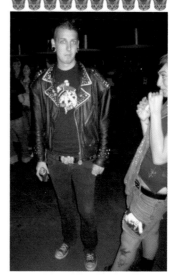

Everyone who *used* to have plugs needs to go on a national Snoopy-Ears Tour, where they try to explain to guys like this what the future will hold.

If a pretty girl tells you she was dumped a good line is, "Well, it was cool of you to be open-minded enough to date a blind guy in the first place."

If I was the Bible, I'd be a little concerned that 100 percent of crazy people are really into me.

Spending lots of money on boots can turn even the dorkiest jock chick into a horny British aristocrat way out of her boyfriend's league.

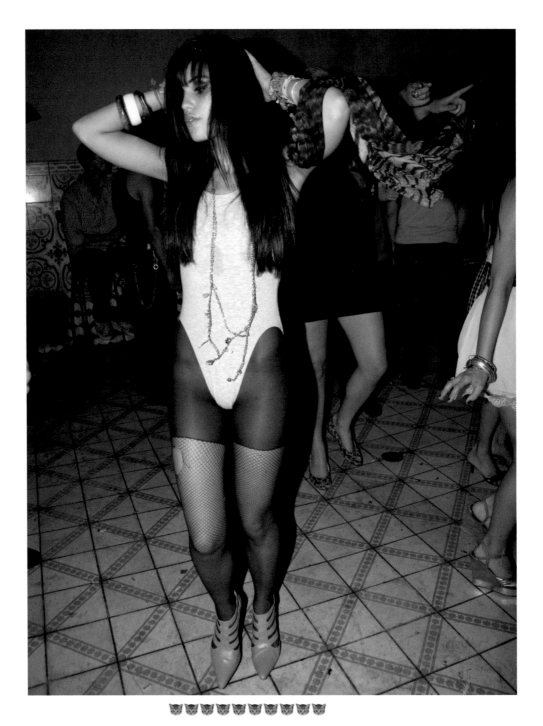

Tens like this teenage Béatrice Dalle need to dress mentally ill. That way when we see them, we can convince ourselves they might be crazy enough to talk to us.

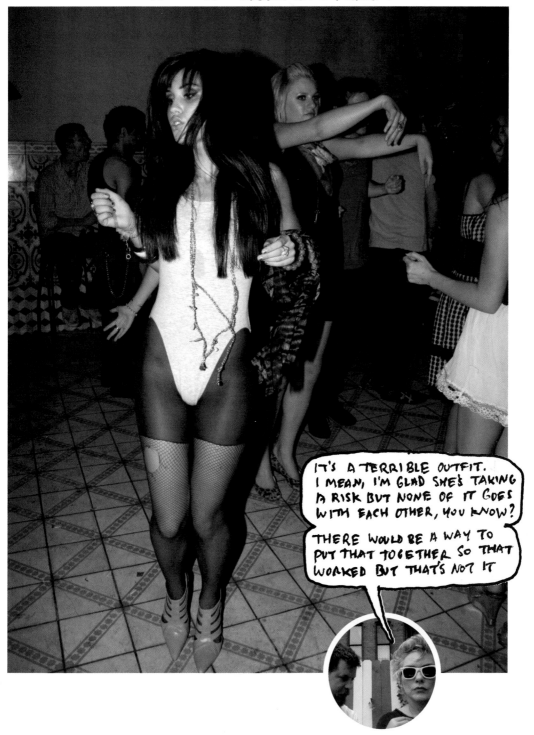

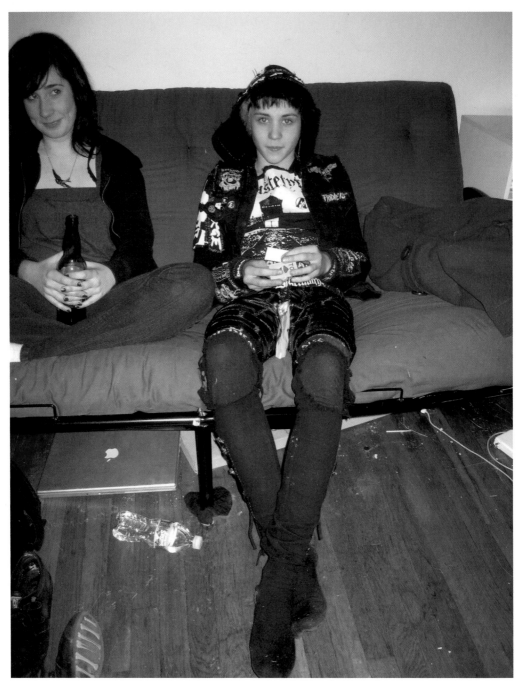

Ten years ago, crusties were the homeless losers of the punk scene but we kept sewing and sewing and sticking on patches because we knew, one day, middle-American college nerds would call on us during their naughty phase.

Why is porn totally incapable of capturing the scalding hotness that goes on when people in the real world get horny?

Can you imagine the kind of porking that went on back when glam was big and AIDS was not?

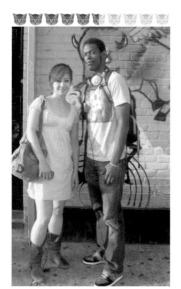

Come on guys, you're 20 and living in New York City. You can't just phone it in with some funny bangs, one sideburn, and a trip to the thrift shop. You look like alternative Bosnians.

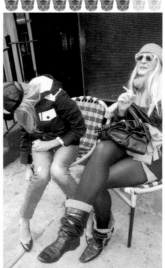

You can tell exactly how stoned a girl is by how much weird shit she puts on right before leaving the house.

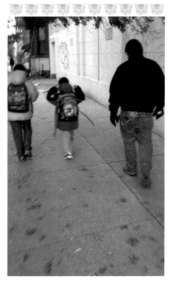

This guy was walking his kids home with his iPod BLARING Metallica. So, who's walking who?

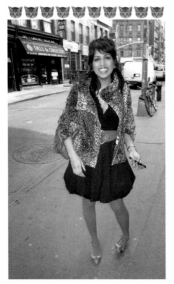

My penis would like to go Paki bashing in her vagina.

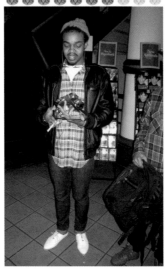

A lot of people want to know how New Yorkers got so stylish but trust us, the device they use is so complicated, you're better off sticking to your skull blazer and your stressed-out denim.

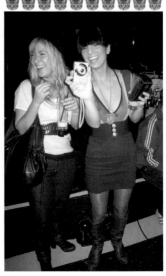

Oh fuck, if this book could turn the tables on me and see who's writing these, they would laugh their fucking heads off.

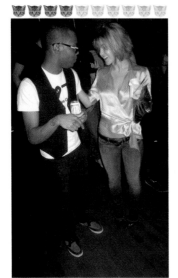

Imagine all the shitheads out there who see this as "a dork with a hot chick" instead of "a mensch with some TV reporter chick dressed like Chevrolet's idea of cool."

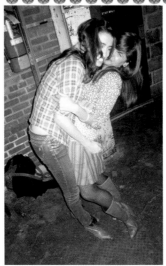

This is what Brazilian fours do when they get to London and realize they're now considered 11s.

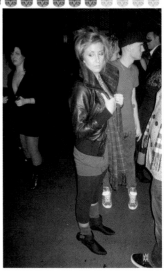

French Canadian women don't get old. They just turn into Roxette.

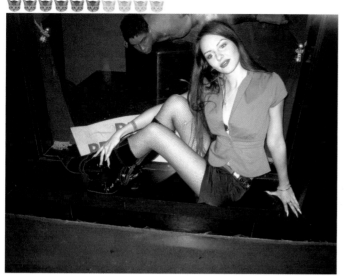

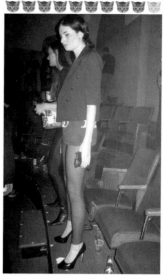

This looks like that phase when girls think they can paint and they watercolor up some totally ridiculous scenario that could NEVER occur in real life.

Five-inch stilettos give all girls Holy Shit status. Even if their head is dressed like a flashcard for the word *girl*.

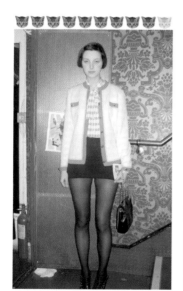

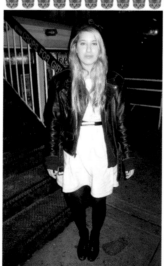

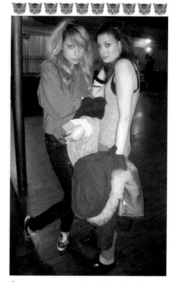

Girls Gone Wild is the opposite of this. Instead of vapid sluts flashing their drunken tits to athletic cavemen in tight baseball hats, we have a quiet nerd who has recently discovered her sexuality but has no intention of showing it to anyone but you — maybe.

When even *slightly* Middle Eastern girls dye their hair blonde, it's a delicious mind fuck because they become all-American girls who America is spending $600 billion trying to destroy.

From now on, every time I hear Rocky Dennis say, "My mom says I look like a lion," I'm going to get a boner.

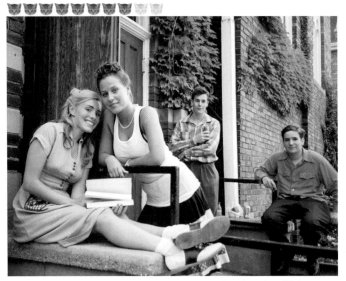

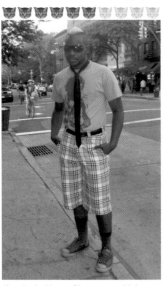

Just remember, no matter how bad things seem, you are still getting about 37 times more pussy than your grandfather ever did. I mean, look at him.

If you're looking to file a personal injury suit after a breakdancing accident, the Black Eyed Peas' lawyer is one of the best guys out there.

You can always tell which guys are only pretending to be zany. They're the ones standing around with the "all right, I bought all this bullshit, can I get laid now please?" face.

Girl, you lucky you dressed like the gum under my desk cuz I'm about to chew you like a leather strap in a guy's mouth back in the 1800s when they didn't have anesthetics and he's getting his leg sawed off or whatever.

If you ever get sick of being a badass in Orlando you could always try being a laughingstock in New York.

Sometimes a stranger will do a weird thing with her mouth where you instantly fuck her in your mind so many times that by the time you introduce yourself, you guys are basically married.

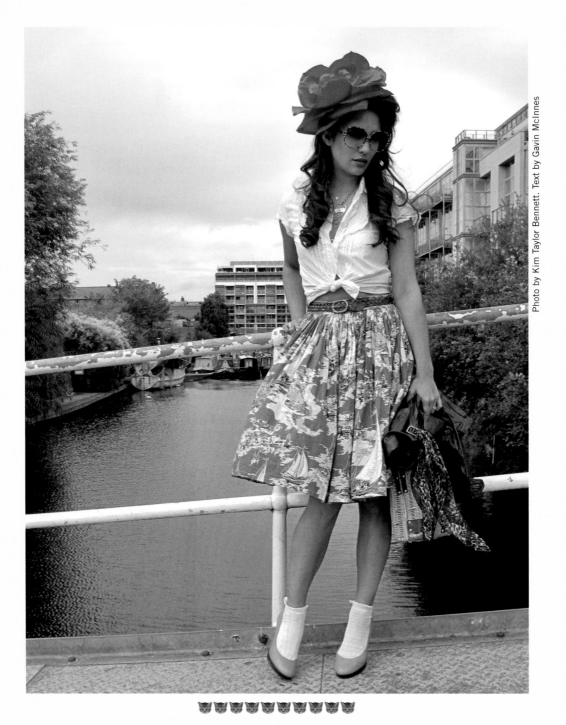

This is Kim Taylor Bennett. I can't get into exactly how I feel about her or my wife will be serving me with divorce papers.

WHAT ABOUT LONDON?
An Interview With Kim Taylor Bennett

Whoops! I've been spending so much time talking about LA vs. New York, I forgot there's a bunch of other cities in the world, like London and Montreal. Let's start with the first one and interview the ten kitten-est chick I know over there. She's a British writer/TV presenter who cares about how people dress almost as much as I do.

New Yorkers love to crap on LA and London and just assume their city is all that matters, but London takes way more risks fashion-wise, don't you think?
London is hands down the most fashionable city in the world. I see more fashion-forward dressed people falling out my door to buy a pint of milk than I would barhopping in Brooklyn. As with most cities, however, it really depends what post / zip code you're in. East London has been a photo-op epicenter for decades but if you go to Acton, it's pretty staid High Street fare. Londoners who give a crap about clothes do take more risks, which means sometimes you might pass someone in the street who looks like a cartoon. You'll probably laugh at them but at least it makes the city colorful. Case in point: 2006's nu rave tragedy. Terrible, but a spectacle.

What do you think differentiates London fashion from other cities, like Paris?
Parisians on the whole are more polished, particularly the ladies. The word *chic* was really made for that city and its citizens. London's fashion tribes are distinct and strong. Whether it's the drunk punks hanging out on the lock in Camden or the retro girls with their petticoats and Rita Hayworth hair at the Bethnal Green Working Men's Club or the flamboyant drag queens at the Dalston Superstore, London fashion kids tend to get into their groove and not give a crap what trends other people around the world are following. I think perhaps in other cities like NYC, it's better to look like you've not made too much of an effort. Londoners who want it to work will look like they've considered every aspect of an outfit down to the last stud.

How often do you wear heels and how do you deal with the discomfort?
I wear heels pretty regularly, especially when I go to gigs, so I can dance around and actually see the band. Heels make your legs and butt look awesome, and dancing in them is a much more effective workout than doing so in flats. You can feel the ache the next day. Every smart girl packs a pair of ballet flats in her purse for the stumble home. This also means that should you need to, you can use your heels as a weapon and then run away.

What's some go-to safety look that any woman can pull off no matter how fat?
Dresses. A well-cut, perhaps empire line dress will successfully and flatteringly encase the flab.

Do you have a dealbreaker with guys? Something where, no matter how great they are, you just can't get over that they wore that?
Men who wear their trousers cinched below the bum so when they walk it looks like their pants are full of turds. Fashion / complex haircuts of any kind. I find men who spend time on their hair pretty repulsive, and this includes highlights, lowlights, goatees, or soul patches. Shirts with logos like Versace. Soccer shirts, unless they're actually playing the damn game. White jeans and deep V, American Apparel T-shirts. Just get lost already. Seriously. A normal V-neck equals good. Plunging is unnecessary. I'm also not OK with those little baby foot socks that end just below the ankle. I don't know what it is about them but I find them incredibly creepy. I know they're practical and should make sense but they just don't. They're vile. I'd rather have a sweaty foot than a sorta-sock.
However, as much as I hate all these things, if they were really awesome and we burned these items together, then I think I could get over it. I'm forgiving.
I'm also a big advocator of a white T-shirt and a pair of well-fitting Levi's. Era-less hot.

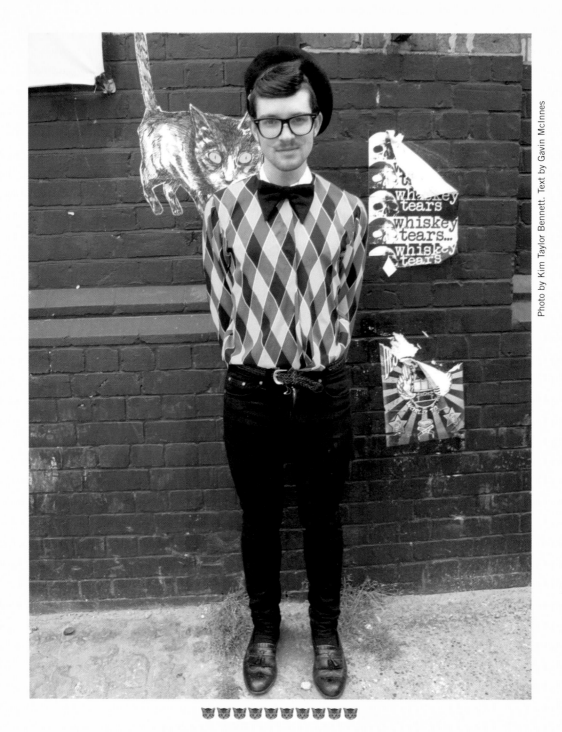

Photo by Kim Taylor Bennett. Text by Gavin McInnes

It's amazing how few members of Gorilla Unit "get" this guy.

Photo by Kim Taylor Bennett. Text by Gavin McInnes

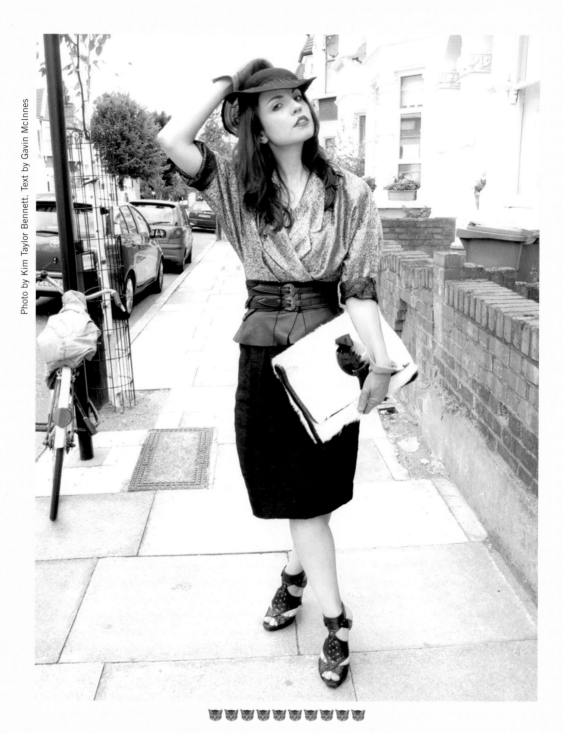

"You're not the boss of me" is an incredibly effective putdown, unless of course you would be honored to have that person be the boss of you.

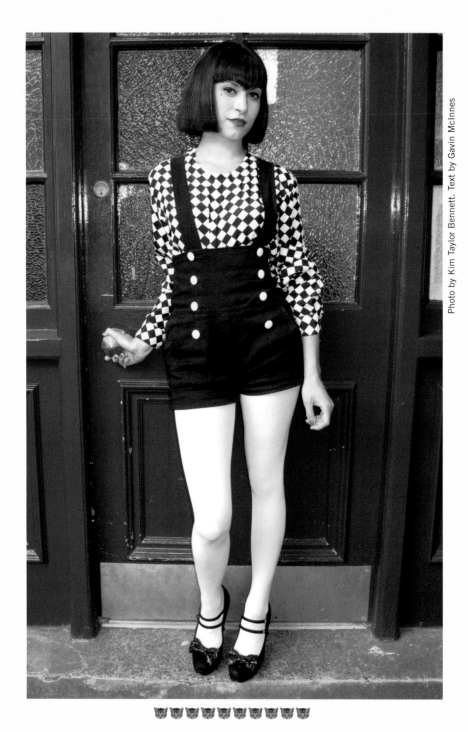

I would take all the LSD in the world if it would make Alice in Bonerland part of my hallucinations.

Photo by Kim Taylor Bennett. Text by Gavin McInnes

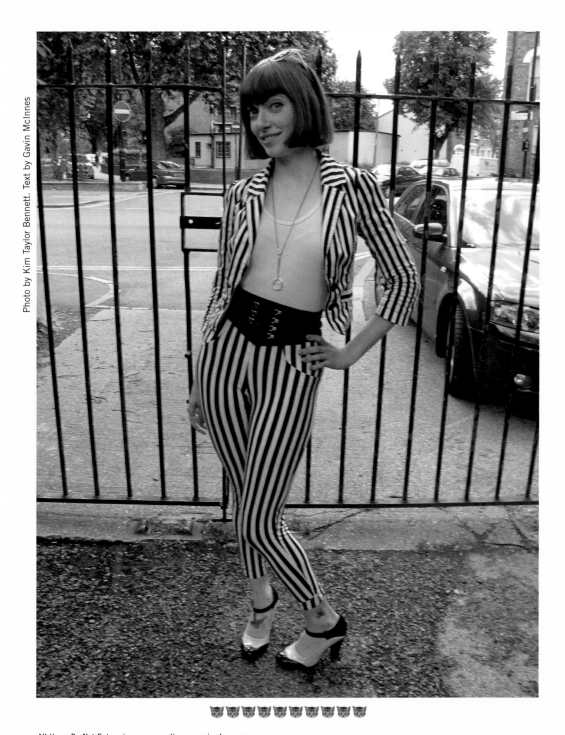

All those Do Not Enter signs are sending me mixed messages.

The perfect wife is a slut in the bedroom, a cook in the kitchen, and a buddy in the living room (and has a really hot friend, so you can constantly wonder what life would be like if you had married her instead).

You're only single and fucking for about 15 percent of your life so carpe diem, boners! (That's Latin for "Do the math, you guys.")

I feel a kind of a strange kinship with this because I too consider myself a badass.

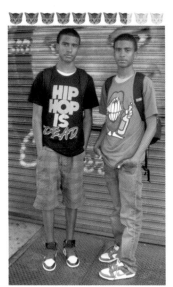

Man, it's hard to judge serious contests when the contestants are twins.
Um … tie?

Dude, I gotta go piss too but unless your penis is a balloon, holding the end shut is an *extremely* temporary fix.

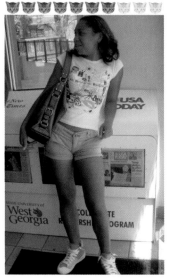

Staring at short shorts is like looking into the eyes of the storm because everything you want out of life is stuffed into one cubic foot of canvas.

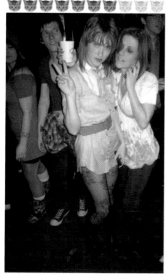

Are you saying peace to looking like the scariest bunny boiler *Fatal Attraction*'s ever seen? Because that look is not at war with you.

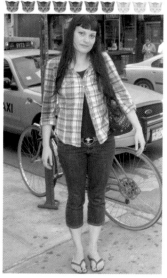

It is virtually impossible not to fall in love with your tour manager if you're in a band but tour managing is a terrible job, so just steal the look and skip the headaches.

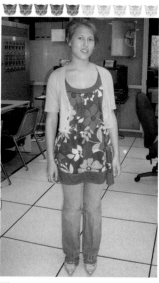

Whoa, way to eat my type, puke her into a bucket of random fabric, then submerge your ass in it and fart.

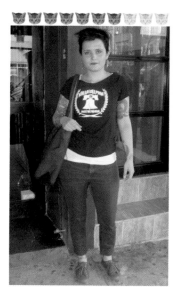

Sometimes when we stop people and ask for a photo they're like, "Really?" Yes, really. Our red carpet is you getting off your bike to go buy tampons.

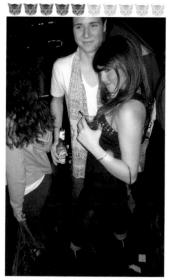

Can Midwesterners go back to sports uniforms, please? They're starting to look like little kids dressed as Bravo contestants for Halloween.

Girls like this used to feel boring and bland until Lissy Trullie came along and put the white back in white-hot.

You're only allowed to look at a girl for two seconds every 45 seconds, so I'm about three hours into look-away debt at this point.

Jesus Christ, ladies, are you trying to pose yourselves to death?

This is so obviously a recent divorcé that thinks he can sneak back into the club scene and nobody will notice that he's really fucking old and really fucking bald.

Dressing like a Hunts Point prostitute to meet guys is like rubbing shit all over your legs to meet flies.

Let me introduce you to my boys. This is "WT" and this is "F?"

You thought your mom was cool when she was your age but look at her. Same old mom just better tits and less wrinkles.

Sociologists say sex and dancing are very similiar. This is because both acts look equally hilarious when unknowingly photographed.

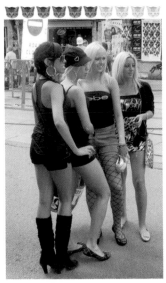

Normal girls dressed up "sexy" is a great way to see women through gay eyes.

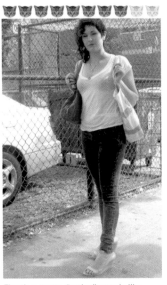

There's a reason "spring" sounds like "schwing."

She needs to frame these in a plexiglass case to serve as a permanent reminder that high school was actually pretty fucking fun.

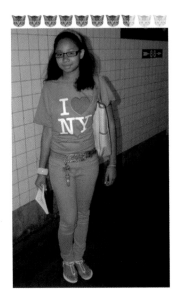

When Bratz came out we were all worried that generation was ruined forever. Then they grew up and did teenager even better than we did. Phew.

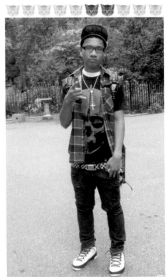

Like a caterpillar to a butterfly, this kid is just finishing his pile-it-on stage and is about to go from douche to dude.

Not sure what you're trying to say, but "I like my keys to bounce atop my anal lips as I walk" is not something you often hear east of the West Village.

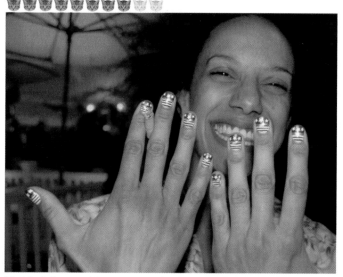

What the fuck are you doing, lady? To carry fingernails like that you have to have the most eye-poppingly cute look since a baby polar bear became friends with a cartoon ladybug on his birthday.

Phew, that was close.

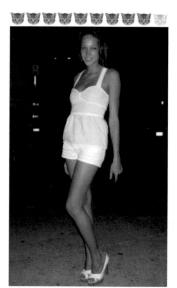

I want to kill myself just to get her attention.

Word to the wise: Any girl who gets super sexy in public and seems to be saying she's a blow job expert is about to turn your penis into ABC gum.

The suburbs are so pissed at themselves for being the suburbs that they punish everyone who tries to be cool by soaking them in ridiculousness.

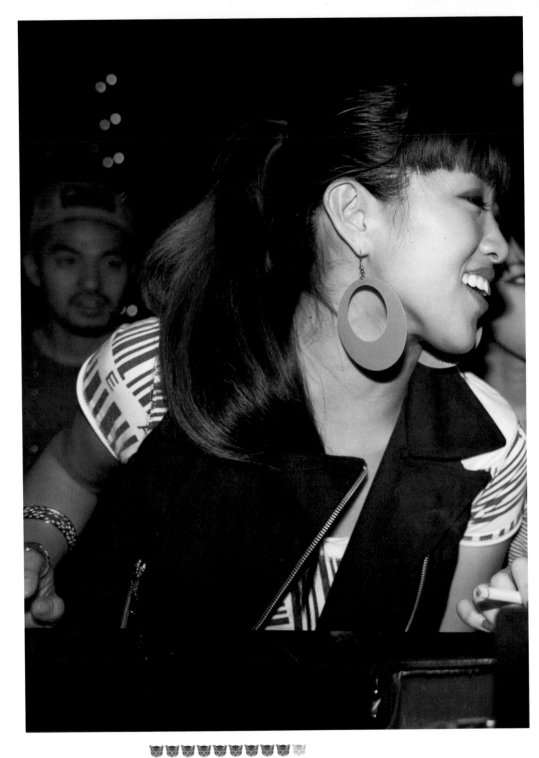

"Don't worry, Mayumi. When we get to America, we will be able to get all the insecure white indie nerds we want."

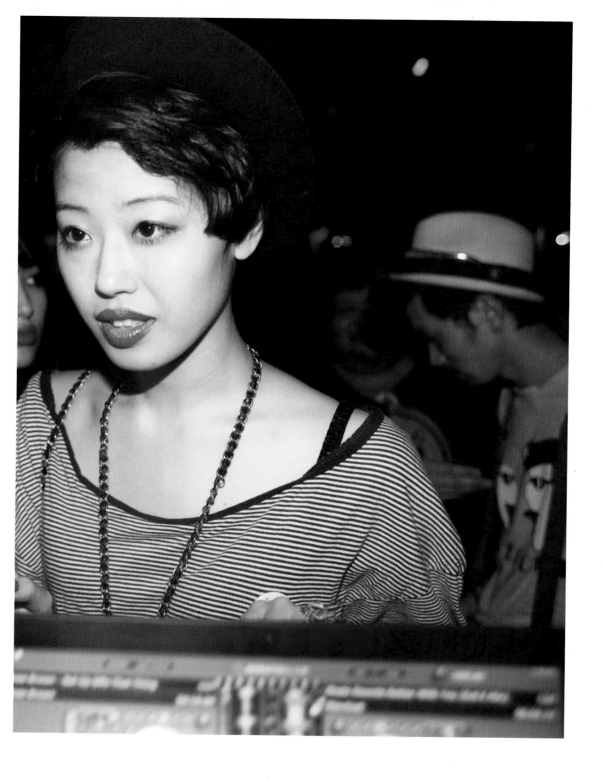

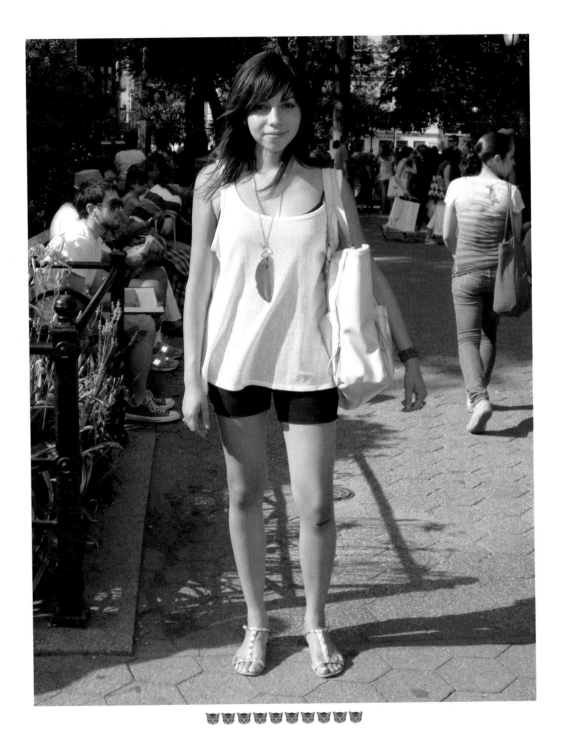

All you have to do to look great this summer is keep it simple, tone down the accessories, and lose the makeup — unless you're fat and ugly, in which case the opposite is true.

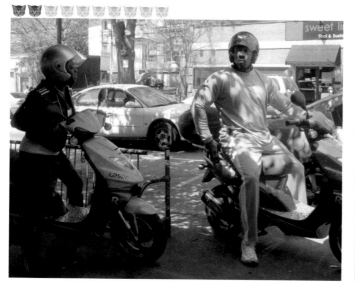

It's nice to see superheroes finally battling things, like me-not-laughing.

Maybe women love shoes so much because the right pair will give our eyeballs an uncontrollable magnetic pull, kind of like what a dog feels when he sees a squirrel giving him the finger.

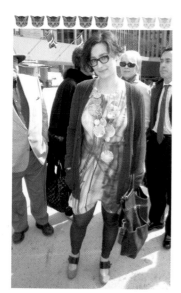

Why is it that all editors of fashion magazines look like the opposite of what they write about all day?

Tits are so gay, they're basically for fags.

How harsh is it when a blind person doesn't have someone reliable to tell them what they're wearing or how they're dancing?

Canadians and White Nationalists are the only ones still clinging to the idea that the Celtic Riverdance look is anything but gross and pale.

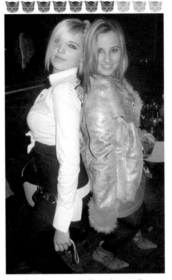

Polish girls are great, if you love vodka, fur, bad karaoke, and pretending you're going to marry her some day.

Remember in *Sid and Nancy* when he ripped the feet off her stockings and sucked her toes? That's what stirrup pants always make me think of: something only a dead junkie could love.

Not only does she never violate any of your secret pet peeves, she shares them. Even the one where you can't stand it when people put used napkins on their finished plates and keep picking. She calls it Dumpster Diving.

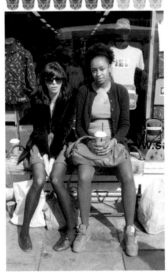

This is how girls' dance teachers used to look back in high school when they took "jazz." (What the fuck was that, by the way? What's jazz dancing?)

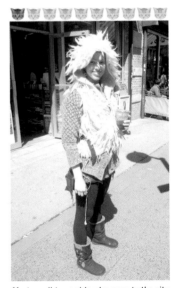

Most small town girls who move to the city either go Carrie Bradshaw, MIA, or Debbie Harry. Then there's that tiny percentage who try to come up with their own thing, like "Fraggle LARP."

If you started a squat in New York instead of working your ass off to pay rent every day, you know there would be eights waiting for you every time you got "home."

Big sisters in the 70s were about alcohol, divorce, smoking "grass," and teaching their little sisters how to give blow jobs.

Hey, sorry I had to put you on hold. There was a fire in the building, and all I could grab was a blanket, a toddler's hair, and some hash dealer's "trainers." Are you still there?

Well, the bad news is gray shoes on black tights are a dealbreaker for me. The good news is you don't care what fags think.

British, New Age hippies smell way worse than their American, Burning Man counterparts because, unlike the desert, rural Britain is very moist, and bacteria never really get a chance to dry.

Originally I was going to say, "The problem with these costumed assholes in bars is they usually end up pulling," but I saw dude at the playground with his kid and he was still wearing that hat, so now I'm just freaked out.

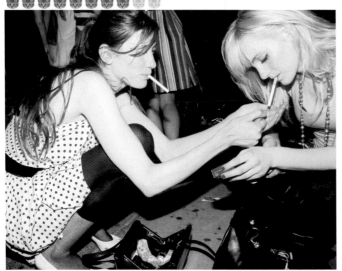

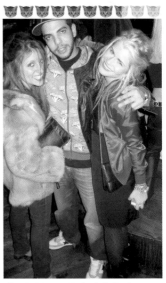

If you're trying to persuade a girl to stop smoking and she starts saying things like "It just looks cooler," try to get the discussion the fuck away from that and back to stuff like health and corporate profits, or you will lose because it does look cooler.

What is this guy, the Dr. Dolittle of vaginas?

Hey, Sylvia Plath, it may look great when you draw it in your journal but a wool hat in a club is like sticking your head in the microwave.

Totally gorgeous. Mega-stunning. Perfect body … no thanks. Might as well be my dead granddad's dick in a red dress.

PS: How funny would it be to do a video for "The Lady in Red" with my dead grand-dad's dick in a red dress?

It's fun when girls dress all comfers cozers because you get to see what they will look like when you fall out of love with them.

How you gonna fuck with this? They are so far over any of our heads, all we can do is step to the left and say, "Play through."

This is from a dream where Michael Jordan woke up and said, "Whoa, what the fuck was *that* about?"

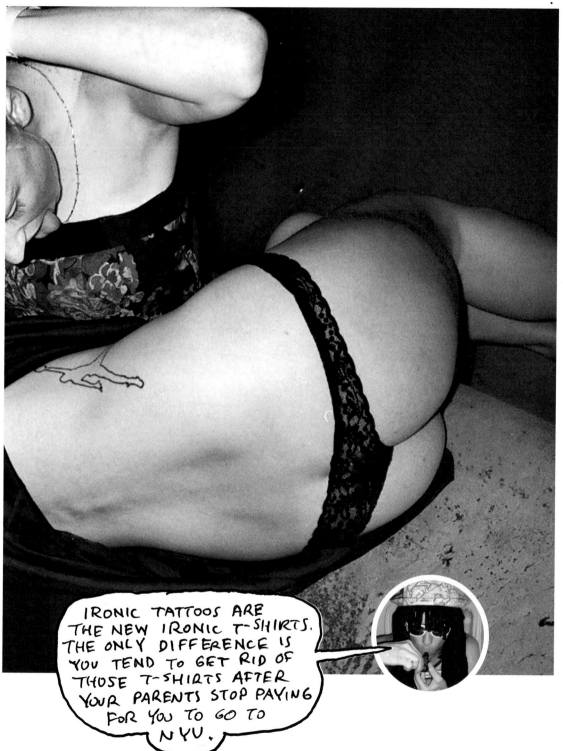

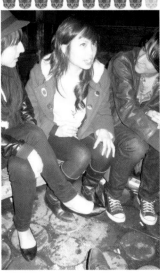

Becoming the No. 1 DJ team in the world and rocking the shit out of 1,000s of people 7 nights a week is a great way to fuck 10s whenever you want, but if you can't spend 12 hours a day setting up a life like that, just buy an 8 ball.

What's better than going out when you really deserve to go out? Like, you just finished a 10-hour shift, and you haven't been out in over a week, and you have some money in your pocket, and you're on, and everyone seems really hot and interesting? It's almost mean to heaven.

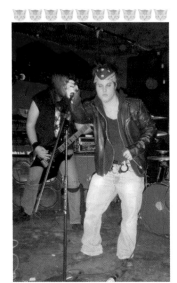

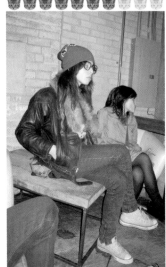

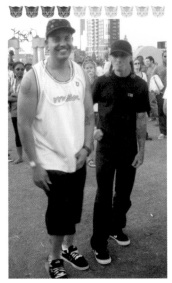

A good band makes you feel good about yourself. If that's because they're such fucking losers in comparison, that still counts.

When you least expect a girl to be the best lay you've ever had in your life, expect it.

Old wiggers like to talk about their baby's momma because they all look like baby daddies.

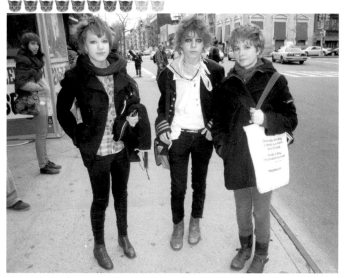

If you're looking for an era to dress like, how about the first three months of punk? We're talking before Vivienne Westwood, before the Sex Pistols, before Carnaby Street ... back when it was still just shit you found around the house.

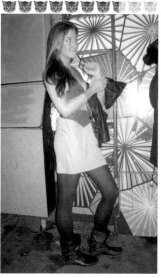

When I was a little kid, I whipped a stick into the air and, after a few seconds of majestic spinning, it just went PLOINK into the mud (it made me and Lee Gratton laugh our fucking heads off for some reason). Anyway, the same thing happens when your eyes get to these boots.

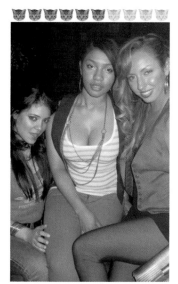

Sorry, Bridge and Tunnel Sirens, my penis is not a sailor, so all I can hear when you sing is some bullshit about astrology and a guy named Vito. Your powers don't work on me.

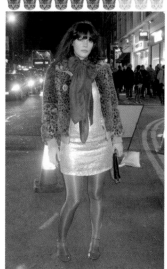

If purple is the color of sexual frustration, I would love to be the first to get my Xanax into her dopamine receptors.

Holy fuck, are Native American readers of Coleridge ever going to be pissed this company is called Albatross.

A woman's biggest fear is someone asking her, "What the fuck are you doing with *him*?" All the guy has to do to avoid that is become so weird that he turns himself into an accoutrement, and then the woman can just say, "Oh, him? He lives under my friend's couch and burns frogs."

This is weird. He has facial tattoos and seems to be making fun of "posing" or whatever but she's obviously into it, and bee tee dubs, why did you get tattoos on your face if you think getting attention is so queer?

Know that if you just turned 40, this is your demographic. Vans and Wayfarers are the sock garters and Bermuda shorts of Generation X.

This guy's pants-and-shoes combo is so CGI, he looks like he's at virtual SXSW.

She looks like a Canadian celebrity, which is like looking like a sexy cartoon, a black nerd, or a giant mouse. Actually, she looks like all those things.

Girls with cankles will forever refer to the time these sandals were popular as "Our Invisible Summer."

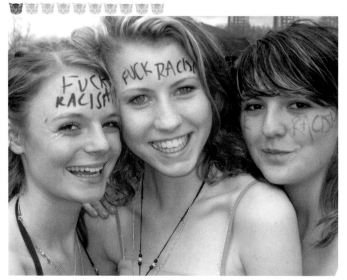

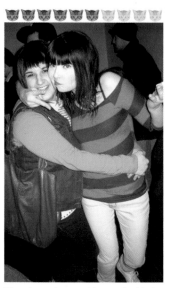

"When we found out Michelle wasn't allowed to sleep over at Sherrelly's because her parents are, like, prejudiced towards people of color, we spent the whole morning totally ending racism. At first it was like, whatever, but then it was like, 'We did it!'"

The only way to wear stripes and not look fat is to just stick them on a skinny girl and carry her around all night.

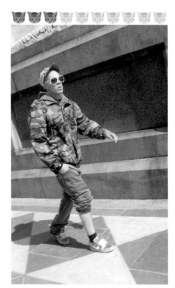

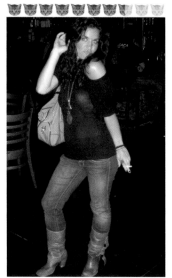

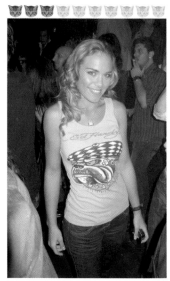

What is it about making beats with Pro Tools all day in a dark basement that turns everyone into baby Steve-Os?

Homos can put 8-year-old ladyboys on the runway until they're stuffed in the face. When it comes down to an actual meal, we'll be eating this, thank you.

She needs to be "goin' back to Cali," where this shit means "kick ass" and she is considered "not boring."

Here's a tip: If somebody with an accent (could be Brooklyn, Southern, Russian, whatever) asks you to apologize for bumping into his girl, apologize immediately. Being overly polite is a prison thing, and the last thing you ever want to do is start fucking with those crazy rules.

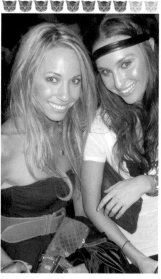

Yes, I agree they're pretty but you know they're both more high maintenance than a one-hitter.

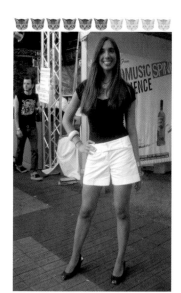

Usually if your mom and dad think you look "drop-dead gorgeous," you probably look pretty fucking lame.

New dads get so into bundling they can't stop themselves, even if it means baking their own genitalia like cicadas in a forest fire.

Got to meet Stevie Nicks after her show in Atlantic City last week, and I was like, "That was amazing — and I'm NOT just trying to blow coke up your ass."

If this is what life is like out of the closet, I am totally content to remain secretly gay.

Excessive foot tattoos are just permanent socks with holes.

This guy is basically punching Getting Laid in the face.

There's something about women who are REALLY into purple that sort of says, "I'm giving up on a normal social life and will be focusing on my cats from now on."

There are some, however, who are an intervention away from being rescued. "I see a bunch of people right here dat love ya like crazy, and dey feel like dey're losin' ya."

When I saw these two and looked down at my own outfit, I felt like how a junkie must feel when he sees how awesome your apartment is.

Window dressers need to keep their lifestyle choices private and not let it influence their work. It doesn't really make sense to see mannequins screaming, "We're here, we're queer, get used to it!"

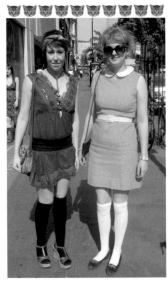

If you've recently had penile surgery and cannot get an erection, do not picture these two British girls, with just those socks on, giggling in your bed, all weekend.

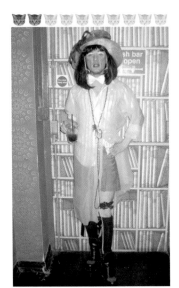

Whoever says he went home with a chick and was stunned to find out it was actually a dude is a gay, blind liar.

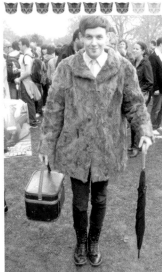

It would be nice if every goombah in Brooklyn had one of these to tell him when he's being "far too brutish" but you know the poor kid's nose bone wouldn't last an hour.

Partying with your shirt off is a great way to say, "I'm not here to meet girls. Let's get down to some serious boozing," which is why your dad likes it so much.

First Asia brings us mad cow, then bird flu, and now a massive influx of brown nylons, something we got rid of almost a quarter of a century ago. Thanks for making us look at toes that look like they're about to rob a bank, Mai Lynn.

When she puts her hood up, she becomes the cutest little snuggle bunny in the history of the Klan.

Oh, how the mighty have gone from drumming for Sigue Sigue Sputnik at the Budokon to schlepping boxes for an old Jewish guy who calls him "Clown Head."

Even the most pathetic homeless loser can learn to be a pimp. All he needs is a lot of confidence and no eyes.

She may not be your cup of tea but if this bitch gets even *close* to the Caribbean Parade, it will make Beatlemania look like a handful of fans who were mildly interested in a mediocre British band.

The best way to get chicks is to be as weird as humanly possible and have some kind of project going on. This caters to their cave instinct of wanting to be part of the group and makes your group look particularly special.

Is that Data from *Star Trek* with his collar up, or are you just happy to see me?

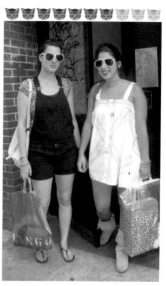

It's sad when they're old but there's something about young JAPs bleeding daddy's credit card that just seems so soft and plump and smooth.

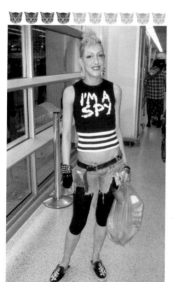

Yeah, but who asked you to infiltrate the "girls we have absolutely no interest in fucking" scene?

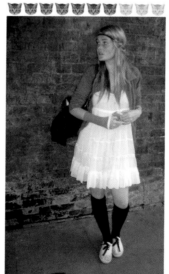

She may have been headed for a cute schoolgirl kind of thing but the end result is more of a very attractive and young bag lady.

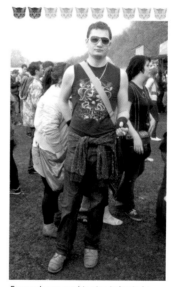

Farmers' sons need to stop trying to be "urban" and realize there's nothing realer than a bearded hick with muddy Wellingtons and a pair of overalls.

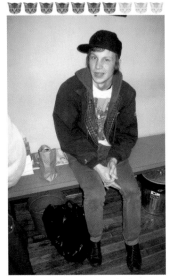

If Chucks, Dunks, Wallabees, Loakes, desert boots, Rod Lavers, Vans, Red Wings, and old Doc Martens were a jacket, they would be the Harrington.

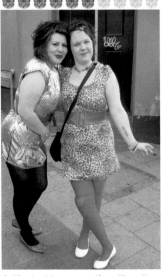

California girls are great if you like ogling morons, but if you want to have a really great time and drink more booze than you've ever heard of, go Scottish or go home.

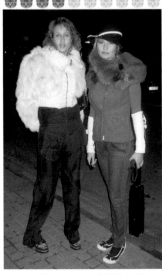

Russian chicks are materialistic but they come from a place with no materials, so the end result looks like homeless people broke into Macy's.

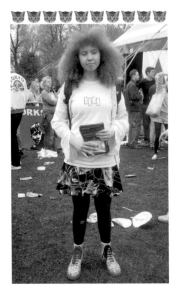

We're at the age where 14-year-olds are our friends' kids, and it's pretty reassuring to see how totally honest, unaffected, and over-it this next generation is.

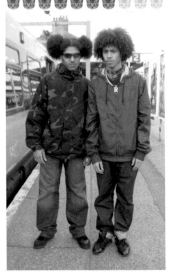

The secret to any hairdo is to say to yourself, "Can I pull this off when I'm walking home alone?" Unless you're very drunk, the answer to the Mickey Mouse afro is: No.

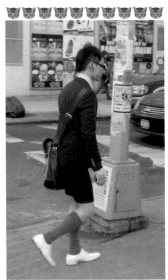

God bless the nerds who pull up their socks, step into the fray, and say, "I'm vastly different than most of you reprobates. Deal with it."

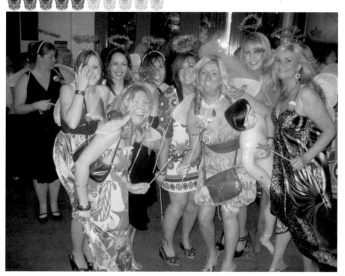

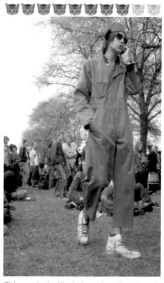

Sometimes when you're 14 and you're beating off, you want a dozen women to appear in your bedroom so bad that you basically soak your dick in tears. If only you knew back then what a complete fucking nightmare that would be.

This guy looks like he's saying, "It's done," to the greatest prank planner of all time. Within the next two minutes you are going to see a 300-foot Penis Swastika balloon black out the sky above.

This is the kind of girl who you could find out has herpes, and you'd be like, "Well, if they're not flared up, I mean, is it so risky?"

The hot new thing with hardcore kids is dressing like boaters from the 50s being raped by bikers from the 70s.

You can never not get it up for small girls. We don't want to get into the psychology of *why* because it's probably illegal.

When they say, "Youth is wasted on the young," they mean, "Youth is wasted on SOME young." Most of them are having a great time wearing, eating, and fucking things you never can again.

NY thugs are pretty sure nobody knows they grew up without a dad. I mean, how could anyone possibly find out?

He's accepting the Gorgeous Penis Award.

What is with people tying their Chucks so tight they look like white canvas S&M corsets? Are they scared their feet are going to escape?

His hair is like the projects but for microbacteria.

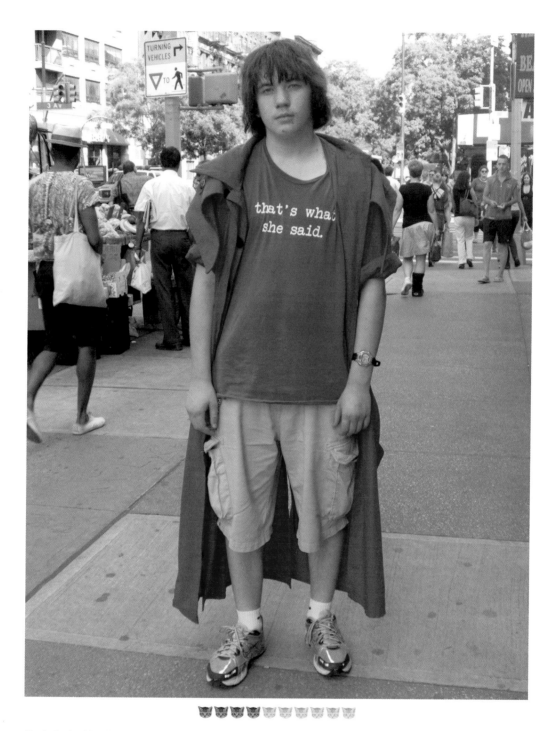

Nice jacket but it's so long and big, I'm not sure if I can handle it.

Drinking all day in the summer is a great buzz but if you add pot cookies to the mix, you will instantly go from mad blotto to mad blogged.

Every time he calls his dad back home the music from *Mary Tyler Moore* starts playing in the background. Just kidding. He has no dad.

Socks with sandals are annoying on people who actually *have* a home. When you spend your days falling asleep in puddles, however, it's downright negligent.

This is a much better way to treat the world as your oyster: dark colors, protective and comfortable shoes, warm vest, sleeping hat, glasses safely stored, and a general overall hipness that makes people more likely to see this whole situation as temporary.

A lot of these guys don't see themselves as lying down. They've just been hurled at a wall by some strange sideways gravitational pull and are unable to peel themselves off it.

If you really want to make it in pop music, get off the subway platform, lose the bucket, and replace that mic with Clive Davis's wrinkly, old penis.

The incredibly rich have the exact same lifestyle as the incredibly poor. They both get wasted all the time, do shitty drugs, cheat, get in fistfights with relatives, and play the acoustic guitar at five in the morning. The only difference is this jacket.

The key to pulling off a good 90s revival look is to remember what a huge percentage of our clothes were found on a girl's floor.

Women from Long Island talk like they have a really pissed-off fireman stuck in their mouth.

British girls always appear so pure and refined when they're in New York. This must be how New York coke feels when it's in Britain.

A Bad Brains show is a great place to meet people who spend way too much time on their hair.

Jesus is a little too gross hippyish but if they could get a religion where you worship Japanese women who perfectly replicate Parisian pop stars from the 50s, I would thump my Bible like it owed me money.

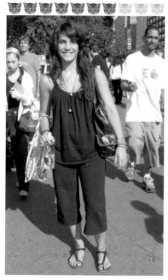

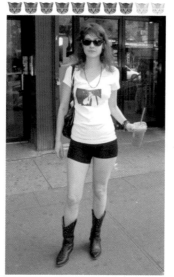

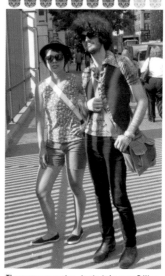

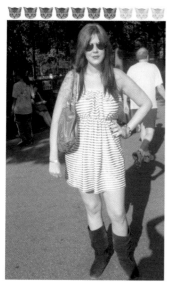

Just one pair of yellow, high-top Chucks could bring this girl from your sister's clarinet tutor to wife.

What's the matter with a girl knowing she's hot? She'd have to be retarded not to notice, and (sorry but) retards are never hot.

The best way to keep fucking 20-year-olds forever is to become famous. Pretending to be famous also works quite well.

Manhattan is the Island of Misfit Toys, if misfit toys were those few bad girls in high school that hated cheerleaders and didn't know we all hated them too.

This look is so uncomplicated you could fit most of it in a tiny ball on the floor by the foot of your bed, forever.

The more computers try to take over DJ'ing and loop sets like on Sirius or try to make random work like Pandora.com, the more you realize radio has to be done by actual music fans who actually buy records and actually like them.

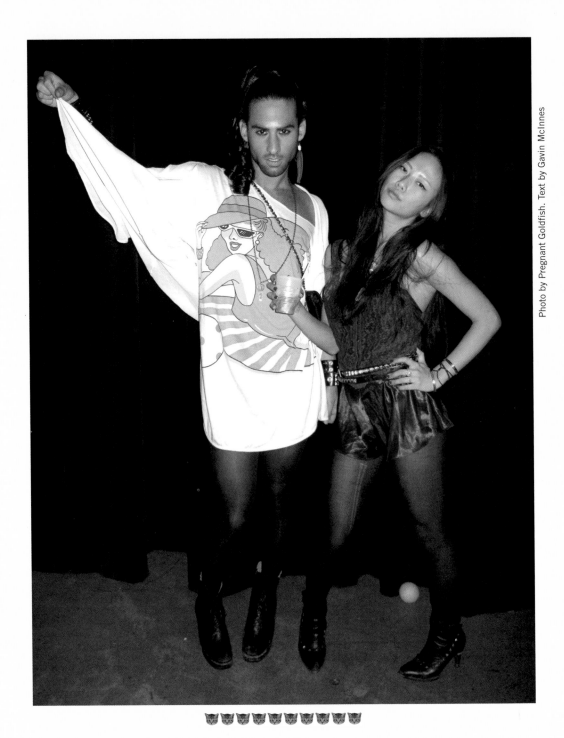

Photo by Pregnant Goldfish. Text by Gavin McInnes

This isn't the folks at Pregnant Goldfish but it is what their brains look like.

WHAT ABOUT MONTREAL?
An Interview With Street Fashion Blog Pregnant Goldfish

Why are Montrealers so hot? Is it because the Europeans fucked the Natives?
Marilis (girl): Clearly the mix of hot Parisian prostitutes and the sexy skin tone and bone structure of Natives (what's the politically correct word again?) has translated into some of the finest humans around. Unfortunately, this pairing worked in a positive way only for the ladies, because the straight boys are all short and love hair gel.

What separates Montreal fashion from New York and LA?
Marilis: Montrealers are poor and have to use pretty basic resources to look good. Maybe it goes back to our ancestors, crafting their party outfits out of old dishrags and a couple of leaves? Montreal youth dress out of stuff they find on the street and often end up wearing exactly the same outfits as the bums that hang out downtown, only they are fortunate enough to be youthful, sexy, and showered, so they look good.

How would you compare English Montreal fashion with French Montreal fashion?
Alison (girl): I am 100% English which is probably why I think Quebecois French fashion is, like, the world's funniest thing. Everything is asymmetrical, lots of weird, loose necklines, like a hybrid between 1990s pseudo-modern-*Matrix* meets Moulin Rouge and makeup, kind of like the band Orgy — remember them?

Montreal has to be the most homo-friendly city in North America next to San Francisco but they seem to have taken over. Where'd all the straight guys go?
Alison: It's funny you ask this, because a few months ago I realized that I have no straight male friends. NONE. Not one. Well, maybe one but he is probably gay.
Marilis: See, we love the gays here, especially the amazing ones who grab your boobs and make out with you on the dance floor because that's pretty much the most action girls here get all week. About ten Montreal straight boys know that striped button-ups and loose jeans are not proper attire — ever. Most girls here look so good all the time that, out of boredom, they end up questioning their heterosexual identity every Saturday night.
Dane (boy): It's dandy the gays and the strays are amalgamated. It's like everyone in Montreal is androgynous and bisexual. I catch a lot of people making out with a lot of people they probably wouldn't be with if they weren't so high and drunk.

The DOs & DON'Ts started in Montreal mostly out of frustration with unilingual Frogs and how totally clueless they are. In retrospect, I kind of dig their isolation and appreciate their uncoolness. How has Quebec's bizarre culture affected the way they dress?
Marilis: Quebecois — especially middle-aged, Francophone women — seem to think that the more seams, patterns, and fabric contents you can fit in your dress, the more fashionable you are. They use words like "funky," "edgy," and "original" to describe everything, when really they should be using the words "tacky," "painful," and "fucking ugly." Eyesore central.

Is there a particular look that girls wear that just kills you?
Alison: I hate people who wear white leggings. It is absolutely NOT okay to wear white leggings unless you are as skinny as, I don't know, let's say Mary-Kate. I don't want to see your cellulite. Even gray leggings are sometimes pushing it.
Marilis: Hiking boots, running shoes, boot-cut jeans, leather pants, pleated miniskirts, polyester, tight and short T-shirts, lamé, kitten heels, duvet jackets.
Dane: I hate everyone who wears a pair of jeans and an old T-shirt every single day. I think everyone should romp around in catsuits and try embellishing a little more. Pin on a crow or a dove. Tie a crown of baby kitties around your head.

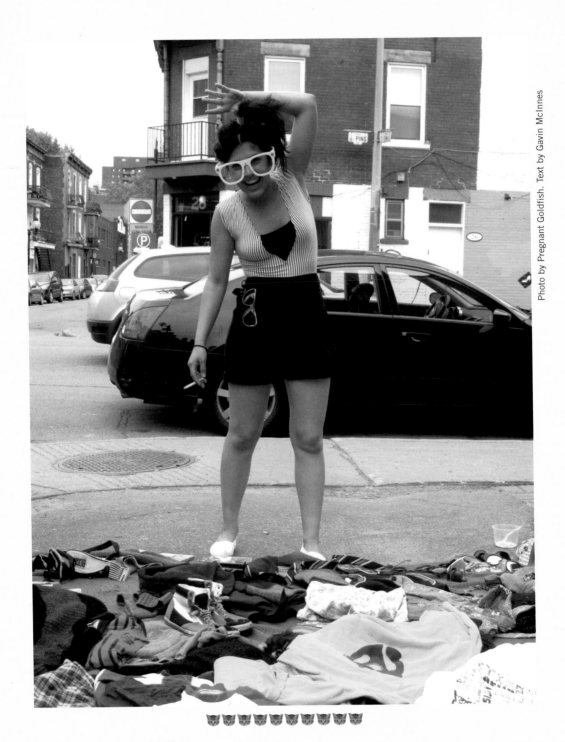

Photo by Pregnant Goldfish. Text by Gavin McInnes

Men rent beer. Women rent used clothing.

Photo by Pregnant Goldfish. Text by Gavin McInnes

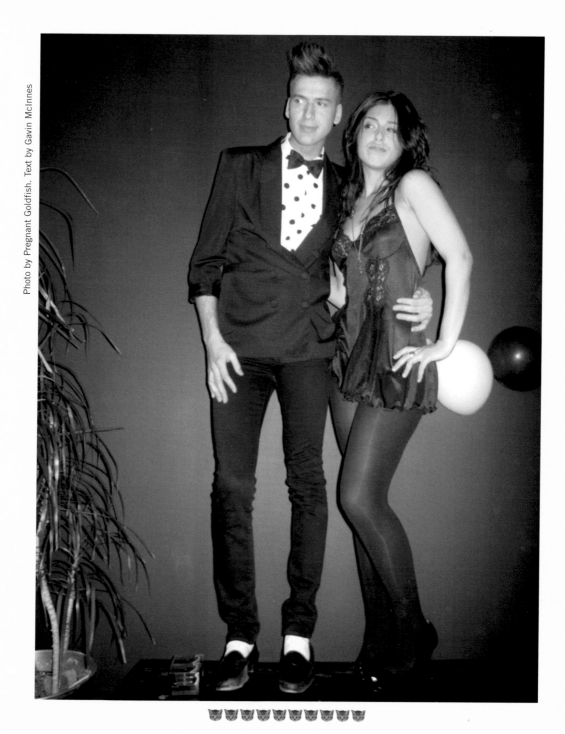

What's black and white with cum all over? My computer screen.

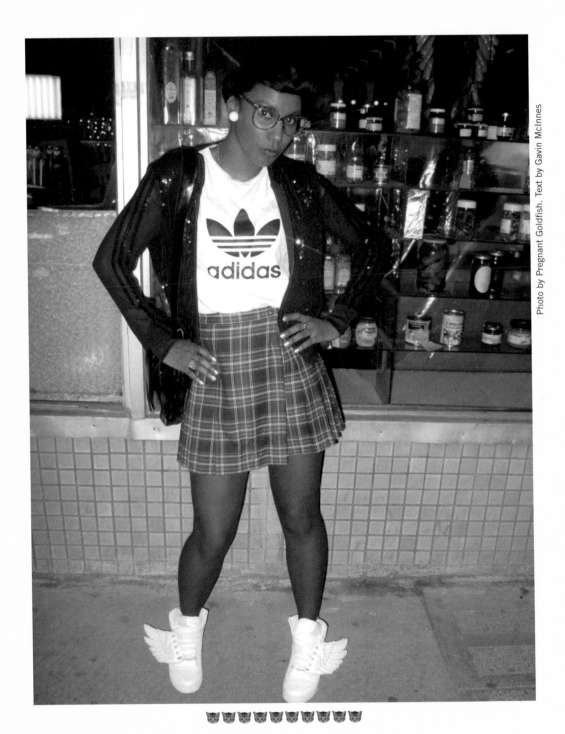

Photo by Pregnant Goldfish. Text by Gavin McInnes

It makes sense that she'd have the same shoes as the Roman god Mercury because that girl is poison.

Photo by Pregnant Goldfish. Text by Gavin McInnes

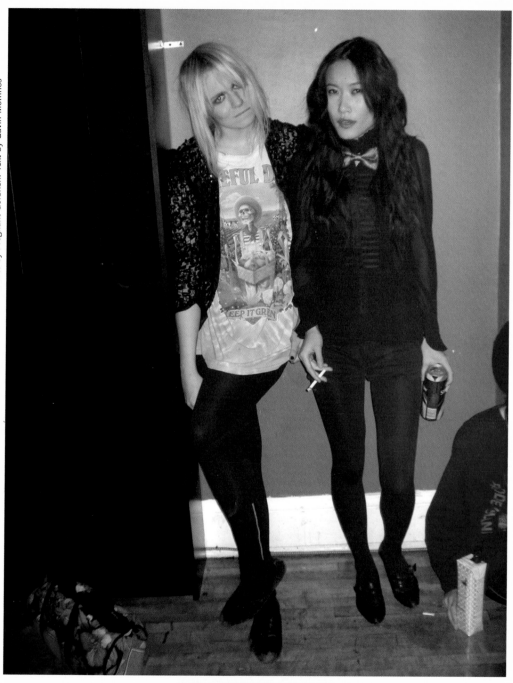

They both look like the puppets Cruella de Vil would have if she became a ventriloquist.

Dude, you meet girls at a *book*store. A *comic book* store is where penises are made.

Italy is the best place to go thrifting because men were so small there one generation ago, all the blazers fit like thick shirts.

Ten kittens for the superhero of sleep-overs.

He's mortified to discover the Lakers lost again and there's no more fucking Budweisers in the fridge.

The great thing about taking the Tokyo-gothic-Lolita-baby-doll look and bringing it to a wet, hot, American summer is that nobody's going to bite your shit.

Fuck.

This isn't just some grown man who likes cartoons. The Decepticons were a badass Brooklyn gang in the late 80s, and he must be a younger kid who's doing some kind of "respect your elders" thing.

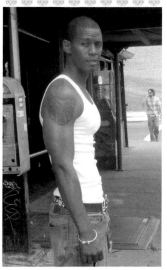

Wait, the Deceps' rivals were called Autobots, so unless this guy loves Bloods AND Crips, he IS just a grown man that loves cartoons.

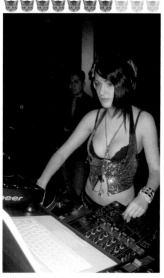

DJ'ing is primarily a male pursuit because it takes a lot of concentration, and testosterone is a concentration drug. Now that Adderall is here, however, there is no limit to what women can do.

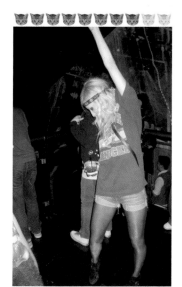

If you listen to the Ting Tings before you go out, the whole night becomes your music video.

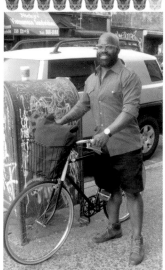

Every time David Cross comes back from a day of sunbathing, he's just got, I don't know, a better vibe.

"OK, just do it to me. Fry me. Give me ONE kitten, for all I care. I'm done." Guess what, bitch? Your flippant, punk rock, lumberjack attitude scored you an eight.

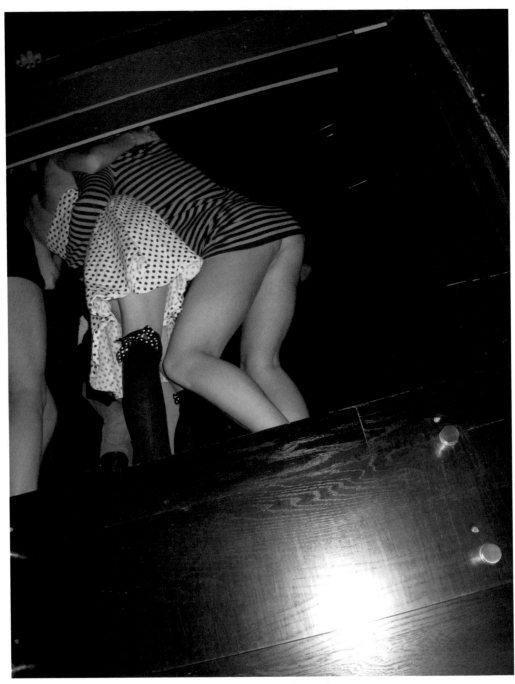

You know you're a fucking pervert when you catch yourself being jealous of a fly.

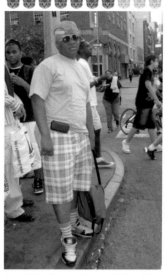

Dear Offspring of the Future,
Your uncle was not the fascinating bohemian bad boy your parents say he was. He was a Canadian dork just like your aunt.

In case you're wondering if it's wrong to be attracted to a wealthy Girl Scout who has recently suffered some sort of violent attack, the answer is: "Shhhh."

If you think the eccentric cousin from the rural South is funny in his own environment, wait until you see him try to cope in the deluxe apartments of the Upper East Side! Coming up after the break, on My 9.

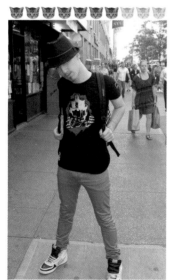

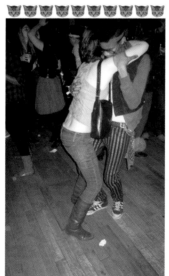

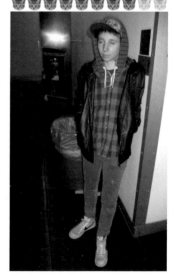

Fedoras need to get the fuck off back to the 50s and stop trying to take over upturned baseball hats that say "Suicidal" on the brim.

Every party has one straight, black guy that hates rap and loves Jeremy Scott. If you get there first, grab the fucker and don't let anyone else near him.

Why do parents hate neck tattoos so much? They only prevent you from getting jobs you don't want, and they turn hopeless skater nerds into mysterious art rockers that may or may not have killed a guy.

Street Boners is really about Us vs. Them. It takes thousands of pictures to explain exactly what the difference is but sometimes just one can really nail it.

Fuck the working class. The Salt of the Earth of Fashion works way harder and is way more fun to be around.

All Canadians like to dress up when they party, so figuring out which ones are gay takes some real, heavy duty wisdom.

PS: This is from my stag, and that's my dad's head.

Someone charge this bitch with murder for boring me to death with that outfit.

Oooh, it's the Free Shit Bandit. He shows up at openings and gets wasted on "Free B.R." while grabbing dozens of promo CDs and T-shirts that don't quite fit.

This is what your penis sees every time you pull him out in a bar. Poor guy, he must feel like the Elephant Man.

I woud be so fucking bored of this look if I was 6,000 years old and friends with God.

Congratulations, you just owned summer.

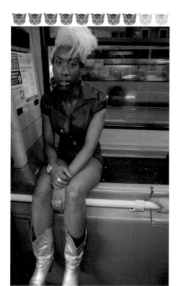

This is the look you would get if you were naïve enough to challenge her to a dance off.

Mom's finally got it together but until her daughter can get down to around 10 pounds or so, we're not counting shit.

This is an old person. They are unattractive and require a lot of assistance. I'd say, "Fuck them," but even that is impossible.

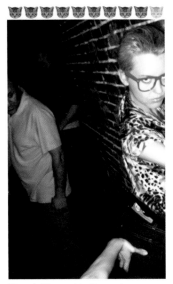

The only thing sadder than seeing a restaurant owner stare out from his empty restaurant is seeing an old penis owner stare out from his empty life.

I know you think you're untouchable just because you're kidding but even goofs have rules. You can't do short shorts with hairy legs, and Mario as a muscle tee doesn't work when you're actually muscular. FAIL.

A good way to know if you're dying of alcohol poisoning is to check if your beer goggles can't see a problem here.

For the right number of firstborns, Satan can guarantee all women who dump you will turn into this.

If those Axe Body Spray ads were true, women would wake up the next day scream barfing.

Nerd pride is about the only time whites are allowed to be happy with their lot in life.

Threesomes happen to the average male about once a lifetime, so if opportunity knocks (and I obviously have no idea if this is an example of that), rip the fucking door off its hinges.

Sunglasses like this are racist towards cartoonists because you leave them unable to exaggerate.

Most Canadians don't know this but NOBODY outside of Canada has EVER heard of Parachute Club.

"Um, sorry, I still don't see it."

Hmm, which pants make me look more retarded: the ones that say, "I like choo-choo trains," or the ones that say, "I like every sports team in the world," or both at the same time?

It's so lonely getting off a plane. Can't these girls be waiting for us just once and say, "I hope you ain't hungry, motherfucker, because we're already late for two parties and a fistfight."

It takes real courage to make a punk mountain out of the molehill of hair that's left after you go bald.

And the winner of this year's Never Been Done Competition is: the guy dressed as an androgynous bully in tassled, Vivienne Westwood clogs.

All an eight has to do to become a six is dip herself in a huge vat of Toronto Girl, and kaboom! She's Sheila E.'s limo driver.

What would you rather get for telling brown nylons to fuck off by using your legs, seven kittens or a golden butt plug you'll never use?

It sucks that bosses used to fuck their secretaries but what would you do if this was your gal Friday? You'd have to constantly play a DVD of your parents fucking just to stay sane.

Don't you wish girls were like gays and they'd just come up to you all, "Hey, I'm horny too. Should we do this thing?"

She looks like when you've been hanging out with your best friend for so long you go, "I wish you could just turn into a chick" and then he's like KAPOOF! "How's this?"

From now on, you can only bring your girlfriend out with us if she's really fat or has burns on her face. Bringing ten kittens into the mix is like a reverse stink bomb for our libidos, and it's literally a dick move.

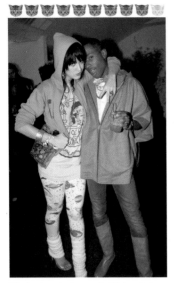

The best way to hang out with tens is to pretend you're gay. It's a pain in the ass to talk about hair and clothes all day but when she starts using you to practice blow jobs, all your previous suffering explodes.

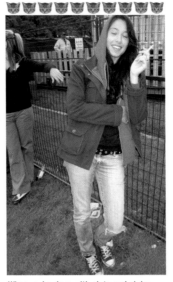

When you're done with sluts and clubs and coke and you're ready to start adulthood, she will be waiting for you right here, ready to get pregnant and start a life.

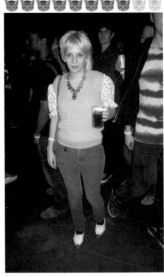

Everything she's doing is against the rules but I didn't know she was going to take the rule book, eat it up, crap it out her vagina, and make me eat every page.

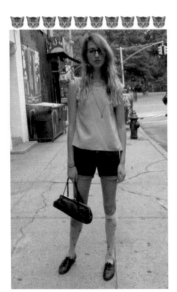

God's pencil case has a rainbow for a protractor, multiculturalism for pencil crayons, and compass legs over here for drawing cirlces.

You know, if we were in the Middle East, we'd have no way of knowing her ass thinks she's hanging upside down.

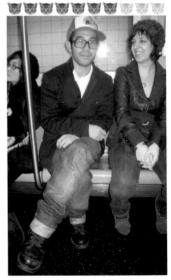

Grunge is back! And this time it has weird proportions.

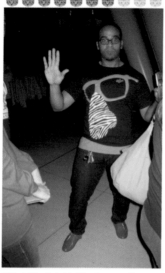

Oh, don't give me that "Who me?" bull-shit. You knew giving the middle finger to the socks-and-shoes establishment was going to get you some paparazzi.

"All right, all right, I'll get some skinny jeans. Relax."

Before you get mad at famous people for cheating on their girlfriends, know that horny, drunk girls are constantly dancing like this, hoping to get their attention. What's Justin Timberlake supposed to do, punch his dick out?

They say we don't like "Rubenesque" women anymore because we're more con-cerned with finding a buddy than breed-ing. Sure. There's that. There's also the part where they're fucking hot and their pussies taste like water.

Skintight grunge on a shopaholic in 5-inch pumps is like a skintight vagina on a nymphomaniac after five bumps.

"Vinnie, you need to get the fuck over here right now. Some old dude saying he's from 'The Boners' keeps following me around and taking my picture."

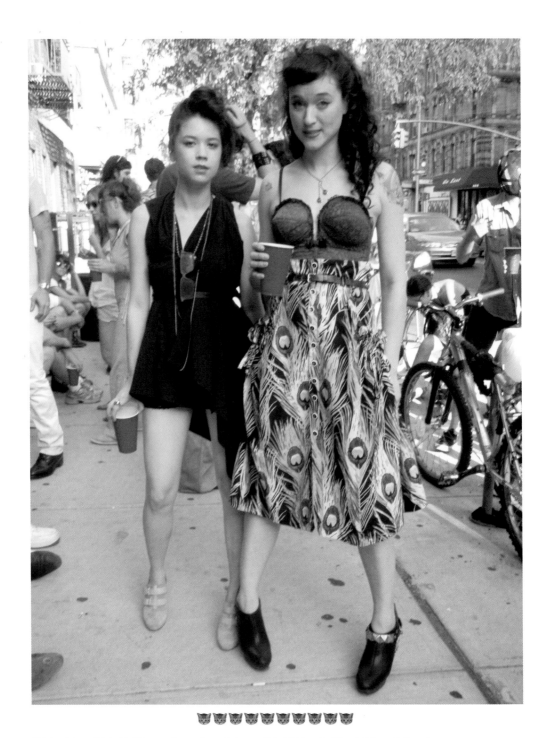

This is what you think of in February when you're mad at yourself for bitching about how hot it was in August.

Well, I'm looking at you, so I see no evil, and you're obviously not speaking any, so all we need to do is say, "Neh neh neh la la," when people talk to us, and we'll have all three covered.

This is who we'll send if another planet ever asks us for an ambassador to represent "guys."

Next to a huge gap in her teeth, glasses are about the greatest trait a woman can have. They say, "I'm hot and smart, and I will never cheat on you," and they remind us of underdog babes like Bailey from *WKRP* or Betty from *Archie* comics.

Guys love tits, drunk chicks, and subtlety.

Heavily gelled hair says, "Imagine I just stepped out of the shower," and a piercing-sized beard says, "Imagine my mouth is a stripper's cunt."

Someone needs to show Foreigner this picture the next time they bitch about Wanting to Know What Love Is. It's tight jeans, high-heeled hearts, and big fat glasses on a heart-shaped face.

"What? Hello? I can't hear you. It's so gay out here that I can't hear a word you're saying."

It's fun to see what three hours of primping and preening can do to a guy. This turd is so polished that I can see my own face in it.

Do Southern blacks think New York blacks are a bunch of faggot-ass pussy sellouts? That's racist, if they do.

These girls think they're hot shit just because they're hot, having a great time, loved by everyone, and rich as shit.

This guy wants moms to let him know "if they want his body and they think he's sexy" so bad, he's even wearing their jeans.

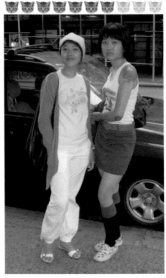

If the Chinese government could see what their retardoid one-child policy has done to the New York chick population, they would crap a brick of jealousy.

What beer bongs really mean is, "I love being under 30 and not getting hang-overs, so fuck you if you're old."

If you're going to wear tights with shorts make sure they're thigh-highs. Being sexy is all about the fantasy but now we have to picture that awkward stage of no shorts and just tights before the inevitable ass-plugging.

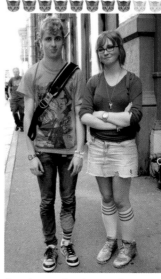

Zany shoes can be a bummer when you first get them but when they're finally bro-ken in, it looks like a rodeo clown passed out in the gutter (which is essentially what punk is).

Look at this wimp in his floppy dorm clothes. He couldn't fight his way out of a wet paper fag.

Holy shit, this tattoo is turning me into a yo-yo. Le Tigre ought to do a song about it but instead of going, "Misogynist? Genius? Misogynist? Genius?" they could show him to the crowd and yell, "Bummer? Awesome? Bummer? Awesome?"

Nu rave and Jews go together like a good sense of humor and abnormally gifted intelligence.

It took some refugee gangs, David Choe, and a whole lot of tattoos, but Asians have finally washed off that nerd stench the previous generation left behind.

Junkies get into shit that's so disgusting, you basically have to drop acid and wear 3-D glasses to even begin to conceive how shitty their lives are.

Ignoring the obvious body bummers, swimming brings out some of the worst shoe taste known to the world of Strangers' Toes. If it's not some castrated yuppie in his aqua-safety socks, it's the Mother of Many in her eponymous "hippo" Crocs.

This is the kind of guy who says, "Hey, it is what it is," way too much.

New hot look: I have way too much shit.

This is around that time the next day when you realize you guys cheated death and not only are you not tired from drinking all night, you're not even that wasted.

2010 will always be remembered as the year rich white boys took over the gangsta lean and brought it to limbonic proportions.

My dick's never going to forgive me for giving this only six kittens but what's with the Minneapolis bridge collapse where it goes sockettes <space> legwarmers? Not having one continuous sock is like having pants with holes in the ass. It's a superfluous asshole.

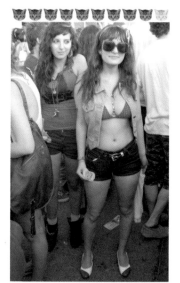

We like when girls take way too long to get ready because they end up looking like Christmas ornaments for your boner.

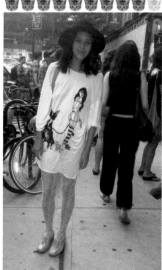

Music nerds may hate her, but Yoko Ono was the first one to tell pants they can go fuck themselves. That changed things forever.

I know you're reading some of these and thinking, "These guys need a swift kick in the ass." Believe us. We know.

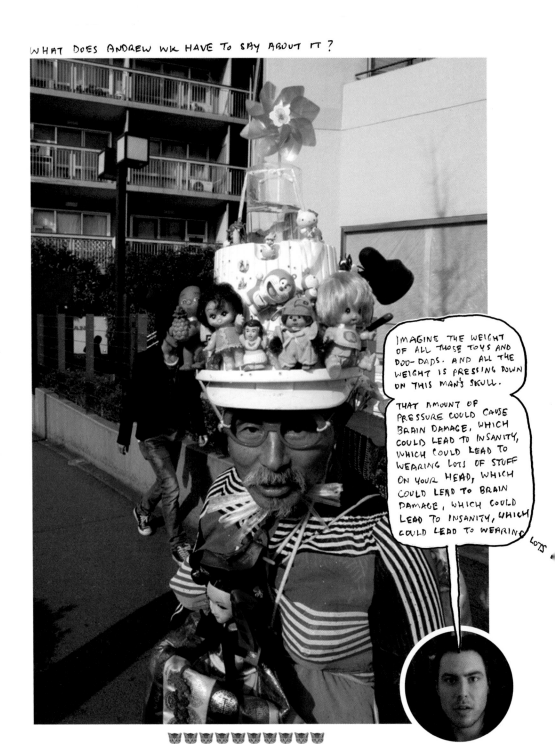

IMAGINE THE WEIGHT OF ALL THOSE TOYS AND DOO-DADS. AND ALL THE WEIGHT IS PRESSING DOWN ON THIS MAN'S SKULL.

THAT AMOUNT OF PRESSURE COULD CAUSE BRAIN DAMAGE, WHICH COULD LEAD TO INSANITY, WHICH COULD LEAD TO WEARING LOTS OF STUFF ON YOUR HEAD, WHICH COULD LEAD TO BRAIN DAMAGE, WHICH COULD LEAD TO INSANITY, WHICH COULD LEAD TO WEARING LOTS.

Crazy people look great and everything but it's like those fancy recipes in the *New York Times Magazine*. Who has the time?

All right, all right. Maybe flashing your dick IS totally different than a girl flashing her tits. Fine.

Despite the fact that San Francisco gets perfect outfit weather and New York's stuck with heat wave after heat wave, they all look like mountain climbers who play electric guitar, and we manage to fart out casual greatness like this.

Balenciaga started a gladiator sandal avalanche that swallowed the whole summer but it wiped out flip-flops, and that made it worth every toe.

Puerto Rican bodega owners may let their cats sleep on the bread but when they produce offspring like this, you can forgive them anything.

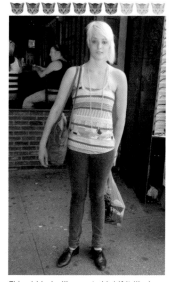

This girl looks like a cute bird if it liked modern dance and its head was an apostrophe.

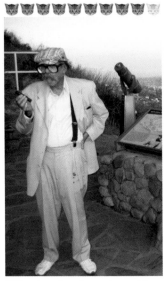

Well, we know from the sneakers and the stain he's not an eccentric millionaire but what the fuck is he, a radio legend, Mr. Magoo's business manager, me?

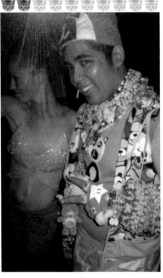

Candy ravers were a funny drug joke in 1994 but in 2010 it's like someone blaring happy hardcore at a funeral and yelling, "Come on, people, PLUR!"

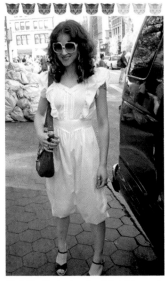

She's like the best parts of *Taxi Driver* and *Sid and Nancy* but without any of the heroin or prostitution.

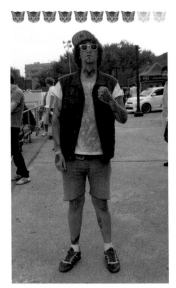

This guy looks like a supervillain who was formed when somebody spilled some radioactive waste on an Andrew WK song.

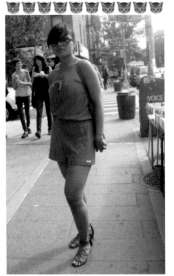

Girls, take this photo and use it to give you ideas for beating the heat. Boys, do the same but with the meat.

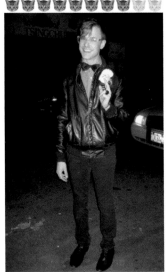

New York is for guys who are either really young or really rich. If you aren't one of those three things, split.

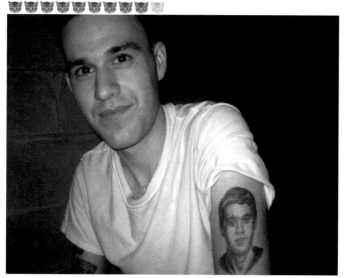

If you can't think of a tattoo idea just get a portrait of someone you really care about, someone you will love forever.

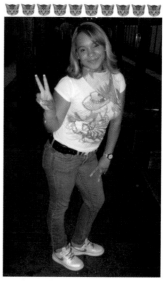

The Bronx basically invented the idea of using the dollar store to make yourself look like a million bucks.

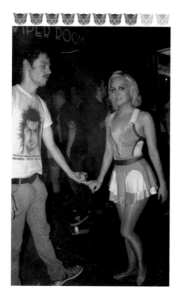

If you're having trouble meeting girls, make your own out of magic hearts, rainbow moonbeams, and sparkle kisses. Don't set her free, though. It's not worth the risk.

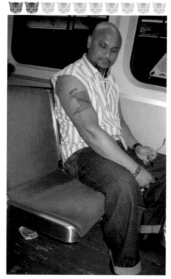

I don't know about Tobago but Trinidad? Are you kidding me? The place where they still whip prisoners and have a law that says, "No fags allowed"? Nice. You're proud of being from the 1200s.

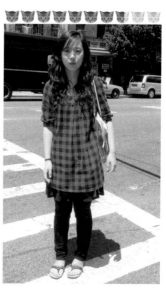

Wow, she's got the cutesy thing right down to the part where babies have no idea what they're doing here.

You call this drunk Jenga? No tower of furniture, no swastika in marker, no condom filled with hand soap inserted in the ass with a pencil? Shit. You basically just turned on the nightlight, tucked him in, and kissed him on the forehead while whispering, "Good night, my angel."

Unlike most gold medalists, winners of the Best Guy Olympics don't get any money for sponsoring all their amazing shit.

If you told a 1977 mohawk that it was going to be the stuff of little kids and their fathers in 30 years, it would spin in its grave like a poo being flushed down the toilet.

Dear Cougars,
Forever 21 is an oxymoron, so unless you look like these girls and can pull off the Pocahontas Pixie, please stop shopping there.

Not sure you should be spending that many hours on your hair when you're infin-ity-years-old.

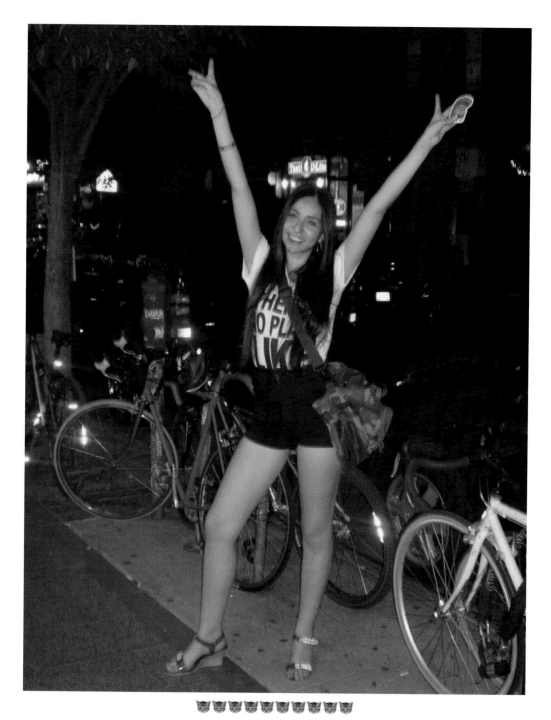

Here's a fun new game: The next time you hear some catcallers, turn around and yell back, "Yay! He likes me!" Seriously, try it. It totally fucks them up.

First they're better at math, then they stop having b.o. or crime or even body hair. If it wasn't for those gross brown nylons they all love, we would just hand them the keys to the race war and say, "Take it. It's yours."

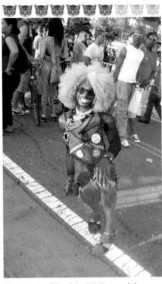

Back in the 70s girls didn't complain about polyester and even when it was really fucking hot, they'd still get dressed up. We'd do anything to go back to those boner salad days.

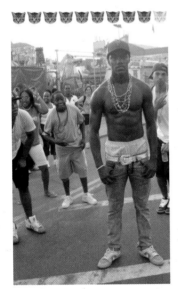

This is the part right before the fight when you realize you're going to lose and your kneecaps start doing that involuntary jiggling thing that sketches you out and makes you lose worse.

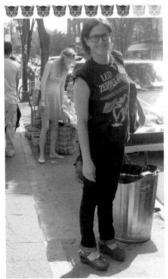

This is a Wow in Harrumph's clothing, and if you know anything about investing, you will buy low and never sell this stock no matter how high it goes.

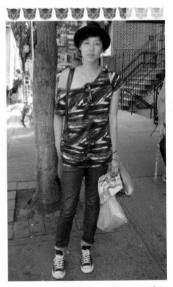

Stop telling us we force you to wear make-up and high-heeled shoes. You're the one spending hundreds of dollars on that shit. All we ever asked for was this and up.

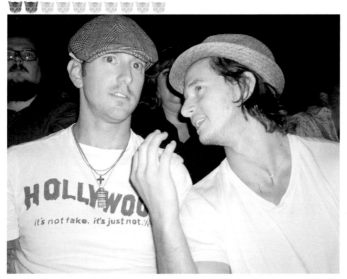

It sucks when the guys behind you are talking through the whole set, but when you turn around to give them the "shut up" glare and you see this, it's like, "OK, so that's sight and hearing taken care of. What are you going to do to the other three senses, punch me in the tongue with diarrhea?"

The ambitious skirt is only a little annoying but the Crocs drag everything down so fast it's like a life jacket made of anvils.

While most moms are melting into their track pants, there are a select few who are aging so gracefully that they're basically wizards.

If you provide sanctuary to one of these men during the imminent Fedora Wars, know that we will be forced to execute you both, no matter how gorgeous.

"DUDE! Remember when you said Shadiq's plan was bullshit and we're never going to get out of Kyrgyzstan alive? You are not going to BELIEVE where I'm calling from right now."

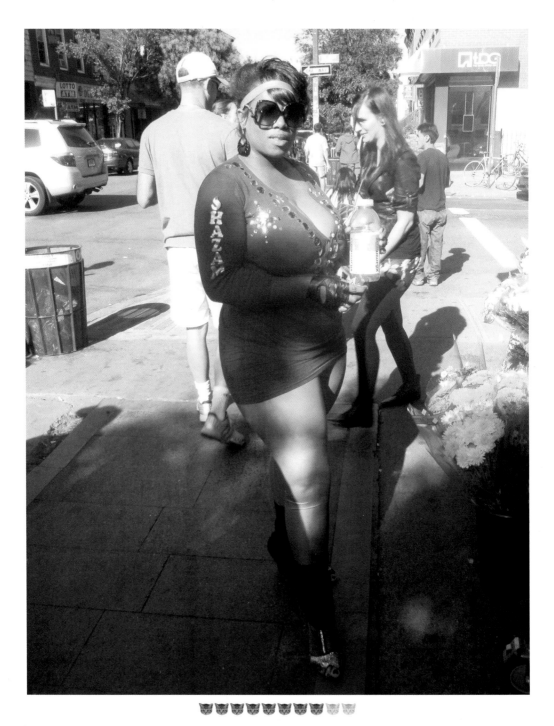

This girl is so out of your league, your only hope would be to befriend her tits first and hope they put in a good word for you.

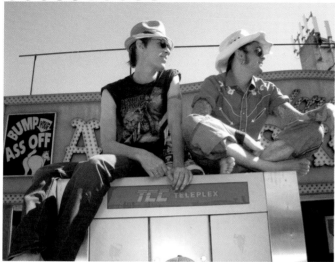

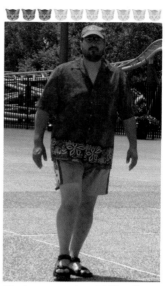

Do the boys of summer realize how totally contrived and phony their whole Funny Hats look is? They make Halloween look like casual Fridays.

Who dresses normal people? Who tells them scrunched baseball hats, Hawaiian groundskeeper clothes, and baby shoes are the way to go? Whoever it is needs to get a high five for hilarious.

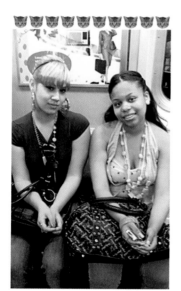

The girl in the pink bra is cute but the girl next to her is so ghetto punk fabulous she looks like that Girl Talk song where he samples X-Ray Spex.

When you see Puerto Rican teenagers driving brand new Scions, it's kind of hard not to wonder where they got that kind of money.

Sure, technology's blowing our minds, and phones are computers, and you can talk to your car, etc. But who's doing shit with back pockets? Who's moving them to new places and making baggy jeans tight and shaking the foundations of the pants community?

Why did God make Central American hipsters look exactly the same as French Canadian art fags?

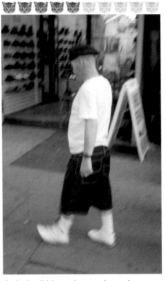

And why did he make grandpas who grew up in the Lower East Side look exactly the same as their grandkids?

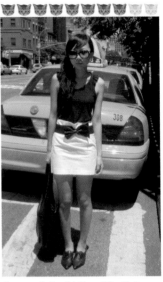

If you can't stop thinking of Stockholm Syndrome and that trunk, it may be time to polish up your game a bit.

If your long hair gets in the way and you don't cut it, the implication is there's a time when you really enjoy the extra hair and it's most likely at night, in the nude.

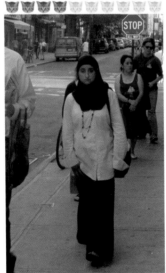

Hey, lady, you can take off that boiling-hot, black, polyester, claustrophobia hat that's making you go bald — you're free now.

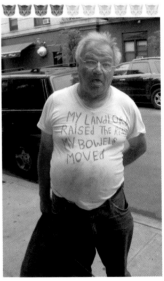

This is a human gift to anyone who claims they miss old New York.



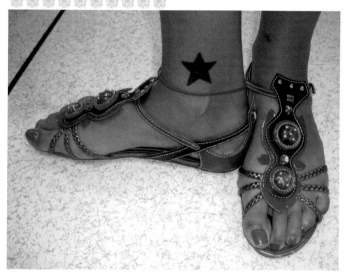

If you're getting a divorce, you don't have to pay her half if she cheated on you or was abusive during the marriage. These count.

This 1950s mental-institution shoe is great for everything from limping around your pirate ship a hundred years ago to courting Frankenstein.

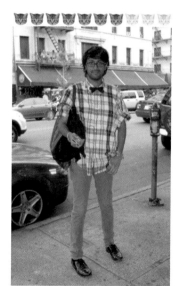

This guy must be doing something right because somehow I didn't notice his shirt is made of maternity wear and he's got a purse.

Sucks when you throw together some perfect, off-the-shoulder, Native American number with matching shoes, and then some shitty best friend in flip-flops and a wifebeater blouse gets tied around your neck for the rest of the night like an albatross.

Ass Wednesday is meant to remind Christian men that "you are an ass, and to an ass you shall return."

This guy looks like he's having a long, deep, heavy conversation with his beer goggles.

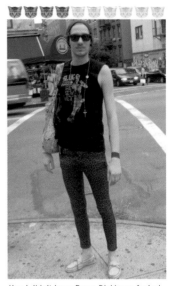

Cutters are punishing themselves for being so self-absorbed. Perfect.

Hey, I didn't know Bruce Dickinson fucked my nana.

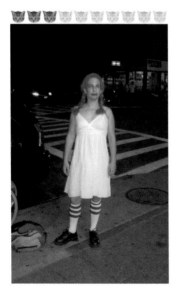

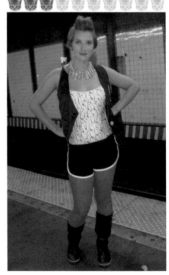

Sometimes when a Blade Runner *retires* a Replicant you're like, "Good."

This would even be a bummer if it was on a doll and he was made in Romania by blind Christians.

She looks like she was playing musical chairs in a bag of clothes and lost.

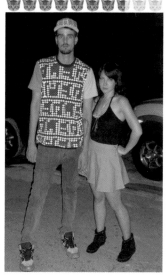

Hipster bashers always come across as sad, old people who just can't accept their youth is over. Kind of like that song "Lust for Life."

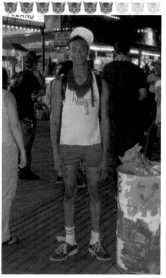

This guy looks like an imaginary friend for poor kids.

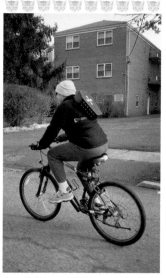

Dude, losing your child is a tragedy of unimaginable proportions but sometimes you just have to let it go and get on with your life.

If you think the *New York Times*' ballet critics are too harsh, call them out and ask them to do better. A lot of them will.

Crazy girls are to men what assholes are to women.

Lily Allen kind of killed the whole "sneakers and a dress" thing, which is too bad because it looks like ice cream and adventures.

I wonder if this guy knows the character he's dressed up as is called Winky and the woman who plays him is Asian. That's racist.

It's fun to big-up your hometown, especially if it's in Canada, but every time you go back, you get this tidal wave of memory and think, "Oh yeah, I forgot how many fucking *losers* live here."

What are you, on the cover of *Before Picture* magazine?

Having a girlfriend in the Bronx is *The Lion, the Witch and the Wardrobe* of dating.

I can personally guarantee that whoever this guy is texting has no intention of ever getting back to him — ever.

What the fuck? Is she out of her mind? Why in the motherfucking shit is she replying to a crusty raver tranny? Is he in a band I don't know about, or did he just finish some hilarious skit with *Human Giant*? If not, I am officially a sexist starting now.

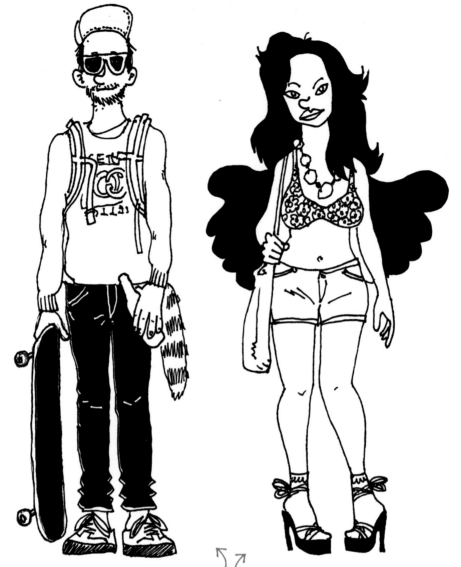

Text and illustrations by Gavin McInnes

WHAT IS A HIPSTER?
A Brief History of Cool

Do you ever get this thing when you're reading and you see a little squiggle that must be on your actual eyeball? The more you try to look at it, the more it sort of bounces out of your line of vision, right? The same goes for trying to define "cool." Like "sexy" and "humor," the more you try to define it, the more elusive it becomes.

Well fuck that. Check it out: "Sexy" is any kind of plausible allusion to sexual intercourse. Thigh-high socks and a short skirt imply it would be easy to get in there and penetrate her. Also, as was said in the intro, it's "sexy" to exaggerate the difference between the genders. Women can grow hair longer than men, so they look hotter with long hair. They have bigger asses and thinner legs and are frailer than men, so they exaggerate all three with high-heeled shoes. Men are sexy when — ew, I can't talk about sexy men.

Humor is simply a new way of looking at something we all take for granted. Like good art and social commentary, it takes a day-to-day concept out of context and forces you to see it in a different light. This is usually done best by depressed people because the only way they can stave off suicide is to have a quirky take on the world around them. When us non-depressed people hear this fun angle, it makes us even happier, like a normal person taking Prozac.

Have you ever read two less sexy or funny paragraphs in your life? Well, prepare for some of the least cool reading your eyes have ever smelled.

GREASERS 1940s/1950s

Cool began in the 1940s when teenagers were invented. Before teens, people aged 13 to 19 were simply underdeveloped adults. You have no idea how square people were back then. You'd have married couples that had been together for 40 years and never even see each other's genitalia. Can you believe that? Isn't it basically *your* genitalia at that point?

Anyway, when the WWII veterans came back from traveling the world, blowing people's heads off all over Europe and Russia and fucking Africa(!), they got back to Brooklyn and said, "You have no idea how square you people are right now." The vets bought motorbikes and started telling everyone to fuck off. Then, in 1953 a motorcycle movie called *The Wild One* came out and told the world what I just told you. Two years later, *Rebel Without a Cause* came out and defined this new culture. They took the ex-soldier biker attitude, poured some James Dean on it, and called it "teenage." This concept was the birth of cool, and it's still very prevalent in the hipsters of today. The days of "young adult" were finally over and replaced with "Actually, fuck adults. I hate their stupid guts." This is actually the first time the word "hipster" was used. No joke.

Teenagers had the power to do this because the baby boom provided a huge surge of population and people tend to take you seriously when you become the majority. This generation gap was not only the impetus of cool, it defined it. Whatever old people didn't get became cool. If your dad is sketched out by negroes, you stick one of their dicks in your hand and say, "How you like me now, dad?"

BEATNIKS 1950s

The beatniks listened to negro music and even invented their own version called rock and roll (how funny does that phrase sound, by the way —"rock and roll"?). These guys were the first to realize how cool black people are and learned to harness their power to make more of it.

MODS 1960s

Across the pond, patriotic, working class kids turned their noses up at looking like shit and began dancing to negro music and wearing suits. They fought with greasers on the beaches of Normandy or something like that (JK, it was Brighton) and the whole thing was beautifully portrayed in 1973's *Quadrophenia*. I grew up in Canada, where we followed British subcultures religiously. About half my friends were mods (the rest were punks), and I gotta say, I never met a mod with any kind of balls whatsoever. There's something about teenagers dressing incredibly neatly that just screams nerd, and it feels weird including them in this list.

Though drawing that mod chick did kind of give me a boner.

HIPPIES 1960s/1970s

After the beatniks and the greasy rock and rollers you had hippies with huge bales of pubic hair eating each other out and coming up with controversial ideas, like "War is bad." Whoa.

Around this time, something really fucking weird happened. You see, young people not only love reveling in the current version of whatever cool is. They also enjoy going back a generation and redoing the previous version. In the 1970s there were truckloads of hippies but there were also TONS of greasers redoing the 1950s thing. They brought back Marlon Brando's motorcycle jacket and put Brylcreem in their hair and perfectly simulated the damaged war vets from a quarter of a century ago. This shit is always going on, by the way. Today there are more hippies worldwide than there ever were in the 1960s. When I was a teenager you had to order green hair dye and Doctor Martens from one punk store in London. Today it's a cinch to get all the gear you need for every subculture under the sun, no matter where you live. Shit, in Mexico City you have chaos punks fighting with emo punks because they think the latter isn't punk enough. In my day, you'd have skinheads hanging out with fat goth chicks and anarchist peace punks and mods just because there were so few of them and the weirdoes had to stick together. Personally, I'm thrilled with the way things panned out. Fuck all that bullshit about the "commodification of youth culture." The more the merrier. "Let a hundred flowers bloom," as Mao would say (though in a slightly different context).

PUNKS 1970s/1980s

OK, sorry to go off at a tangent there. Punk is one of the weirdest accidents in the history of cool. Here's the deal: As I just said, in the 1970s you had all these kids pretending they were back in the 1950s. Nobody did this better than Brooklyn goombahs. They styled their hair perfectly, wore sunglasses 24 hours a day, and had balls the size of watermelons. They were also some of the biggest morons in the history of youth and had that shitty, retard, Brooklyn accent to really drive it home. Instead of hiding it, however, they owned the shit and pretended they wanted to be dumb. If you're smart, you're a fucking nerd and deserve to have your underwear pulled on. Hollywood was in Brooklyn back then, so if New York endorsed it, it became fact. 1950s movies like *Grease*, *American Graffiti*, and *Lords of Flatbush* were actually shot in the 1970s, and this remake of greasers became way more popular than the original greasers. Winkler continued the moronic Italian, 50s, tough guy, greaser character he did in *Flatbush* with the Fonz on *Happy Days*, and "Bowzer" from a 50s a cappella band called Sha Na Na did the same thing. When some low IQ, Queens meatheads wanted to start a band, they had no choice but to do what everyone else was doing and ride the goombah tidal wave. They called themselves the Ramones. If you weren't a hippy in the 70s, you were mimicking Brooklyn Italians mimicking 50s teenagers mimick-

ing 40s war vets. As if this bizarre fashion double helix wasn't twisted enough, the leaders of this movement (Arthur Fonzarelli, Bowzer, and Joey Ramone) were middle-class Jewish kids! They were sick of having their underwear pulled by wops and were actually doing a mockery of this persona.

OK, this is where it gets even weirder. So, one of these bands, the Ramones, goes to London to show British people what it sounds like when Jewish nerds do Italian idiots do 50s teens do 40s war vets and everyone who hears them goes, "WHAT THE FUCK JUST HAPPENED TO MY MIND!? THIS IS THE GREATEST SHIT I'VE EVER HEARD!"

You see, instead of seeing this weird Brooklyn accident for what it is, Britain's superior education overanalyzed it and created this huge cultural manifesto about class. The Ramones weren't a crappy 50s cover band. They were prole-tariats taking back the guitar from the man and telling the world, "You can do it too! You can do anything!" How they got that from "Hey, ho, let's go" I will never know. New York City may have invented punk (accidentally) but Britain dressed it up and gave it a background. After the Ramones played their leg-endary London gig, we got the Clash, the Sex Pistols, the Damned; Oi was born as a "working class protest"; and so on and so on. They really took the ball and ran with it. They still are. Amazing, eh?

DISCO, HARDCORE, AND THE BIG BOOM 1980s

America was confused by Britain's version of the Ramones, so they shaved their heads and sped up the music and ran into each other like methheads in jail. That was hardcore. Hardcore had a baby called emo.

Now, at this point, subcultures went from one or two competing factions to what sociologists refer to as the "Big Boom of Cool" (I just made up that term but let's start using it, and it will become a fact). Punks and mods had been divided and subdivided into: chaos punks, anarcho punks, crusties, New Age Travellers, Nazi skins, anti-racist skins, boot boys, suede heads, rude boys, chelseas, and scooter boys. When all this was going on, disco had appeared and offered girls something to do that was actually fun for a change. This col-lided into punk and became New Wave. That later tripped and became No Wave. It was anarchy. You couldn't be a teenager without being some "thing." Even nerds and losers became a thing.

METALHEADS 1980s

It's hard to point to the beginning of bangers. They're just hard rockers, right? I mean, fucking Judas Priest started in 1969. However, the version we think of today — the long haired, zit-faced, stoned wastoid — really hit its stride in the 80s. After that, the whole thing split into grindcore, thrash, prog rock, sludge, melodeath, death metal, black metal, speed metal — the list goes on and on. In a strange twist of fate, nerds recently figured out pocket protectors and mil-itary haircuts were making them an easy target and have adopted metal as their new home. This was a huge blow to the non-jock bully world and has left a lot of tough guys wondering what the fuck to do with their rage.

RAP 1980s

While cool fractioned off into more subdivisions than Christianity, black people were having block parties and playing records while talking about each other on a microphone. This became rap and basically ran cool for the entire dura-tion of the 80s and 90s. Like punk, it fractioned off into IQ-related categories

ranging from dumb people talking about killing people to smart people talking about people killing. The one thing that unites this group is the Four Elements of Hip Hop. They are: yelling poems about yourself, spray painting your nickname on other people's property, spinning on your head, and playing records backwards for incredibly short periods of time.

Unlike the beatniks and the mods, this version of cool didn't play well with other races and wouldn't be amalgamated into the broader definition of the word until 20 years later — with hipsters.

GRUNGE 1990s
As rap bounced along its merry way, punk got a lot less colorful and became a sloppy version of metal. Their leader killed himself and that was the end of that.

INDIE ROCK 1990s
In the center of all this hullabaloo came Lollapalooza and the zenith of Indie Rock. It's tricky talking about this because "independent rock" is intertwangled throughout all of these but you couldn't do a chronology of cool without mentioning Pavement and Sonic Youth and those stupid mechanic's coats that has someone else's name in an oblong.

RAVERS 90s
Dance music has been a constant option throughout all these morphing definitions because girls represent 50% of the population and they don't give a shit if Brian Baker left Minor Threat to pursue metal. Clubs like Paradise Garage in New York City were playing so much dance music and getting people so high, they changed the way the music was made. They invented garage music, which evolved into house, and then you had all that weird shit, like intelligent drum 'n' bass and dub step and jungle and other hilarious terms British people like to get into arguments about.

Drugs may have been big with the hippies but it was mandatory with rave culture. How could you not be high? The music sucked. But you couldn't have told us that. After sitting on a huge couch and making out on GHB for five hours and then dancing maniacally on E for another five, there was nothing else in the world but clubland. We said shit like, "Rock and roll is finally dead," and, "Guitars are over," with a straight face. Oops.

HIPSTERS 2000
By the end of the 90s, rave and grunge were wandering aimlessly around kids' bedrooms wondering what to do with themselves. Rap was still hanging in there but the excitement of hearing Niggaz Wit Attitudes say, "Fuck the Police," was long gone and too much R&B was making it sound like our parents' music (and this whole thing began with saying "Fuck adults," remember?). Electroclash tried to get on this list by being a new New Wave but was hammered back into the ground by kids that were sick of all this shit. They were born and raised in the Internet, and the whole concept of "one thing" just wasn't cutting it anymore.

CHEAP & SPEEDY TRANSPORT VERY PORTABLE

WHITE-RIMMED SUNGLASSES

SUPREME ONES TOO MUCH $

HIPPY FOOD

JANITOR KEYCHAIN CUZ PANTS ARE TOO TIGHT

CAN'T BE STOLEN

NO THIEF CAN RIDE THIS

CHEAP BEER

A PHONE THAT STORES 4,000 SONGS

AN UNSTEALABLE BIKE WITH NO PARTS.

POOR GUY HAT FROM THRIFT STORE. NOT SO COMMON ANY MORE

Around 2000, André 3000 from Outkast saw the Strokes play a show and shat his drawers (I was there — dude's jaw was on the floor). He started looking into what white people were doing and decided it would be fun to join them. Then Kanye West started wearing tight jeans and black cool became amalgamated with white cool, which ended up as the word *hipster*. For the first time since the beatniks (or the 1940s hipsters when the term was first coined), everyone was on the same page. The Internet generation's idea of cool includes everything on this list and much more. Girl Talk makes songs out of every song in the world; it's totally illegal, and every show he plays is totally packed. Ninjasonik takes Matt & Kim's "Daylight" and raps over it while on tour with hardcore bands like Cerebral Ballzy. Punk rock is a huge part of hipster culture but so is rap. It's all a big confusing mess and nobody over 30 can figure it out. Perfect.

Tight pants, track bikes, and thrift store clothes seem to define the look but there has never been a version of cool that has fewer rules. A hipster is, as the dictionary says, "A fashionable young person (between 15 and 29 — fuck, that leaves me out) with an interest in contemporary alternative music (and some older shit, too)."

Of course, the detractors have a lot to say. They claim hipsters are rich kids pretending to be working class (trucker hats, Pabst Blue Ribbon). They say hipsters have no political agenda and are simply patsies being duped by big corporations to owe their soul to the company cool store. If anything, hipsters are the hardest fuckers to make money off of. I mean, I did a pretty good job of it but I pulled it off by trying *not* to make money. I interviewed King Khan's tit and wrote an article that was "Gloria. G-L-O-R-I-A" 3,000 times. If someone else wants to give that a whirl, go bananas.

In the meantime, the entire record industry just collapsed trying to persuade them to at least pay for something. TV, magazines, and marketing in general are next to walk the plank and the generation gap has never been wider. Have you ever seen a baby boomer try to text someone? Have you ever tried to explain Twitter to an old person? Cool was born as a way for young people to tell old people, "I don't want to be like you." Today they're saying, "I don't want 2 b like u," and grown-ups don't even know how to open the message. Old people react to this exactly the same way they did when Bill Haley and the Comets first sang "Rock Around the Clock": they clench their fists and scream at the sky in frustration.

These critics have no idea how transparent their criticism is. No matter how hard they try to make it sound justified, the real beef is, "They're young and having fun, and they make me feel old and out-of-it."

So while the so-called "hipsters" (they never call themselves that; angry, old people are the ones that resurrected the term) are out partying and getting laid and enjoying their youth, thirty-something bloggers are getting up early in the morning and typing furiously at their keyboards about "the kids today." Ha! They accuse hipsters of being obsessed with irony, yet it's the old person's grumpy attitude that defines what a hipster is in the first place. How's that for ironic?

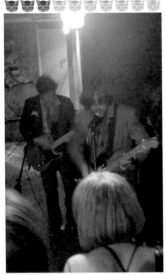

What could be worse than touring? You drive for thousands of miles, eat shitty food, sleep on floors, load equipment, unpack T-shirts, drink hungover, get robbed, lose stuff, reek, and karaoke your own songs every night for $100.

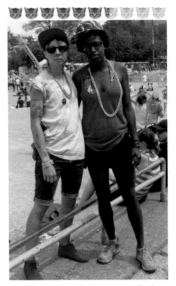

Too bad lesbians (if these two are that) hate us so much. A lot of them seem like really cool guys.

Women want men shaped like V's because they need strong shoulders with Vim and Vigor but men want women shaped like A's because all we really care about is Ass.

When California does British punk, the whole thing ends up like ironic bowling.

This girl is so clean you could use her shit as soap.

The true Four Elements of Hip-Hop are: suburbs, Xbox, weed, and sitting on your ass all day.

Rainy July 4ths are to great outfits what AIDS was to Broadway.

Man, these Williamsburg trust fund hipsters are getting really good at looking working class.

Guys who grew up in all-white countries like Denmark are such weaklings, they make you think of that old Nietzschean apothegm: "Blacks who do not kill me, make me stronger."

When you're hungover, even your Fairy Godmother is a bum-out.

This is that stage right after discovering feminism but right before discovering bush maintenance when not even black guys will fuck you.

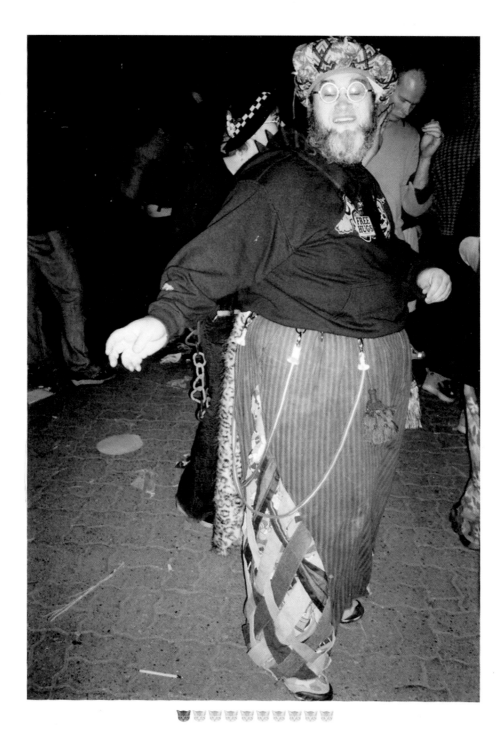

I made fun of this guy about nine years ago assuming he would be so devastated he'd go on a vision quest and finally reappear as John Belushi in *Animal House* but with more poon and better jokes. Unfortunately, he has an equally high opinion of himself and didn't see the need to improve perfection. Now I know how Doctors Without Borders feel.

Anyone over 30 can see this for the cacophony of pheromones it really is. Ew.

You try to warn homeless people about watching horror movies without brown pants but they never listen, which is probably why they're homeless in the first place.

She looks like she's heading to the Native American Academy Awards, where she was nominated for Best Eight.

This wet lump looks like the kind of guy who's best friend is a woman and ... Shit! I just thought of something: He probably asked her to be his best "man" at the wedding. Pee-YUKE!

Since the divorce, your mom's been going out every night and hanging out with um, "single guys" and shit but, I don't know, she'll always be Mrs. Ferguson to me.

The secret to knocking someone out is to believe in yourself and know that you CAN knock him out. After that it's all about him and his insecurities. (I learned both these things from watching *Kung Fu Panda*.)

Does it make me a gay pedophile to want to suck a girl's toes like they're ten little dicks just sitting there?

It's fun to hate on normal girls but when they stop and say, "Seriously?" all you can say is, "Er, wait, would you?" to which they reply, "No," as they walk away, which leaves you saying, "Damn."

I was so sure this girl would have been a candy raver 15 years ago that I went up to Father Time and kissed him on the lips.

These emo dudes always look like their hair is trying to quietly sneak away without them noticing.

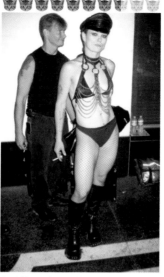

There are no longer any excuses for nerds. Join a band, get a parrot, sell drugs, or just get some nu goth gear and you can have all the 7.5s you can handle.

See? Since when are losers so un-ugly?

The Jackie O / Nancy Reagan church fantasy thing is only hot if you really turn up the heat in the shoe department. Without seeing that we have to reserve judgment.

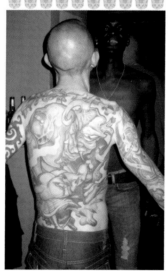

Sometimes the gays get a little too excited and go out of the closet, past the streets, and into outer space.

OK, OK, we get it: You really like the idea of a devil looking up a tiny angel's ass and will always feel this way, until you die.

My boner just exploded.

Blunts wait their whole lives for the opportunity to be rolled. If you're only going to put a small joint's worth of pot into one, you better talk sweet and calm him down or he's going to have a massive panic attack.

Is this an undercover jock trying to infiltrate the gay hipster scene?

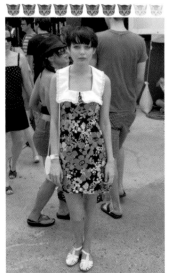

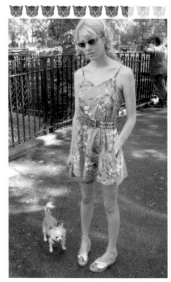

Why do women spend $10,000 on a wedding dress when we like old, white, hippie things about 10,000 times better?

Going into sandal season is like being at the top of the roller coaster but there's shit down below instead of a hairpin turn. Thank God she made it.

Sorry Brooklyn, Manhattan is the only place you'll find hot rich, nerds with their shit together who could care less if you call them the next day. It's simply better there.

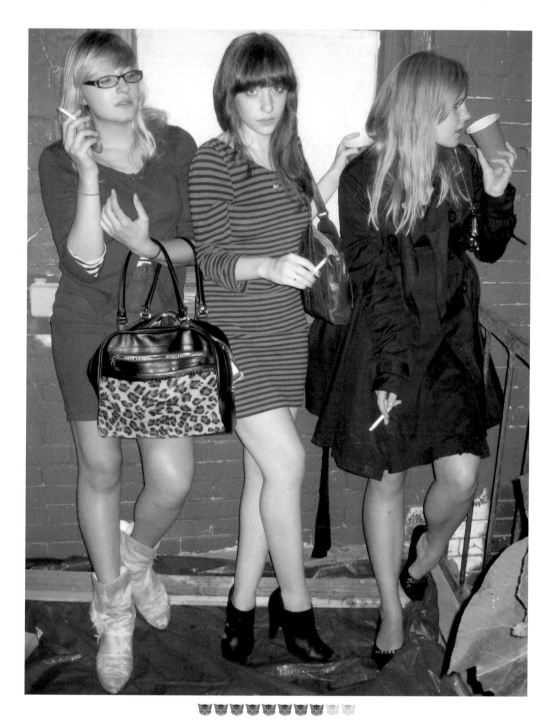

Of course, if you're broke and under 25, nothing beats the affordability and vaginal accessibility of Buttfuck, Brooklyn.

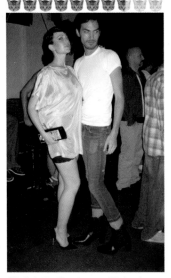

What's hotter than two sexy bitches in 1950s gear and 5-inch heels?

Some people can see auras. I can see STDs.

We tracked down the artist who did this and tried to talk to him about how flyer art that's just kidding is way more highbrow than what's in most galleries today and all he said was, "That's Sparks Knight."

Kids being hippies today is like me being a beatnik — that was your GRANDPAR-ENTS' shit!

Sometimes even clowns get sad when the coke runs out.

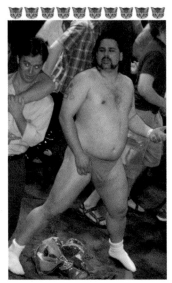

If a song gives you that feeling, that con-nection, that overwhelming kick in the ass, you have no choice but to let your body free and feel it. No matter where you are.

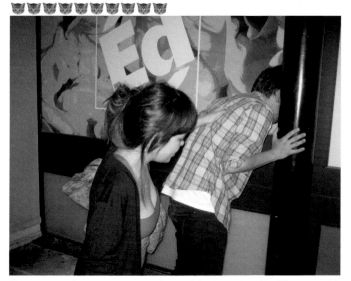

If a woman consoles you when you're barfing, she's inadvertently saying, "Marry me and I will never leave you, even when the cancer treatment makes you unbearable."

Nice fucking shirt, shithead.

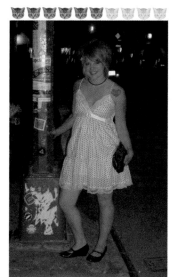

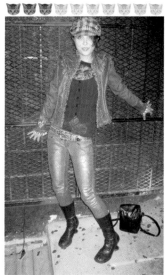

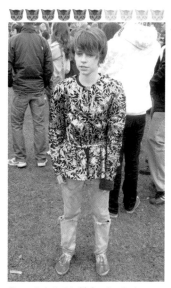

If you love something set it free. If it comes back to you say, "Oh. Um, this is awkward."

When people talk about the problems with immigration they never mention all the shitty pants.

Oh my God, that is SO four hundred years ago.

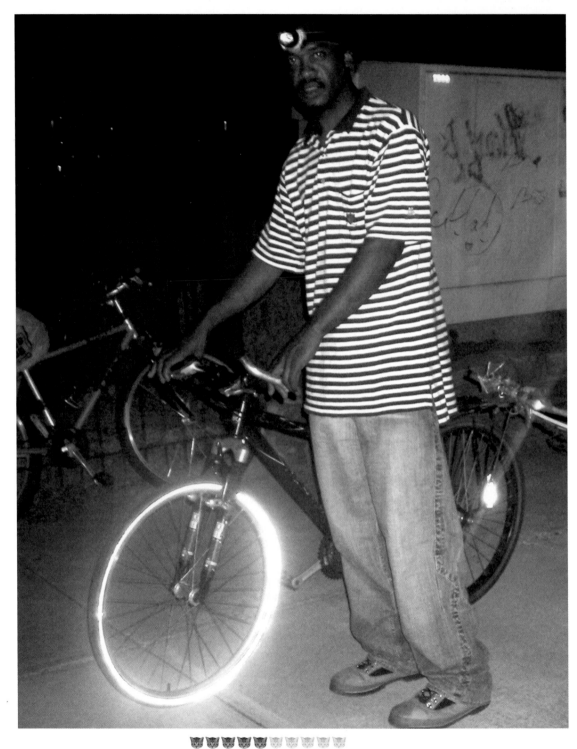

Garbage picking at night can be fruitful, there's no denying that, but an 11-foot trailer? What are you hoping to find, my cock?

We're not sure if blondes have more fun but we know incredibly-rich-smart-girls-with-their-shit-together-and-the-ability-to-make-you-bummed-about-your-girl-friend are having a pretty good time.

If this picture infuriates you it's time to put the book down, step outside, and start enjoying your old age.

Like blow jobs and Other People's Pussy, these shoes are gone the second you marry her.

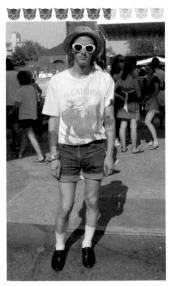

The bohemian look might be a little passé but there's something about bonerhemians that never gets old.

I'd like to personally thank over-the-top wimps like this guy for making women so frustrated they want me to chokefuck them within an inch of their lives.

This looked way better in his head.

Call me an outer spacist* but I am prejudiced towards astronauts in flip-flops.

*I have to credit Derrick Beckles with "outer spacist" or I will NEVER hear the end of it.

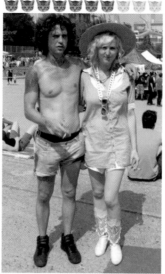

If Angus Young's family never moved to Australia and he never learned to play the guitar, he'd still end up with pretty much the same lifestyle. It's in his gene shorts.

Is it all the butter in their diet? What is it about Parisian girls that makes them so happy and healthy-looking you just want to spread them?

There's something about black heels with short, black socks that makes you think of doggy so hard you don't even notice the other one has a Black Flag tattoo.

What are you, our intern posing for a test photo before we go out shooting Street Boners all night? Oh, you are? Oh hey, Alessandra. Yeah, the flash is fine.

This is the exact moment a "street magician" realizes you've been fucking with him the whole time.

When you see someone hanging out with their dogs this much and occasionally referring to them as "little dudes," you start to think maybe marijuana isn't so harmless after all.

Mothers should love their babies until the babies start to become men, at which point they better pull back or the whole thing starts going in reverse and he becomes a baby again.

I knew a lot of girls like this in high school and the only superpower they had was giving too many blow jobs.

There's something about textured tights that makes the tips of your fingers tingle in anticipation of the touching.

If you want to be the life of the party, go shopping every day and buy absolutely everything you're told to buy, again and again until you're out of room.

If I was a gay this would be my boyfriend and we would literally fuck shit up.

Horror goth is about the only subculture that captures how shitty it was back when the average lifespan was 35 years.

Kids are the ultimate accessory because ... fuck ... where'd she go?

When you see Curly passed out by himself, it kind of makes you wonder if Larry and Moe overdo it sometimes.

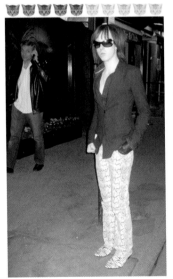

This is either one of the greatest music producers of all time or just a British guy who grew up with way too many sisters.

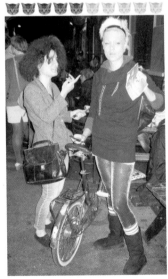

Punk was fun but the detritus it left all over the last two decades kind of wrecks it.

Those who can't do, teach, and those who can't rock, interview bands.

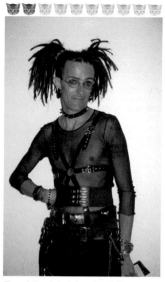

Though it only took America eight years to get the British out, Englishmen have spent entire lifetimes trying to rid themselves of it to no avail.

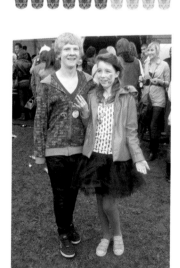

British teenagers look like toddlers dressed up as teenagers for Halloween.

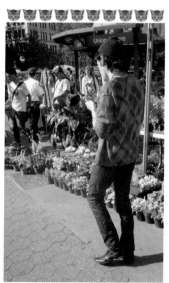

The only thing worse than seeing wool hats and cardigans in the middle of July is seeing couples make out in 100% humidity.

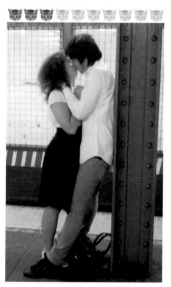

Ew, their turgid genitalia is cooking itself like a cummy, cloth crockpot.

It's amazing someone was able to sneak up on this guy. Oh wait, I'm thinking of eyes on the back of your head, not knees on the backs of your legs.

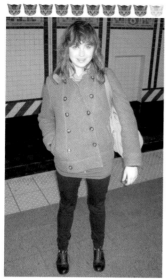

When a mousy girl wears down-home browns, she becomes that piano teacher all students secretly love and dream about 'til they die.

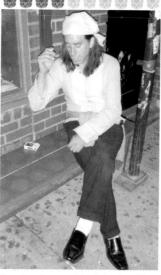

Every time I see an older dude who calls himself a poet and puts a thing on his head, I think, heroin.

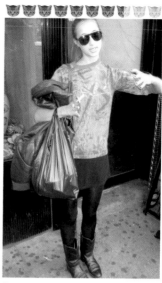

She looks like Stevie Nicks but without the powdery anal lips.

Striped socks and Reeboks are the diplomatic license plates of footwear.

Guys like girls who dress up on Friday nights but on a Sunday we'd way rather watch *Revenge of the Nerds* than *Sex and the City*.

When Koreans say they only sleep four hours a night, they're forgetting the two hours a day they spend collapsing.

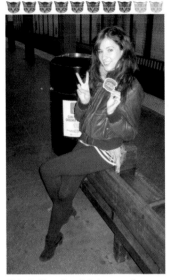

They let kids under 21 drive so they can scoot over to their friends' house and go, "Wow, so you guys are bored just as shit-less?"

Girls don't need pockets because they have purses. So any time we don't get unfettered ass like this, someone is hiding something.

Uh, yeah, I know.

Rich Girl Formal Hot is nice and everything but life is really about Slob Hot and all the whiskey cuddles it showers upon us.

"I miss old New York" is a cliché but when you see a student blissfully snuggling down for eight hours of z's, you're like, "Can we not get just one knife back, please?"

I wish they would invent a visor that didn't have a hole in the top. They could call it a "hat."

The hip, new face of ZOG.

This is exactly how Dutch cartoonists draw black guys.

Americans hate France because European girls are capable of a simple femininity that makes Jennifer Aniston look like Large Marge.

She's doing everything right but I still get the feeling someone's hiding a nerd under the couch.

Everyone was trying to wear as little shoe as humanly possible until this bitch came along with her "one leech each" steez and that was the end of that.

You know you're a redneck when: You push her dog around Park Avenue in a stroller. Oh wait, I meant whipped.

Seeing a mermaid out of context is like seeing your math teacher at the supermarket — you're like, "You do normal shit?"

Oh, hang on, it's just a drunk chav with literally hot legs.

Maybe colored people wouldn't feel so ostracized if they actually made an effort and got involved in the party.

Come on guy, you gotta know that when you have the face of a gorgeous woman, all the moustaches in the world aren't going to stop us from getting mad horny around you.

This is exactly the kind of adorable little angel who will suck your heart out through your pores and digest it with barf like a cruel fly. (Still worth it, though.)

You're not a real man unless you completely lose your temper at least once a month.

Fashion is meant to accentuate your best features. If your best feature is that you're perfect, just stick bright shit all over the place.

She refused his advances until someone showed her a Polaroid of him and a close friend floating in outer space with an enormous bottle of expensive cognac.

The US Army has been known to stoop pretty low when attracting new recruits but getting House of Deréon to do their uniforms is bordering on racist.

Bums are a great barometer of what trends have finally made it to the garbage. (Sorry, Zoo York and diamond jeans.)

If a fat, white guy tried to pull this off, his friends would have to hold an intervention.

When Markus Jokela at the University of Helsinki discovered that pretty girls tend to have more daughters than sons and those hot daughters repeat the process ad infinitum, so women are getting prettier every generation while men are staying just as ugly as their cave ancestors, I said, "Doye."

When a ten closes her eyes you feel like that part in *Mask* where Rocky Dennis is showing the blind girl what a potato is and shit.

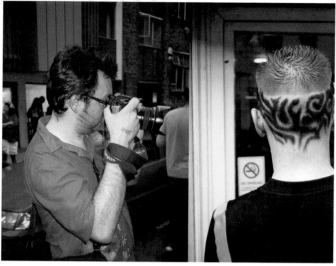

It's weird that the least perceptive photographer of all time would be willing to spend so much money on equipment.

If you see someone like this with a guy who doesn't seem to care, know that it's her brother and he's sick of noticing how hot she is.

I actually like this outfit because I'm allergic to cats and with kittens it's even worse because they have such fine hair.

Fashion is essentially about sex and when you give up on one the other comes tumbling down with it like a clown without a safety net.

Man, you know the economy's in a slump when even Jamiroquai are eating out of the garbage.

If you have a threesome with an 8 and a 7 is that like boning a 7.5, a 15, or a 22.5?

The great thing about dressing like you're 80 is, when you go to jail for 60 years and they hand you back your clothes, everything finally makes sense.

A long time ago I called this guy one of the coolest homos in New York, then I found out he wasn't gay and now look at him. He's toned his look down so much, it's bordering on homophobic.

Drunk people must hate history because nobody has ever won a fight with security guards, ever.

How fucking sexy is it that Compagnie de la Baie d'Hudson was once the de facto government in parts of North America before European-based colonies and nation-states existed?

Dear Her Dad,
Dude! What did you do!?

Sorry so blurry but I had to include the part where beers in Harlem come with napkins stuffed in the hole like they're on the rag or something.

A woman can wear a fedora anytime she wants. I don't care if it's raining in the suburbs of Portland and she just got kicked out of a party for screaming about abortion.

Men, on the other hand, can't be the Three Stooges manager on top when their bottom half is teaching his little brother how to play guitar. It looks like an exquisite corpse.

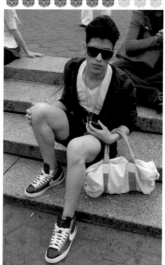

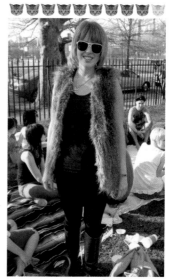

Wow, you are one thing away from being nude. That is the opposite of living in Canada in the winter.

Dude, you're doing the high-top trick and we can STILL see your sockettes. That's like leaving your mistress's IM conversation on your wife's computer.

I'd like to throw blood on that fucking vest, and by "blood" I mean my nude body.

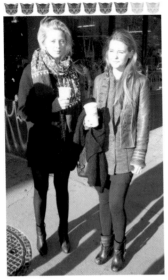

As this picture was being taken, my boner nuclear-exploded into a tornado of light that turned their faces into Freddy skin.

It's fun seeing the multiculturalists struggle with the part where the Bible was written before we knew other places existed.

A lot of people see being a Street Boner as the official beginning of their Salad Days.

Right when you're about to bore me to death with your Midwestern-ness, the fucking heels come flying out from behind the bar and yell, "Surpri-i-i-i-ise!"

Oh my God, those poor mohawks.

When women can hold their liquor better than you, it's like finding a kilo of cocaine because it's cool and fun but it's also kind of worrying.

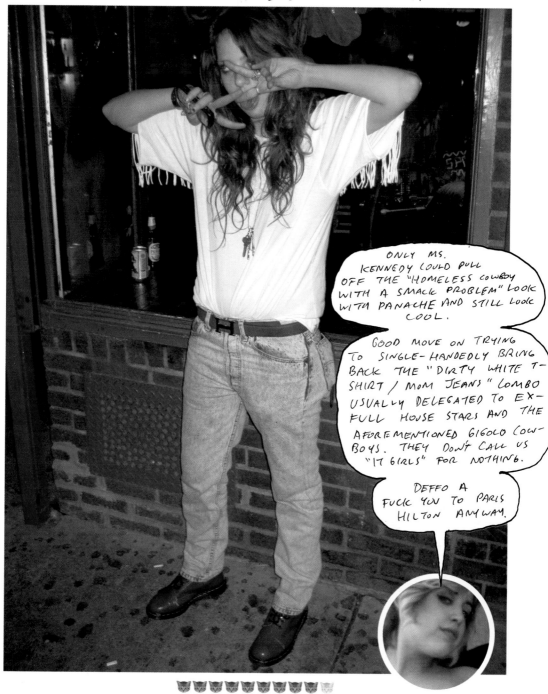

ONLY MS. KENNEDY COULD PULL OFF THE "HOMELESS COWBOY WITH A SMACK PROBLEM" LOOK WITH PANACHE AND STILL LOOK COOL.

GOOD MOVE ON TRYING TO SINGLE-HANDEDLY BRING BACK THE "DIRTY WHITE T-SHIRT / MOM JEANS" COMBO USUALLY DELEGATED TO EX-FULL HOUSE STARS AND THE AFOREMENTIONED GIGOLO COW-BOYS. THEY DON'T CALL US "IT GIRLS" FOR NOTHING.

DEFFO A FUCK YOU TO PARIS HILTON ANYWAY.

You know when you see a girl dressed like Ronnie James Dio if he worked at Marks & Spencer in 1985, she is probably fucking hot and really sick of it.

They say New York City is the only place where all people, even Jews and Texans, talk to each other but something about it seems like a lie.

Why take up professional boxing when you can become just as retarded pushing on the skin next to your eyes?

Ever since girls started dressing like this, drag queens have been running around like dicks with their heads cut off trying to figure out how to look like a lady without appearing old-fashioned.

Well? I have an entire bottle of champagne, and I'm at a bar. You know how hard that is to do? They usually only give you a glass. I got a whole bottle. Hello?

A woman needs a man like Bam Margera needs a bicycle.

Hey, your dad looked like a novelty pencil when he was young. Oh, that's you?

Nice try, you bourgeois fucking Hollywood pussies. That's not an American cockroach. That's one of those Madagascan ones you can buy online. Do movies think we're blind?

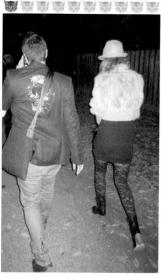

Ah! Bag straps scraping off skull sequins is the new fingernails on a chalkboard.

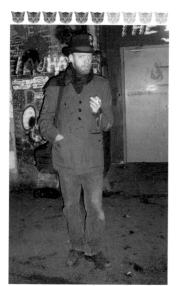

Do cartoonists ever get laid?

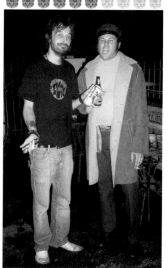

Thrift stores have provided a whole road map of different ways aging hipsters can get lost.

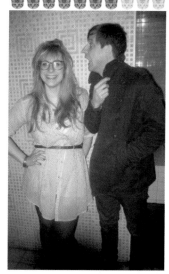

Back before her cunty, Tony Danza phase, Judith Light was the kind of solid seven guys like Marc Ronson would kill for.

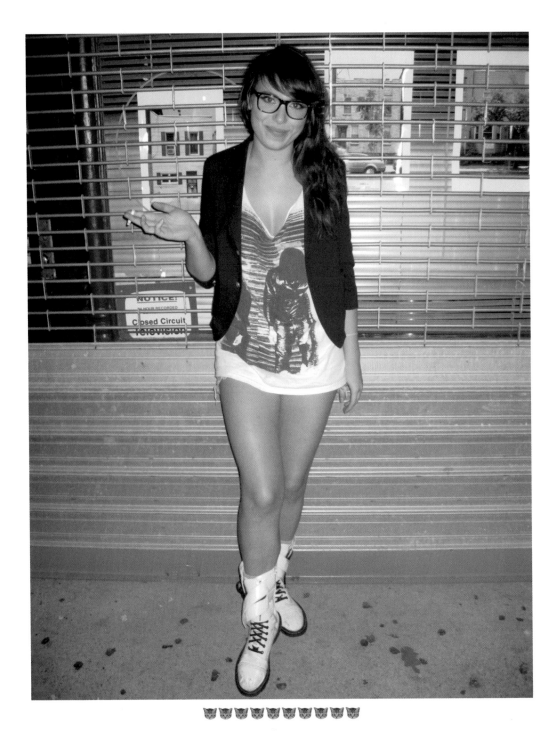

Shorts have become so tiny they look like there's no pants there, which is what she looks like when she stays over at your house, which is great because it cuts out a whole middleman of fantasizing.

If you have the power to pick up an Italian tourist from scratch, I would like to hang out with your tongue.

Ironic racism only works if it folds back on itself three times and becomes nice again.

Every time one farts in public the other says, "There but for the grace of God go I."

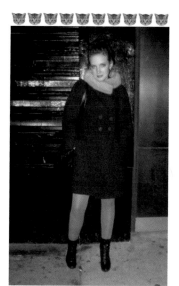

Seeing hot girls in the winter is like seeing an East Anglian cockchafer in its pupal stage.

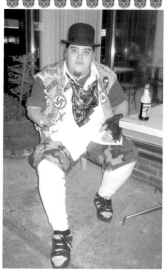

Just when you thought this guy couldn't fit any more subcultures on his body, he stuffed pirate in there at the last second.

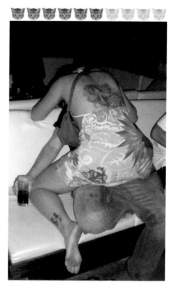

At least a praying mantis gets an actual fuck in before getting eaten.

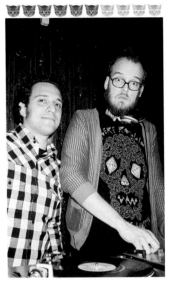

Hey, do you have that Tenacity song "Two Nerds Who Turned It Around"?

"Fuck you, dad" kind of loses its impact when you are a dad.

The shy thing can be kind of hot but when you take it this far, it's like you farted.

Hangover shits just keep coming and coming and coming. They're like when you're with a fat chick and nobody knows you're there. (We can all admit those are actually the best lays of our lives, right?)

It may be eponymous as a motherfucker, but being photographed next to boners is not a great way to get pussy.

These guys are such pieces of shit, toilets drool when they walk by.

What the fuck does that even mean? This is the weirdest text I've ever received.

The fu-? Hungh, oof! Ah! Humprk ach ouch, eef, oooh. Ow! Oh, uh, HAP! Ouch, ow, ow, ooh. Uh. Ooooooh. Oh, shiiit.

This generation is so fucking cool their heads are cold.

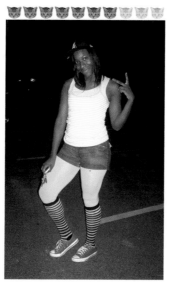

If rock, paper, scissors is the only factor deciding whether she'll go home with you, always go with rock.

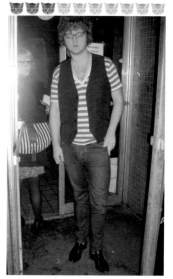

Expensive, thin glasses scream "unpunch-able" so loud, it shrinks your dink to winter skinny-dipper size.

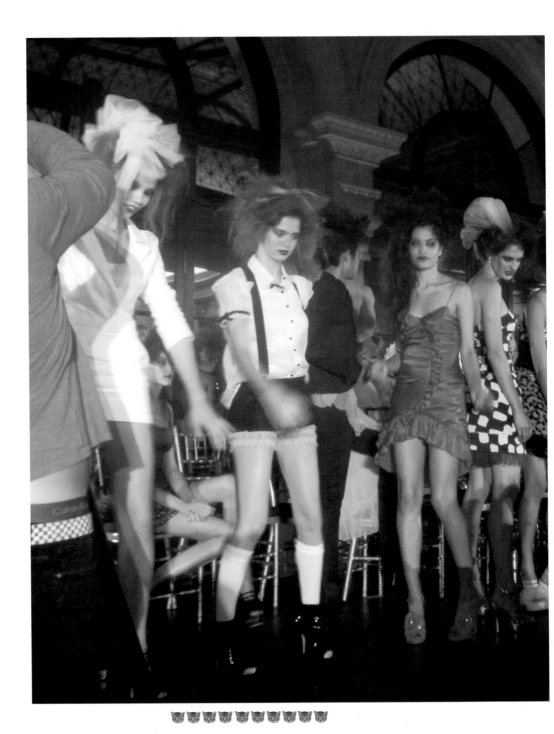

After I fuck all these girls I'm going to stitch all their clothes together and make a Laids Quilt.

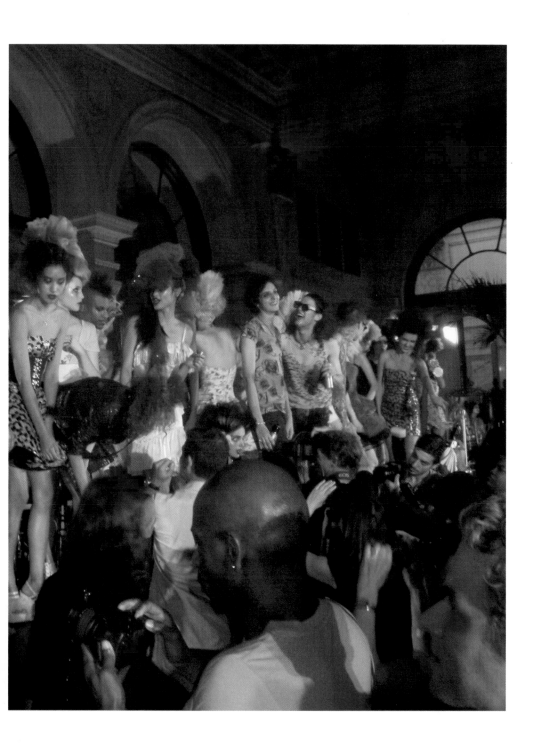

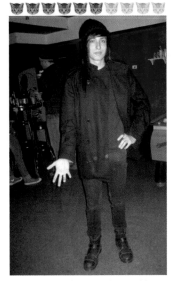

He's going to look back at these as his Tomboy Years.

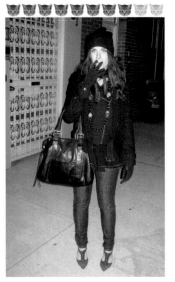

When you see an ex-girlfriend and she looks WAY better than when you guys were going out, it makes you want to forcefeed her doughnuts.

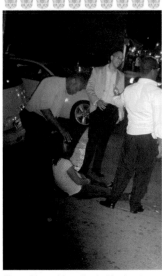

The problem with roofies is it's almost impossible to get the timing right.

Note: Just kidding! Please don't sue me, you guys. It wrote itself.

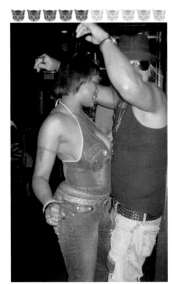

After this guy confessed he was only *pretending* to be Kid Rock, she probably said, "Why bother? I would have fucked you if you were a kid or a rock."

Who has it worse: crippled, black stuttering retards, or ugly, fat, lesbian nerds?

PS: I think this is the meanest one I've ever done, and I don't even know if that's a dude or not. Shit! That's even meaner. I'll stop now.

Why don't you grow your fingernails to strange-Indian-man proportions and shove those in my face while you're at it?

Boy, it really hits you how much female attraction is based on submission when your boner sees them dressed as children's book characters.

Casts are great and everything but they're way too easy to maintain, and they don't make anyone barf.

There, that's more like it.

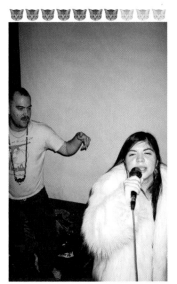

Ninjas always eat, shit, and sleep in hiding because they say those are the three times you're most vulnerable. They forgot one.

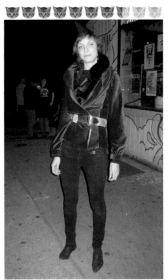

After a blackout drunk, you often wake up and can't remember if you really did meet someone who looked like a stewardess from Cocaine Airlines.

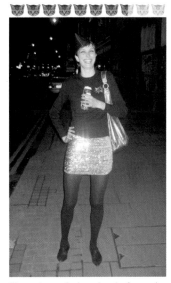

Then, when you're less pissed a few weeks later, you run into the same girl and think, "Man, she really likes that hat."

Let's face it, you guys: The Third World blows.

Women shouldn't wear pigtails after 22, short socks with heels after 25, and tutus after 6.

This fucker gets women so wet, they can't even think about him without sitting on the toilet.

Is it possible to love a woman without one molecule of punk in her?

Traveling with one bag is what God intended.

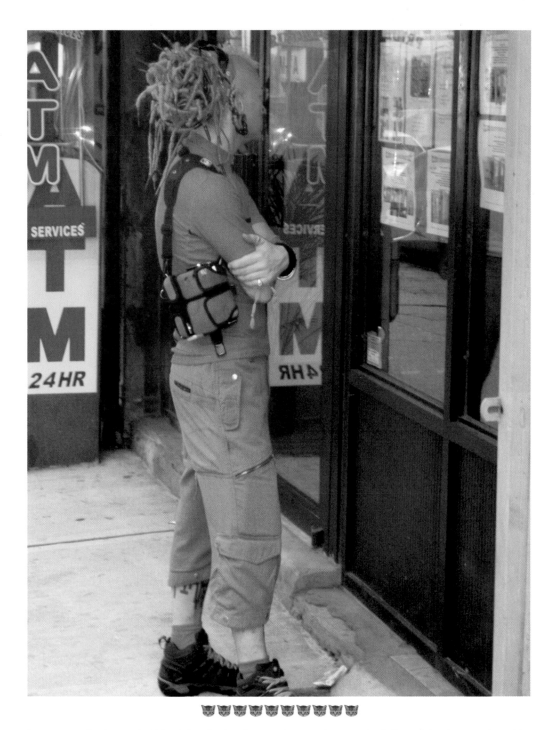

Trance is great if you're a really old French Canadian from Germany who loves urban mountain climbing and doesn't want to rhyme with anything.

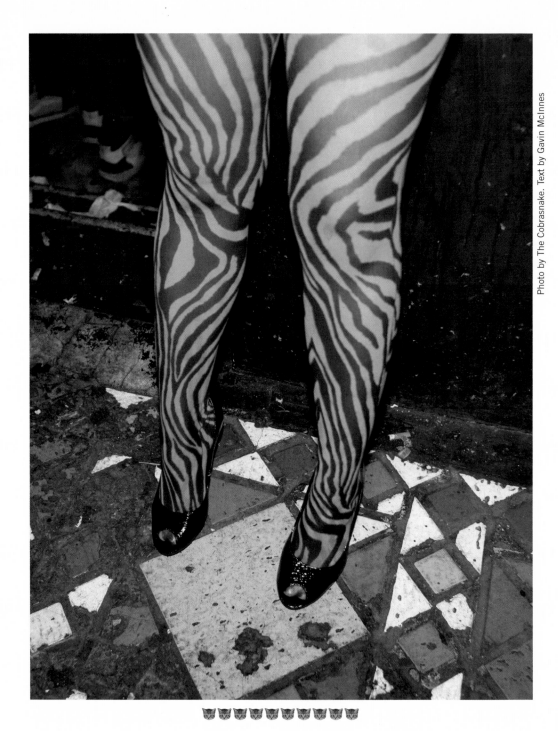

Photo by The Cobrasnake. Text by Gavin McInnes

🐱🐱🐱🐱🐱🐱🐱🐱🐱🐱

I'd link to The Cobrasnake way more if he didn't always crop out the shoes. Every once and awhile he makes up for it, though, with one of these delicious monsters.

WHAT ABOUT LA?
An Interview With Nightlife Photoblog The Cobrasnake

You seem to like LA. How can you like LA? You've traveled all over the world and should know better. They all have skulls on their blazers in LA.
Loving LA is like being into fat girls: You can't learn how to do it no matter how hard you try, and you would never want to if you weren't already. You just have to "get it." Plus it's mostly Mexicans who rock skull blazers now.

Why does New York have less douchebags?
What about Midtown? What about the Puerto Ricans? What about New Jersey? What about Williamsburg, like, two years from now? Or downtown five years from now? New York is only going to get more and more douchey but LA's douche tide might actually start receding in the next decade.

I think New York dresses better because the trial and error of being around people every day helps you iron out the kinks. In LA you only see people sporadically so you develop slower.
There are no "mistakes" in LA, only dreams. Every person walking around is a unique, timeless snowflake of fashion and personal identity. For 99 percent of the people that means they totally suck but there's also a couple people, like me and Jonny Makeup, who "make it work."

I wanted to do a book on young people who invented their own jobs but you're the only one I could think of. Did you invent this whole idea of going to parties and photoblogging them?
Yes. I invented the photoblog and by definition I also invented the nightlife photoblog. Not only did I invent the nightlife photoblog, but I still have the only one that really matters, no matter how many times you link to pictures of girls "going wild" on other party blogs. I get very upset when people deny me my invention. Like, I get heart palpitations, and I need to just drink a vegetable juice and lay down.

Could you basically get any girl you want?
I could do a lot of things but I don't want to because I'm an Eagle Scout and a nice Jewish boy. I really am an Eagle Scout. Also, I was prom king.

I've always said guys who aren't conventionally attractive should go the goof route and just go bananas with retarded outfits. This seems to be working for you now but how do you age with this gracefully?
That's true, except the "goof route" works even better if you're really, really handsome, like me.
Aging gracefully is tough. I'm sure you're looking for pointers on that. Like, it's pretty pathetic to be all covered with tattoos and still trying super hard when you're 45. I'll probably move straight into "classy old Hollywood Jew" after 30, and when I die, I'll be buried in the fanciest Jewish cemetery "no problemo" because I don't have any stupid Ed Hardy tattoos.

You started the whole nu rave thing. You were wearing neon fanny packs before any of those dudes. Then it was everywhere. Now it seems to be disappearing. Are you just going to wait 'til it comes back around or go for a new look?
My overall look was never completely nu rave, but I do think fashion historians will look back and confirm that I rocked some of the best and earliest neon flavor of the "Naughty Aughties." Also, I started wearing pink at least a year before Cam'ron.
Nu rave was a dumb name but now that it's over, the good news is that the ante really got upped on neon garments and accessories. If you're going to wear neon in the future, it has to be something really amazing like a neon backpack with a giant clock embedded inside it.

What's the worst faux pas men make today?
Taking themselves too seriously.

Sometimes you'll be looking at a perfect chick and realize, "Holy shit, God is a design nerd."

Photo by The Cobrasnake. Text by Gavin McInnes

Photo by The Cobrasnake. Text by Gavin McInnes

See? The right shoes put a woman on a pedestal and make her something worth worshiping.

I know you want to brainwash girls who are out of your league and make them like you but they'd never be truly happy. Leave the tens to the guys who can handle them.

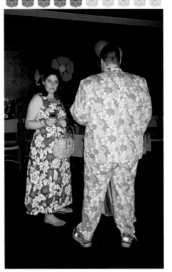

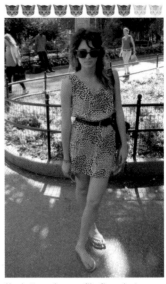

Don't hate the pigeon-toed thing. It's not a woman pretending to be a child. It's a woman pretending to pretend to be a child — as in, "I'm versatile."

When I see easy targets like this I feel like a gay Boy Scout leader. Must ... resist ...

You better enjoy your flip-flop minutes because we're giving you three days a week and there's no rollovers. Not even for eights.

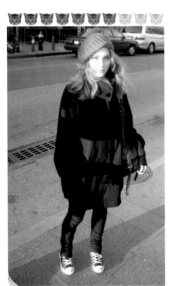

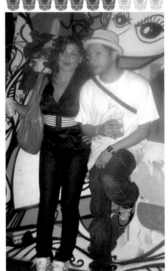

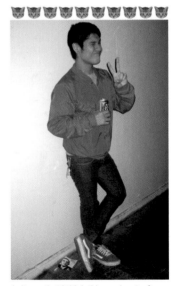

Whenever you see a really fat guy with a cute girlfriend like this, it's impossible not to wonder how they fuck.

If a blind person asked me how people dress today I'd say, "Just imagine your grandparents were into hip-hop."

Is it gay that I think this guy is a ten?

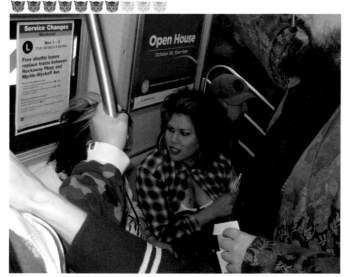

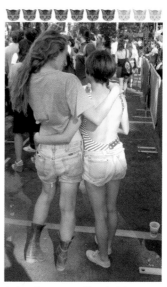

There's no anorexics in New York because the second a girl thinks she may be getting a bit chunky, a million Puerto Ricans holler compliments.

Just as the warm weather winds to a close, frayed denim short shorts appear and then peace out like that adorable groundhog in *Caddyshack*.

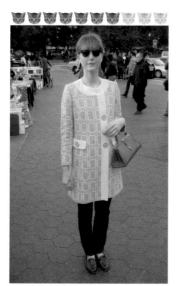

As my drunk, Scottish grandfather would say, "She's a wee bit of sanity in a world gone mad."

If your dress fits like a plastic bag for someone else, it shouldn't be made out of Look At Me.

Rubber boots are to formalwear what gasoline is to a flaming boner.

The shoes make the man but man, oh man, do the woman's shoes ever make the man want to make out with the woman.

Musicals are like gay porn in the sense that you spend the whole movie dreading the part where they're about to stop what they're doing and just start going for it.

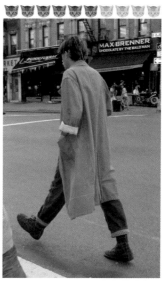

This is that stage right after "Who gives a shit?" in college where you figure Dexy's Midnight Runners pants and three dreads still means you're above it all.

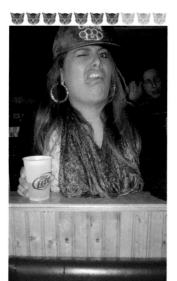

One surefire way to avoid detection during a raid is to become one of the novelty items behind the bar.

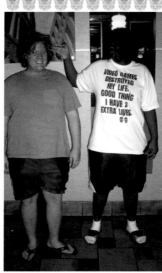

San Francisco weather is perfect for good outfits. Conversely, the entire South is perfect for dressing like you're at camp.

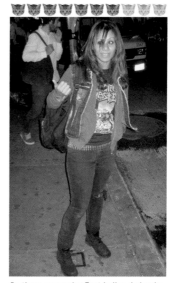

Do those oppressive East Indian dads who say, "No makeup, no high heels, cover your legs, and your clothing allowance is $50 a month," realize they are forcing their daughters into a life of thrash?

Why is it the only people allowed backstage are the ones with absolutely no interest in being there?

Just think, if Kate Moss was a seven, she could have been yours.

Her shoes pissed her pants.

These guys seem to have a very "try to find something wrong with us" vibe, which is pretty ostentatious for two people who just let the worst farts I've ever smelled.

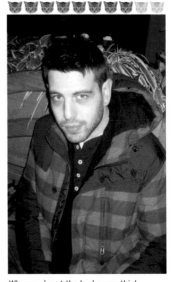

When you're at the barber you think, "Yeah, why not go short back and sides with a bunch on top?" Then a few days later you go, "Oh yeah, because it makes me look like a really rich, smart, shit-together homosexual."

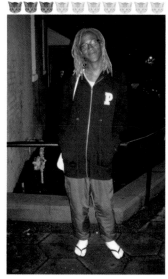

Are you trying to make me and your dad buddies by bumming us both out?

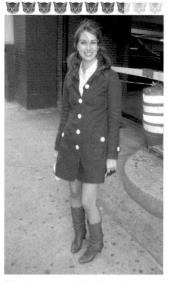

There's no suicide hotline for deaf people, so what we usually do is show them this picture and explain there are girls out there who are human versions of a Friday.

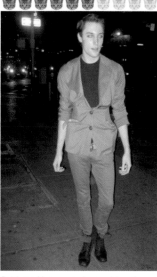

Putting a king can and a novel in a tiny blazer is like letting Shaq fuck Tila Tequila.

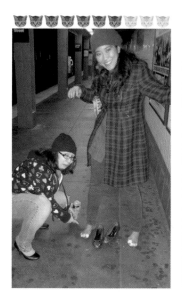

That thing about their vaginas being sideways is bullshit but there is a lot of evidence to suggest their toes menstruate.

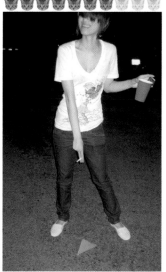

What's hotter than hearing about the Pythagorean sum of the areas of the respective projections on the three principal planes slurred?

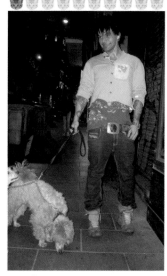

The difference between male prostitutes and French men is one gets fucked up the ass while the other getz fugged up dee h'ass.

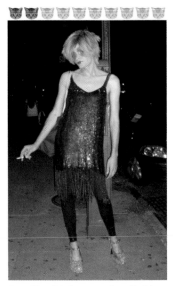

Seeing metalheads try to "zane up" formalwear by wearing kooky earrings is irritating. Be a rocker OR be a conductor. Don't try to blow my mind by mixing it up.

It would suck to be roommates with this guy because you know he'd be a total diva about doing the dishes.

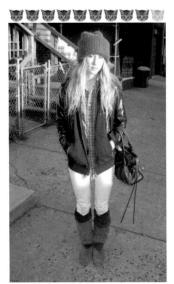

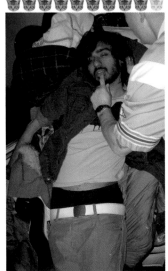

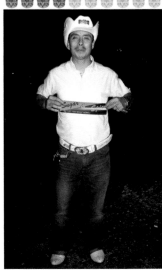

Most hot girls disappear after November because they find a mate to hibernate with, so if you see one, grab her wrist and scream, "DIBS!"

It's probably bullshit that it's good luck to rub a drunk Paki's lips but why not at least try it?

Can you believe 600,000 people died to keep this country united? Why?

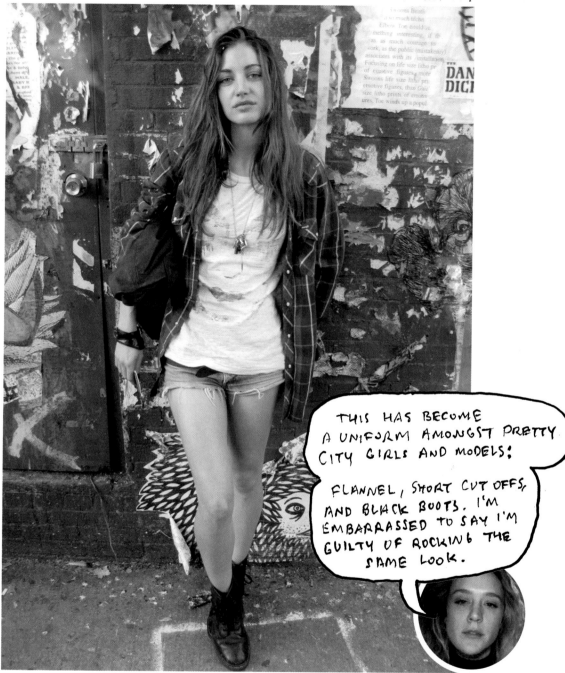

THIS HAS BECOME A UNIFORM AMONGST PRETTY CITY GIRLS AND MODELS:

FLANNEL, SHORT CUT OFFS, AND BLACK BOOTS. I'M EMBARRASSED TO SAY I'M GUILTY OF ROCKING THE SAME LOOK.

Apparently Eddie Vedder put out a line of lingerie called, "Oh ... My ... Fucking ... God."

When you're a virgin, fat chicks are gross. Then you practice fucking for a bit and you're like, "More dessert, please."

Jocks think it's gay to care about fashion but her Steve Maddens say a thousand words, most of which are excruciatingly dull.

High heels would transform this girl from Kermit the Frog's sister-in-law into some kind of Iranian socialite.

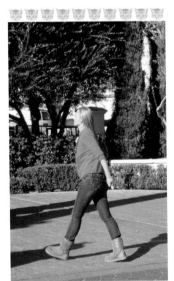

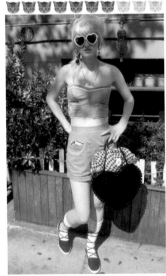

It's hard to see Uggs in the summer and not picture ten slimy toes wriggling around like sardines in hot Vaseline.

Dear Drag Queens,
We know you see this and think, "That looks fun. I'd like to try it," but here's the rub: <u>You are a dude</u>. Only cute young girls can do this. That's the whole point.

Ever wonder what it would be like if your girlfriend was in a band like Taken by Trees and everyone loved them and they went on tour all the time? Too late. You're already dumped.

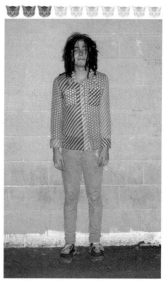

It must be hard to get noticed if you're gay in Britain because everybody's already such a ponce.

After Dora got popular, Raggedy Ann was out of a job.

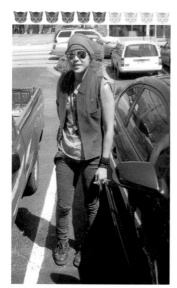

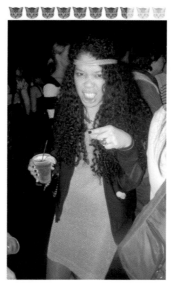

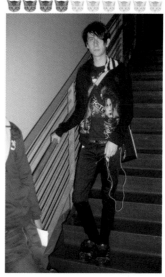

This girl must be going for the Lisa Bonet look because she's certainly not going for the Lisa BonER look.

(This is the Lisa Boner look, bee-tee-dubs.)

How can anyone be serious about that movie after *Edward Penishands* came out?

What could be more punk rock than being illegal?

Of course, if these guys are legal residents, they are total posers who should be ashamed of themselves.

She's definitely not doing anything wrong but Jesus Christ can we not have just one tiny dash of flair? Even a zit would be a nice splash of color.

These two were wearing bras outside their clothes. When I asked them why, they went on this tirade about hacking the system that was so boring, it made my eyes water.

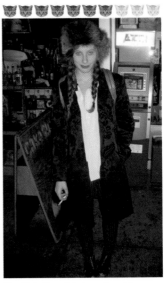

My wife told me this doesn't work because brocade and pinstripes don't go together. Man, women have a lot of rules.

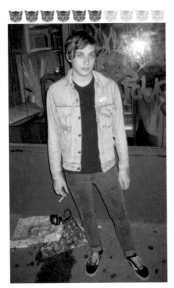

Dude, take it easy on the jean pajamas. You've got on more denim than my mom's ass.

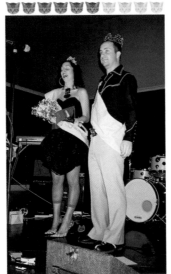

If you're a six, do yourself a favor and leave New York. You'd be considered royalty in any other town.

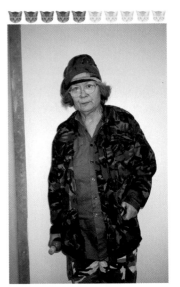

She's a vet from the war on you guys making too much noise during the sleepover. Look at the time, for chrissakes. Now get to bed!

The bonfire of potential a sheer dress gives can easily be snuffed out by a pair of flats. Patent leather, lace up stilettos, on the other hand, are a fucking flint made of gasoline bombs.

And you thought dead teenage Marines in Afghanistan was a waste. What about an eight blowing her potential with a boring outfit like this?

You can spend $11,000 on an Hermès Birkin and starve yourself to 110 but we prefer a size 6 with a 12 pack.

According to the dictionary, to rule is to "exercise supreme authority." That rules.

"You're seriously asking me why I bother to get all dressed up before I go out?"

Gays have no idea how unbelievably punk rock they are.

Has anyone seen this documentary about what Santa was like in his 20s? Mrs. Claus was INSANELY hot back then, and she dressed like a B.E.D. (Boner Exploding Device).

Look at her! What is she, a 30?

"I'll just wait here while you try to guess my gender. I have a feeling I'm going to be waiting a long, long time."

That Bif Naked look is something all young boys dream of. Then they get pubes.

This is what would happen if *The View* moved in with you.

Um, the silicon chip inside *my* head just got switched to overload.

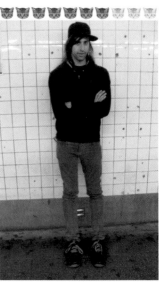

What kind of blind man wears shoes after they turn into 14th century pauper slippers? They look like someone got elephant scrotums for their birthday.

Actually, a pretty decent dude wears these shoes. The moral? We need to raise awareness big time.

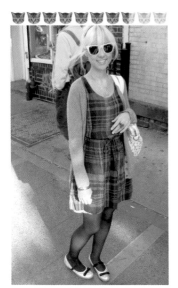

Wearing shoes your boyfriend bought you is like listening to death metal your girl-friend bought you.

Easy lady, your tits just turned the world's most important politician into the baby from *Family Guy*.

No wonder hip-hop sucks so bad; it's got over 40 pounds of impacted feces in its colon.

And the award for Nerdiest Jew in the World goes to …

This is to encourage you to pronounce it correctly, like when reporters say "Neechkar-r-r-ragua."

She'd be a goddess in Glasgow but here in New York she's just pretty, normal, and pretty normal.

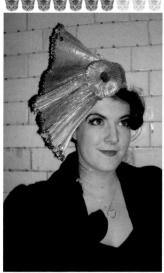

The 40s looked great. The only bad thing you could possibly say about it was that 60 million people died fighting a world war.

The best way to avoid letting people know you like Toby Keith is to throw them off the scent with a Prince shirt and some Rasta headphones.

To pack such a wallop of hotness into a boring red dress and some shitty shoes is like stuffing the Holy Grail into a black sock, wrapping it in newsprint, and leaving it on the bus.

This guy has three times as many cameras as he does fans.

(Seriously, though, we were trying to enjoy our beers and this cocksucker kept fucking our earholes with his loud, hippie bullshit about "just having another dandelion day." I'm still pissed about it right now.)

I asked my dick what he thought of this and he said, "I love the gray and blue palette. It's so retro." Is it normal for your dick to talk like that?

In Canada all you can see is some face, a bit of hair, and her taste in coats, so you end up choosing a mate based on about four percent of her.

We finally have the technology to turn muffin tops into stomach aches.

Slob fags are one of those lovable rule breakers who defy stereotypes as well as they chug beer.

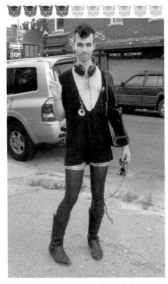

Whoa, whoa, whoa. When I scoffed at "Guylons," I had no idea some of you were going to *own it* so *fiercely*. You go, dude.

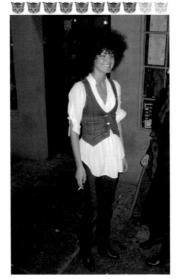

Who knew you could put spandex, a 70s Afro, and a white cotton peasant blouse in a blender and get Vivienne Westwood if she worked at Forever 21? (Yes, I'm a fag.)

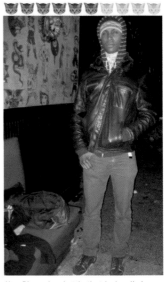

Hey, Pharaoh, what is that look called, Blue Steel? Why are you trying to look so sexy when you're so fucking cold?

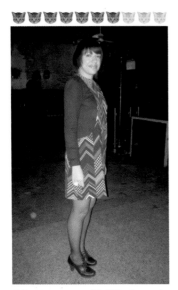

If Americans never settled this place and Indians never discovered booze, "Northo Americazaukaca" (or whatever they'd end up calling it) would have a president who looked like this.

Look at this piece of shit glide into the bar with his slushy Tevas and his goose pimple cargoes like it isn't December 20th (note the Santa hat). The only reason he's still alive is we didn't miss summer once the whole time he was there.

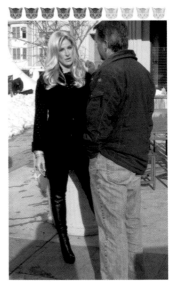

Whenever people make fun of her for wearing a wig, you can see the black *Housewives of Atlanta* squirm in their seats and go, "Er, can you focus on other bad shit about her, please?"

Most janitors are complete shitheads.

Can you fucking BELIEVE people still believe in God? Graveyards must be filled with bodies going, "You're kidding, right?"

The only thing worse than wearing anime clothes is knowing that they're anime clothes and photographing them for your book of fashion jokes.

Drunk driving may kill a lot of high school students but what about the dangers of drunk shopping? I have no fucking clue what this is or when I bought it.

I'm actually glad she didn't top it all off with high-heeled boots. My corpora cavernosa couldn't handle that much venous blood.

When I'm mayor, everyone with a hangover will be met with specially chosen "Coffee Hostesses" the second they step out the front door. These girls don't talk, and they get you to where you have to go — no questions asked.

Hey Derrick, if you're the only guy in the world with a picture of my wife from 9/11, can you not use it as a mother-fucking beer coaster please?

This is the face you make when you realize you're finally too old for the pit.

Friday night doesn't tell you shit. If you really want to get to the core of a lady's style, see how she handles Wednesdays after work.

Some guys are just such fucking bitches you have to slap the living shit out of their ass and quarantine them, even if you're menstruating.

It's impossible to look hot in the cold so just relax, listen to music, and mull over the boner onslaught you are going to hit us with in the spring.

This is a great look if you're 1 inch tall and someone's looking for a bingo dauber.

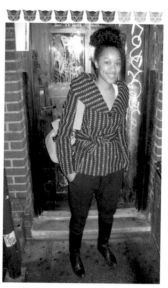

Mannequins can go way farther out on a limb looks-wise because they don't have to worry about being fag bashed.

You can't really beat a juxtaposition like New York black chick meets British aristocrat on a fox hunt.

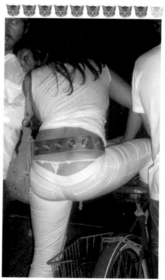

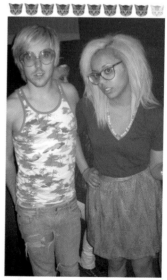

Someone needs to tell this vacuum cleaner to chill the fuck out. Jesus dude, you're not at NASCAR.

Darwin says women developed breasts after we started walking upright because they needed us to start paying some attention to the front. Most women already know this.

Their carpets are as close to their drapes as their genitals will ever be to each other.

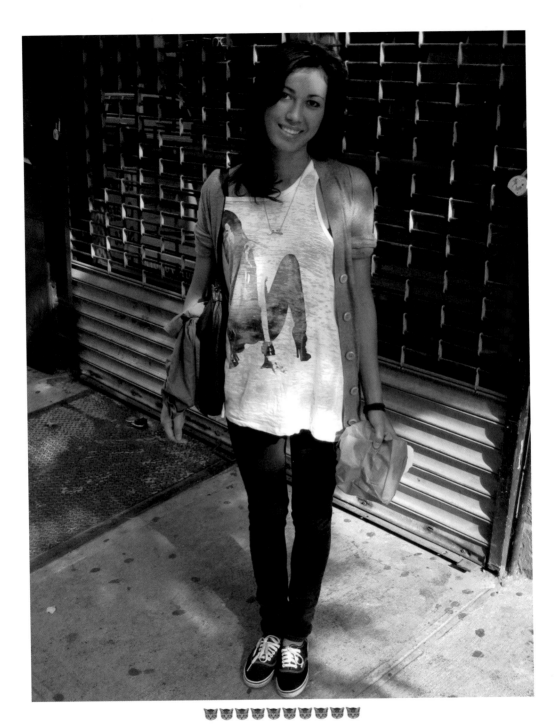

When you first see a Slob Babe, your little brain tells you you're the only one who notices her beauty and you should go for it. Then your big brain kicks in and points out Earth also finds her attractive so you give up and go back to 6s where you belong.

Being an Obamaniac was fine before he was president but now that he's our boss, you just look like a baby that likes being coddled and swaddled and told when it's bed time.

"My president is black / My boss rules too / And I'll be goddamned if I don't love my high school principal / I love paying tax / I love obeying the law / Gimme some more rules / I love it all."

Keeping prefectly sculpted, supple legs hidden in pants all winter is like keeping an albino tiger in a jar. It's time for a vagaytion.

When you're a kid, you're all about "The Revolution" and "Eat the Rich" but then you meet some of them, and you're like, "Um, can we put an 'Out' at the end of that last one?"

If you can't be bothered to fix a broken door, just paint this on the front and say it doesn't *want* to close properly.

Um, did this guy just trip and fall into a huge vat of Best Friend Sauce?

Whoever threw this chick in the garbage needs to take his eyes to small claims court.

They're giving such great anti-depressants to kids these days, a lot of them are faking being sad just to get high.

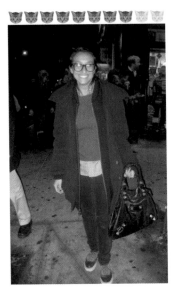

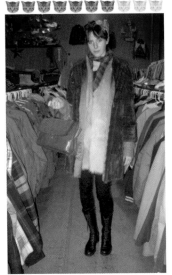

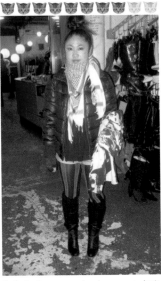

Taking home a healthy nerd and dressing her up in lingerie is like taking in a stray dog and teaching it to kill.

Fur is both murder and cozy.

Is that a bun on your head, or are you just Happy Tosemi?

It's always so fucking obvious when gay dudes are trying to act straight.

If you aren't into dealing coke, the best way to get laid is to be in a band, and the best way to do that is to play the one instrument nobody else wants to play: the bass.

After living in New York for awhile, you start to understand why "Get da fuck oudda heah" is such a popular phrase.

Love 'em or hate 'em, tattoos are a great way to separate the LA girls (here for a good time, not a long time) from the New York girls (in for the long haul).

You better enjoy this Deathset/Ninjasonik/Cerebral Ballzy look while you can because it's only a matter of time before teenagers start getting on your nerves again.

It was a long hard struggle but Doc Martens have finally recovered from the stigma grunge left behind, and punks can finally return to the joys of orthopedic panhandling.

When a drunk girl in rubber boots dances funny on your table, all strip clubs become rotten Mondays in comparison.

If you just started college and are looking for a gimmick, we highly recommend making your drink of choice "Sniper."

It's weird to think about a model being tired after a hard day's work. It's like a foxymoron.

When a hot girl is really mean, seeing her in terrible footwear is about 1,397 times hotter than seeing her in stilettos.

Dropping a black guy with funny hair into a college party is like dropping a candy into a large container of whatever insect is into candies but has never had one before and might be into trying one if the candy was cool about it and didn't come on too strong.

Some dogs are so confident and just "over it," they bring back all your high school insecurities until you catch yourself secretly giving them the finger from inside your coat.

It freaks us out when you associate yourself with the Virgin Mary because God fucked her and made a magic baby that 2.2 billion people love. Not Normal.

If you don't factor "funny" into wife-hunting, you hate Future You more than Scrooge.

It would be virtually impossible for my grandmother to be this for Halloween.

Remember that Eddie Murphy show *The PJs*? Remember dude's wife? Even though she was clay and old, you could tell she was real cute in her day.

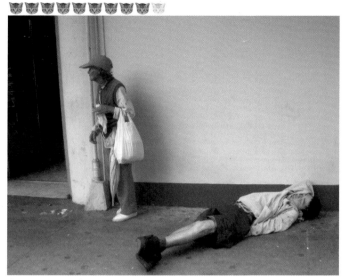

You know you were fucked up last night when you wake up in Ecuador.

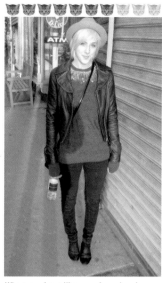

When you dress like a punk nerd and throw on a kooky hat, you end up looking like the token "badass" from *Top Chef*.

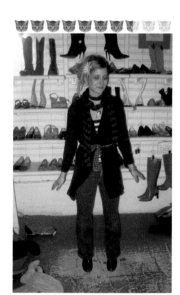

Girls who work in clothing stores dress themselves up like dolls, which is cute when they're young but CRUCIAL when they get to the soccer mom years.

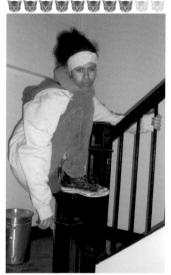

If you're going home with a crazy chick, there's inevitably that point where you wonder if this is all a big mistake. Then she says something like, "Did you ever cum upside down?" and you're up the stairs faster than when you were scared of the basement.

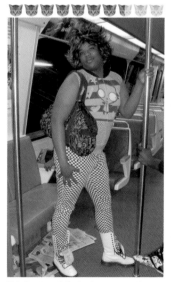

This is what all fagbashers eventually become.

Hey, it's the exact opposite of Archie Bunker's brain.

Sure your lawyer doesn't want you to skip bail but would you rather be working on your motorbike in Costa Rica for the next 10 years or having sharp toothbrush fights in the shower?

When Europeans come to New York they get dipped in glow-in-the-dark sauce and end up looking like a giant baby who grew up in a thrift store.

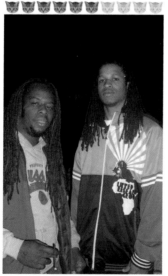

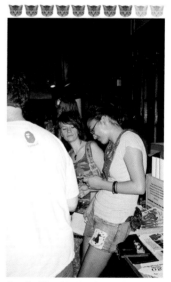

She looks like the centerfold from *Hobbit Maxim*.

Dreads like this always make me think of scientifical hip-hop, which is more parenthetical than diabolical, so less diametricals will face more obstacles and blah, blah — shut the fuck up and go read a book.

If you're 18 and looking for a wife, a slightly ethnic, anarchist chick at a 'zine conference is the best of like, 37 worlds.

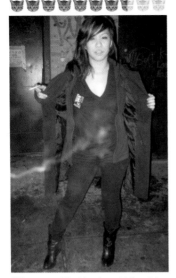

This new president has brought Hope into every facet of American life, even second base.

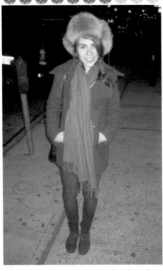

All you have to worry about this winter is your coat and maybe a hat, which is fine, but you better come exploding out of the gate this spring with some crazy shit we've never even thought of like hot pants with feathers on the ass and some weird rubber stilettos with black dad socks.

If you're going to have dinner with someone who was recently raped, make sure you bring along at least one Zany Guy to keep the conversation light.

It's amazing how many people at streetwear trade shows have progeria.

Update: Someone recently told me this guy doesn't have progeria. Thanks, joke police!

She gets an A for effort and a WFUL for everything else.

Hey fuckface, ever thought of this: How about you give evolving a try? You look like you're about 450 million years old.

Oh, hmm, limited edition Chuck Taylor's that only nine people in the world own. I wonder who's wearing those?

Oh nobody, just a girl I want to eat out until my beard wears off.

Your friends may not appreciate it, but dating a crazy chick turns every Friday night into a horny adventure that lasts all weekend.

Sometimes the only way to get the theme song from *Fame* out of your head is to let it into your body.

This Asian chick looks like a Canadian in New York trying to look like she's from London.

When jocks and snobs hate a group of people, it becomes almost impossible not to jump on board and pretend to be one of them, no matter how completely fucking ridiculous said group is.

Text and illustrations by Gavin McInnes

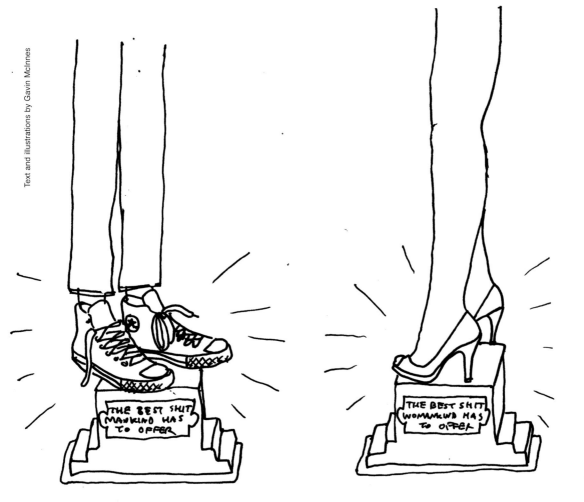

THE BEST SHIT
MANKIND HAS
TO OFFER

THE BEST SHIT
WOMANKIND HAS
TO OFFER

THE RULES
What to DO and What to DON'T do

OK, first of all, can we assume the person reading this is not some date-raping frat boy in a striped polo, bent baseball hat, wood choker, giant shorts, and Adidas slippers? If I have to sit here discussing shit like having spiky gel in your hair, what a bummer fedoras are, jocks with mohawks, fauxhawks, dress shirts with silkscreens, blazers with skulls, suits with t-shirts, diamonds on trucker hats, sunglasses indoors, white guys with dreads, anyone with perfect dreads, stirrup pants, stressed denim, baggy jeans, seat belt buckles, Skechers, Campers, Birkenstocks, Uggs, Crocs*, and shit like a tie with a t-shirt, we're going to be here all day. This is about the basics of getting dressed in the morning, and it's not for the mentally retarded. It's for someone who has at least a glimmer of hope.

Also, you'll notice women don't get much of a talking to during these rules. That's because, after shoes, they seem to have everything under control. I'm not going to sit here and tell some chick it's tacky to wear Rocawear because, if you've got some Christian Louboutin pumps on, Rocawear's awesome. These rules focus on the problem at hand and that is, for the most part, dudes, especially in the summer.

*In the interest of full disclosure: At least one brand paid me a sizable amount to be kept off this list.

IT'S ALL ABOUT THE SHOES

Once you get your shoes together, everything else kind of falls into place. Whenever a girl tells me she's lonely and can't get laid I tell her, "Wear high-heels and stay at the bar 'til last call." No female is ever lonely after that. Even a tub of lard looks good in heels. Especially after a few beers. (Here's a secret: Men don't even really mind lard. They just hate the stigma that comes from being with fat chicks. The actual lovemaking is actually better than with skinny chicks - shhhh.)

The Basics
(men)
If you wear any one of these for the rest of your life, nobody can fuck with you, I promise: Chuck Taylors, Wallabees, desert boots, Vans Era, Vans Slip-Ons, Rod Lavers, Red Wings (classic work boot), Nike Dunks, Air Jordans, and then maybe some Loake loafers for formal wear. However, when you get to 30, you have to say goodbye to any colorful sneaker on this list or anything related to hip-hop. Also, black Chucks look weird on anyone over 30. They make men look like Chuckie.

Flip-flops
(men and women)
Men's toes eh? Men's fucking toes? I just worked 12 hours straight and you're going to ruin my beer by bringing your fucking toes into the bar? Dude, the only time you can kind of defend flip-flops is on the beach in the middle of summer. Personally, I do just fine wearing my sneakers to my towel and then leaving them in the same spot you leave your flip-flops when we go into the water but I'll let it slide this time.
In the city, with the rats and the piss and the potential for violence, flip-flops go way beyond irritating and drift into assault, like farting in a lineup.
As far as the ladies go, we know we torture you with our love of high-heels (oh yeah, you really hate shopping for them and wearing them around town, poor you) but this ain't Saudi Arabia. We don't want you to suffer inside a burqa all summer, so here's the deal: Women can wear flip-flops exactly three days a week. They have to wear heels every big night out, and the time in-between should be filled with something uncriticizable like flats or something from the guy list up top. Doc Martens? Um, sure. Depends on the context but sure.

Sport Sandals
(men and women)
Never acceptable under any circumstance on God's green earth. No man can ever wear these nor can any woman. They are massive deal breakers along with platform flip-flops and those shoes in the opening paragraph. If a girl shows up wearing any of those, end the date immediately. Some (like David Cross) say this is ridiculous and bordering on gay but what the skeptics don't understand is, a woman wearing terrible shoes is indicative of much more serious problems that will inevitably pop up later on. I hereby promise to pay you $1,000 if any girl who wears platform flip-flops has ever heard of Black Flag.
PS: If you're climbing coral right where the waves break, just get your sneakers wet. There are no exceptions to the sport sandal rule.

Open-toed Boots
(women)
Boots were invented, in America at least, to avoid snakebites. You walk around the Wild West from saloon to saloon and even if a snake gets you, it's not going to make it to the skin. That's the roots of boots. When you have your toes hanging out, it negates the whole heritage of the thing. Like when a guy with shorts wears a wool hat. What, your head's cold but your body's hot? Logic has to be at least somewhere in this equation and there is nothing more illogical than open-toed boots. Get them the fuck out of here.

Aging Gracefully
(women)

18-year-old girls look cute in pigtails and knee-highs, and I'm sure they give 18-year-old boys boners the size of Mars. Once you start getting to 25 and up, you have to say goodbye to those forever. Anything remotely Catholic school girly is fucking LAME. If you want to rock a man's world, do high-heels with short socks. It's the nuclear bomb of female artillery and can only be done from 20 to 28, so milk it while you can.

Aging Gracefully
(men)

All right, you went bald. Big whup. Angels go bald too. Why do you have to go and try to trick me now by shaving the whole thing bald? Do you think I can't see the stubble? I can. In fact, I can see exactly where your hair stops and your bald begins. Don't fucking hide it, dude. It makes you look ashamed of your head. Just go, "Fuck it. I'm bald," and let the sides grow out at least a little bit. This is called being a man, and if you weren't raised by a single mother you'd know what I'm talking about.

Short Hair
(women)

Ladies cannot have short hair. As the King of Queens said, "You look like a weird boy." We're not asking women to look like JonBenét 24 hours a day but when you have short hair, you've swung the pendulum so far in the other direction, you're basically a drag king. Oh and here's another thing: When we fuck you short-haired girls from behind, we look down and see Corey Haim taking it up his gay ass. Thanks a lot, bitch — you just made me fuck a dude.

Bicycle Helmets
(men and women but mostly men)

You look like you're scared of life, you fucking pussy. Grow a ball. Helmets are for retards. When I was a kid, we taped our ghetto blasters to the front of our BMXs, blared Mötley Crüe, and crashed. We had no brakes or fucking shoes, for that matter. You are weaker than a 10-year-old me.

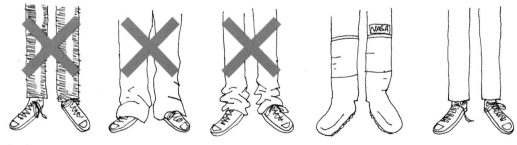

Pants
(men)

Finding a pair of jeans that fits is a bigger bitch than some lady who's mean. The best way to pull this off is to focus on the waist fitting right and then taking them to a tailor to have them tapered relatively close to your leg. Ever see an astronaut's space suit? His pants are always basically equidistant from his leg. Your pants should be about the same.

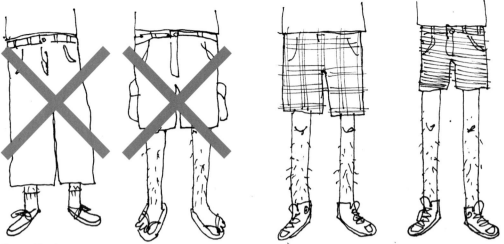

Cargo Shorts
(men)

Men's obsession with long shorts is homophobic. That's right, homophobic. I think what happened is, men went so overboard with the metrosexual grooming and the showing of the toes and the trimming the bag hair and all that, they realized putting on any shorts that go above the knee would turn them into one of the Village People. "Fuck that," they thought. "I'm no fag." So they wore the same shorts dudes wore in 'Nam.

Dudes. Do this: STOP spending all your time grooming and just wear shorts that aren't really just huge, short pants. You don't need all that extra fabric and pockets. You have keys, a phone, a digital camera and a wallet. That's four. The top has four pockets. Stop screaming to the world how gay you aren't. It's gay.

PS: Yes, I wear denim shorts that look like "the Cutters" from the movie *Breaking Away*. Gays don't even wear short shorts anymore. Let's grow a nut and take them back. They're just sitting there.

Glasses
(men)

Why do you have to have such frail frames? They make you look so fragile and delicate, I bet I could break them just by giving you a bear hug. Men should really avoid glasses as much as possible but if you're allergic to contact lenses, get some big-ass nerd frames that show you're not trying to sneak some eyewear past us.

Tattoos
(men and women)

Men can have as many tattoos as they want. Putting them on your neck makes for a lot more pussy in your life but it sure takes a chip out of your relationship with your dad. Everyone in the world has tattoos now, so you can't just grab something off the wall like a tribal Bart Simpson and be on your merry way (that would be kind of awesome, actually). You have to at least put a pube of thought into it. Funny tattoos are great because it adds another level of FTW to the whole thing. I once met a guy who had a tattoo of Hervé Villechaize — get it? Tattoo! Dash Snow had a tattoo of Saddam Hussein's head on a spider's body because he had "Iraqnophobia." How great is that? I'm about to get "Aren't Thou Bored?" from those Randy Macho Man Savage Slim Jim ads on my arm (I know it was "Are Thou Bored?" but "Aren't" implies more of a call to arms and inspires people to party).

With women, things are different. I feel like a Hasid who isn't into bald chicks when I say this but women cannot go as bananas as men when it comes to skin art. They can have no tattoos at all on their legs or anywhere below their waist. Everything from the waist to the neckline is open season but you may not have more than the surface area of two clenched fists - total. After that, you're just starting to look tough, and nobody wants to fuck a tough guy with tits.

Thigh-High Socks With Tights Underneath
(women - doye)

As was said earlier, fashion is heavily linked to sexual attraction, and sexual attraction is obviously linked to sex. Logic and plausibility also play a huge part. When a man sees a woman in a ten-kitten ensemble, he imagines her in his bedroom, taking it off. Thigh-high socks are a bone festival (as are basically all socks) but when we see them on top of tights, we know we'd have to take them off to get the tights off. Then what are we supposed to do, put them back on? Fuck. You wrecked it.

Umbrellas
(men)

In Glasgow, a guy would get his head chopped off for using an umbrella or any rain gear for that matter. They're right.

Socks
(men)

For centuries men have pondered the question, "What the fuck do I do about socks in a heat wave?" This is also known as the "Bobby Sock Conundrum." If you have to wear shorts, you have to wear shorts. Fine. But when you put your shoes on, you are left with very few options.

1- No Socks: Sure, sounds good. You can even add Acme Medicated foot powder in there to stave off the slimy toes but, like love, it's gonna get you, sucka. I've tried the foot powder thing for months but eventually you end up back at square one with your toes sliming around each other like a bunch of wet chocolate tubes. Another bummer with this route is, if you ever have to take your shoes off at someone's house or whatever, your feet look like the ghosts of Christmas Fag.

2- Normal Socks: These are fine when you're 12 but when a grown man walks around with sport socks that go 6 inches up his calves, he feels like a fucking baby. You can get stripes on them and pull them up high like Suicidal Tendencies but that only lasts til you're about 21 or so. Old guys cannot feel comfortable in normal-sized socks.

3- Sockettes: This is the route most men settle on. Just fucking hide some wee sockies in there and pretend like you have no socks on at all. This doesn't work because we can still see the edge of them peeking out there, and it looks like you're trying to trick us. This is the combover of socks, and it's for liars. In the end we are left with one solution: lie. I know I just called someone a liar but that's someone I caught. As the anarcho-punk band Crass used to say, "If you choose to stray from the path that you've been taught, don't expect help and don't get caught." If you have high-tops and wear sockettes underneath them, nobody can see what you're doing. That sock tree just fell in the woods, and it didn't make a sound. Your feet don't slime, and you don't feel like a little kid.

NOTE BIEN: If anyone ever catches you and you say where you heard this, I swear to God I will fucking stab you. If there's one thing we don't tolerate in the world of fashion tips, it's snitches.

HATS

Guys, come on. What the fuck is with all the hats? You've got fedoras on with t-shirts. You've got a wool hat on with shorts. You've got a fucking bowler hat on with a sweatshirt. It's like you can't leave the house without sticking something uncomfortable on your head.

Baseball Hat
(men)

If you really need to wear a hat (Why do you need to wear a hat by the way? They're like sunglasses or pickup trucks: You actually need them about one hundredth of the time people use them), you can wear a baseball hat, I guess. It shouldn't be one of those super oversized ones, and you can't bend the fucking peak on a small one like your face is hiding in the Holland tunnel but it's hard to argue about something as all American as the baseball hat. Trucker hats don't count. They got ruined by the media.

Fedora
(men)

If you want to wear a fedora the answer is most likely going to be no. If you've got on a suit and a trench coat and you're carrying a briefcase, then fine, put a fedora on the top. This is called dressing formal. You can't be all casual'd out with a fucking fedora on your head. It's like wearing a bow tie with a t-shirt. You're either dressed formal or dressed casual. To mix and match is to wear ski boots with your shirt off. Oh, and here's a wild notion: Try to get one that fits your fucking head.

Wool Hats
(men and women)

You can only wear a wool hat if it's cold enough to be wearing a jacket too. I know you hate how your hair is curly and you think it looks cool when it's been sitting in a hat all day but the point is, I know that. Dig? If I know what you're doing, everyone does, and we're all looking at a guy walk down the street with a hair salon on his head. Oh, and why does it have to be all floppy? You look like a Smurf.
After that, the only hat thing that doesn't intrude upon other people's happiness would be some kind of fishing hat (like the Supreme / Budweiser one) while you're partying your ass off on a lake. Stop being so ashamed of your head.

BEARDS

Facial hair is encouraged in men but not women. If you are a woman, you need to bleach your moustache unless it's so big you look like Captain Kangaroo after you bleach it, in which case you have to get it lasered. Sorry.

Shaving was invented to make men look younger so when you do it a lot, it makes you look like you're trying to look younger. A moustache all by itself is great, and as far as beards go, you can (almost) do whatever you like. A big, huge, bushy one is good but you can also do a scruffy, little, stubble thing. The only exceptions are...

Chin Beard

This is out, unless you're in the band Anthrax, which is one guy, and that's not you, so no chin beards. You look like a weird monk or someone who passed out in a big bowl of beard.

Just For Men Beard

I don't care if you want to do sculpting with your facial hair. I made a prosthetic chin with mine. Just don't make the lines so perfect you look like the picture on a box of beard dye. All you have to do to pull this off is fuck with the gradation on the blade guard and use the lowest setting possible where the beard edge meets the bare skin. You should also never use a razor for the skin part. Too intense. Use guardless clippers. You get less zits that way.

Goatee

These were ruined in the 90s by fat guys who wanted to create a face. The only person that is still allowed to wear one is Tom Green.

General Scruff

If you can just let shit grow on your face and you don't need to fuck with it, you are a lucky bastard and, most likely, colored. If you don't have a chin but still let shit go willy nilly, you should know you are actually emphasizing your faults and turning your head into a fuzzy worm with a hole randomly cut in it for the mouth.

Homosexuality

The idea of metrosexuality is fucking ridiculous. Not only is it shitty to waste your time over grooming, women don't even want you to do it. Gays may encourage it in other gays, and that's none of our beeswax but as far as straights go, stop your preening!

However, when something is not gay but you fear it may be interpreted as such, you need to grow the fuck up and carry on with your day. Who gives a shit if someone thinks you're a fag? What's the matter with being a fag? If cars go by yelling "HOMO!" at something like skinny yellow jeans, small shorts, a big moustache, a pink hat, jewelry, or anything that is not actually gay, you need to suck it up and yell back, "SUCK IT!"

Piercings
(men and women)

Are we done with these fucking things yet? Have we not all seen the cavernous holes they inevitably leave behind? Surely the floppy, Snoopy ears left after someone removes their giant cork discs has taught future generations this fad has more cons than pros. If it hasn't and there is even one person left piercing his face, you look like you were molested. Stop.

Black Socks
(men)

If you think you can pull these off with shorts you are fucking naïve. 50s dads rode this train so hard, it gave birth to the term Ugly American. The only way you can rock dad socks is to have pants on. End of story.

Black Socks
(women)

This is a dangerous and crazy field of mind control that only Italian women seem to have full control of. Black socks that go, say, halfway up a woman's shin and into heels or boots are a heavy fucking trip and can actually cause epileptic dicks to have boner seizures. Women wearing dad socks is a scary, wonderful place that is bordering on witchcraft.

Scarves
(men)

One of the reasons Paris didn't even make it to one page of this book is men's obsession with scarves. Like perfume, scarves on men is something everyone in the world agrees is lame. You look like such a little pussy in that thing, and the fact you think it makes you look like an intellectual who spends all day arguing about politics in cafés makes punching you feel like child abuse.

Air Flight
(men and women)

I'm not sure when flying across the country became a sleepover but the number of grown men in their jammies is getting fucking scary. Why does everyone need to be in track pants and slippers to sit on a fucking plane? Maybe it's because I'm usually carrying drugs on me but I always have a collared shirt on during air travel and my pants are always real pants, with pockets and everything. In the 50s everyone looked like they were at a wedding when they got on a plane. We're not saying shit has to be that intense but dial it back a bit, motherfuckers. Please! There's a teenager over there sleeping on the fucking floor!

Your Look
(men and women)

When a mod finds the perfect pair of cowboy boots, he has to bite his tongue and accept that they can't be a part of his life. I don't care if they're perfect Lemmy biker boots that fit him like a foot glove. He's

a mod. They don't wear those. Now, if he wants to stop dressing like a skinny British nerd, that's fine but you can only do a look overhaul like that once a year.

You need to decide what your general parameters are and only buy shit that conforms to those. This especially applies to straight males. You can't be 1920s English professor one day and then Nu Rave it up the next day. Focus on something like homeless aristocrat, deadbeat dad from Venice Beach, Orphan from the *Warriors*, or sexy young man from *Over the Edge,* and stay there until further notice.

As far as ladies go, you guys seem to have everything under control. From the rich hippie thing to the Guinness heiress, Ramones groupie, cunty fashion editor, Parisian dick tease, naïve schoolgirl, pocahipster, and even the nerdy slut, we are in awe of all your focused looks and would appreciate it if you just keep doing what you're doing.

Crazy Tees

― NOT AFTER 30 ―

(men)

Thirty is a tough age for men. Where women simply have to give up looking too cute, men have to give up showing any kind of juvenile traits whatsoever. Just as they're learning to say goodbye to heavy drugs and staying out all night, they have incredibly colorful tees with huge bright prints taken away from them. Same with yellow pants. Gone. Look, I know this is a heartbreaker but youth fashion is about youth. You can't have a gold fanny pack and a bald spot at the same time.

At 30, the only way to show flair is with a colorful bow tie or an ascot. You can have a white suit or even a seersucker but you're no longer allowed to tell the world who your favorite band is. They no longer care. That means your t-shirt cannot say anything at all. Not even "Miami." (Rockers NYC do manage to ignore this rule and pull it off, and the world is yet to figure out how they do it.)

Your hat can't tell anyone what you're feeling either. You can't wear badges or pins that say anything. Basically, your life should closely resemble the women of Islam — only, unlike them, you had your fun. Life after 30 is about getting an actual life and thinking about a family and a career. If the previous 15 years of wild oat sowing didn't cut it, you are a hopeless case who should have been aborted.

The FTW Stage

(men and women but mostly men)

The opposite of the "crazy tees after 30" rule is that irritating phase in college when guys are getting too much pussy and decide to just dress out of the garbage.

It only matters what you wear from, like, 14 to 30. I mean, after 30 there are still rules but it's all about restraint and growing old gracefully. "Showtime" is the 15 party years God made you hangover-proof and horny as fuck. To throw it away is to drive a gold-plated Porsche off a cliff and into a huge crowd of starving Ethiopians on fire. Live a little, you fucking ingrates. Don't let them say, "Youth is wasted on the young." I sure as hell didn't.

OK, I get it. It's rainy season. Jesus Christ, get over yourself.

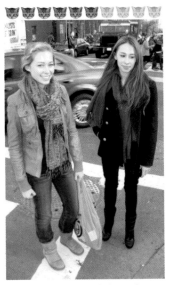

Just when we were considering getting a boner from your weirdly elevated Jetson snow boots, the Uggs come along like a long conversation about child abuse.

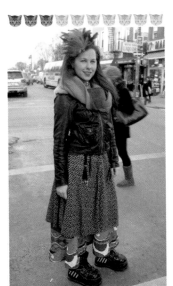

Sometimes the easiest way to get out of a relationship is to make his eyes barf.

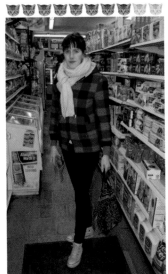

Hot girls who were raised on farms never knew how hot they were, so they end up with the personality of a fat chick.

PS: That's a good band name, eh? Hot Girls Raised on Farms.

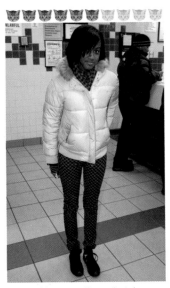

That would be a gyp if you adopted a starving African, fed her fast food her whole life, and she still looked like this.

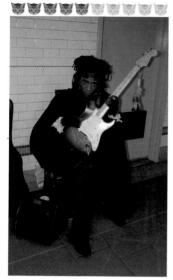

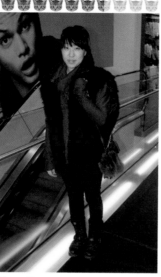

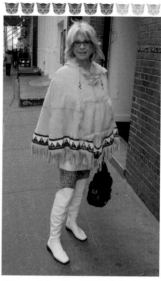

If Jimi Hendrix was never born, 346,940 less white chicks would have fucked a black guy.

If anarchists were rich and enjoyed shopping, a lot more people would be willing to join the movement.

Not sure she's a Mom I'd Like to Fuck particularly but she's certainly a lot of fun for her age. She's a MWLFHA.

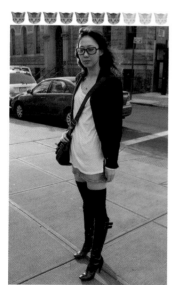

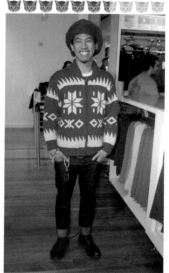

This looks like an algebra tutor got a slut transplant.

The new face of the Taliban is a face of joy, excitement, and love of our Western ways. They're still waging Jihad and they still think Allah is great but the only thing they're ever going to blow up is your spot.

That ice cream is a lot like my cock because it's a moment on the lips, a lifetime in the hips.

Did you ever look at a Rottweiler's ass with sunglasses and think, "That reminds me of someone," and it bugs you for the rest of the night?

Then a month later, you're like, "That's it! Wilford motherfucking Brimley!"

What's easier, seducing this girl and making her punk or just getting a smart, funny, punk chick and not being so picky?

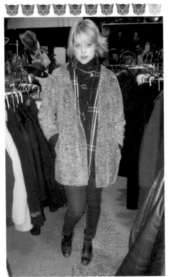

Whoa, the silicon chip in *my* head just switched to overload. Wait, did I already say that?

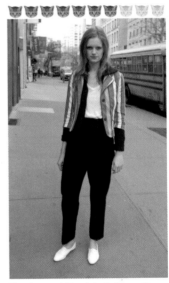

If you've spent the winter in the smelly bed of a chubby earth goddess, it feels good to come out of hibernation into the arms of an androgynous CBGB photo from the 70s.

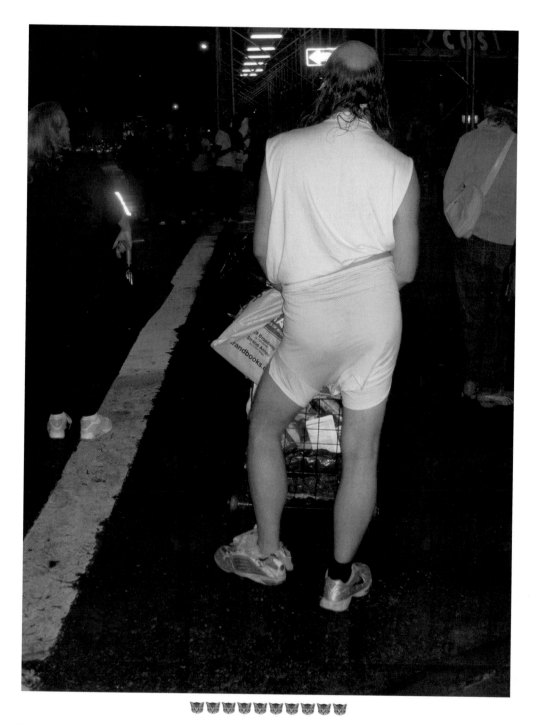

If you're going to wear a T-shirt as pants, you need to own it.

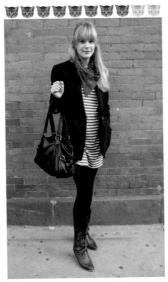

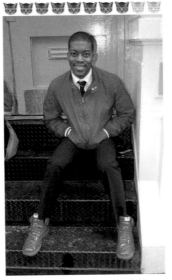

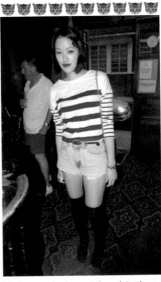

Dear fat, Jewish moms with OK legs, When you try to pull off shit like this, you look like a Tweedledee.

This guy is like the opposite of arthritis.

You know you've been at the pub too long when a mirage asks you if you'd fancy a pint.

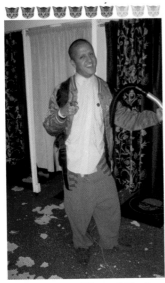

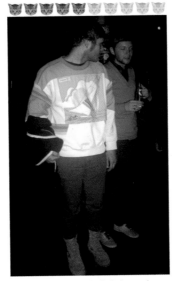

This looks like one of those weird immigrant dudes who moves here and is way crazier than any crazy Westerner until you're like, "What the **fuck** did people think of him back in Turkey?

There are no atheists in foxholes, and there were even fewer hipsters in Desert Storm.

You know you're into MILFs when you devote your whole life to convincingly karaoking "Sweet Caroline."

I thought dental dams were bullshit until I saw this decapitated condom head backstage at a Billy Bragg concert. No, I am not joking.

These two spend way too much time talking about what their kid's name would be.

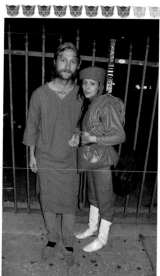

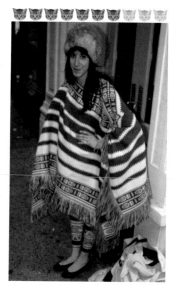

You know when you see a teddy bear some kid doesn't care about anymore and you feel a pang of sympathy? That's how I feel about turntables these days.

This is like the end of *Rocky Horror* but instead of taking Frankenfurter back to Transylvania, they're taking him to Berlin.

This is enough to make you pissed off at cave people for being so lame about their shit. Loincloths? Seriously?

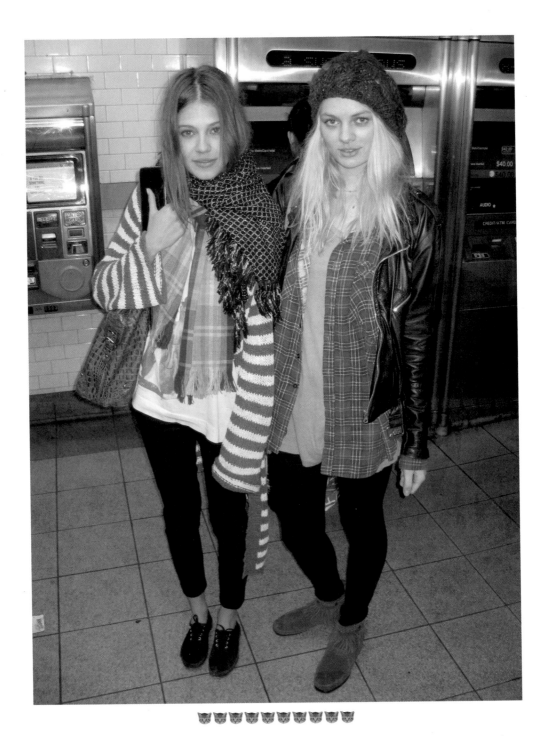

The only way you're going to get these girls to come home with you is to be really rich or in MSTRKRFT or gay. The first two are not happening anytime soon, so just relax your asshole and let's get started.

I might be remembering it wrong but I think this guy got kicked out of the bar for being super wasted and then managed to sneak back in by changing his hairdo slightly and wearing nerdy glasses. Maybe that Clark Kent disguise isn't so implausible after all.

After you get married, you meet nice girls like this and as they talk all you can think is, "Wow, I'm not allowed to fuck you or anyone else ever again."

Whoa, that was close! Those were ALMOST brown nylons, and I was almost outta here.

Finding a weirdo in a shitty town like Atlanta is so rare, a huge boulder comes rolling through the bar when you pick her up and all these Aztec dudes start blowing poisonous darts that get stuck in your big fedora. RUN!

You don't get presentation like this in a city where the males outnumber the females. Thanks, God!

It was a great episode of *Beavis & Butt Head* but unless your monoamine oxidase system is inhibited, the tryptamines from the toad's skin can't be orally active (yes, I've looked into it).

So I go to my buddy, "Who the fuck do you think you are, Captain Pussyhound?" and then we hear this voice behind us go, "Actually, I'M Captain Pussyhound," and I was like, "Holy Shit, that just came off the dome! I didn't know it was an actual guy," but he didn't hear me because he was already getting laid.

Dance like a latchkey child. That is, dance like nobody's ever been watching.

Black Rocker sounds like: a hot rod part, an awesome strain of speed, a foolproof fingering technique, and the most spectacular firework in the world.

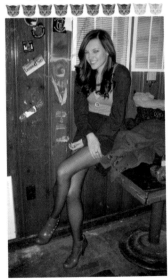

This is the last thing you see before you die if you beat yourself off to death.

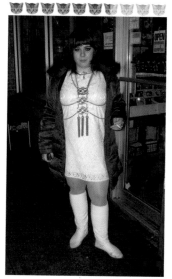

This is what you get when Victorian England meets an Irish Go-go girl at a New York Giants tailgate party: good times.

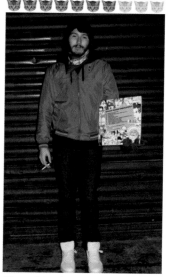

Why can't terrorists do fun shit like hold a gun to this guy's head and give him three minutes to convince a farmer why Hot Chip has no place on ANY Kitsuné Music comp?

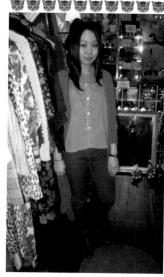

Girls who work in used clothing stores always look like someone you forgot was on *Pee Wee's Playhouse*.

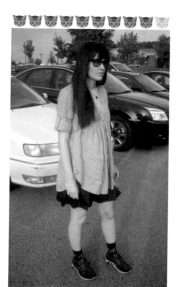

As I was barfing I looked down and saw I had an erection. Huh? What does he see that I don't?

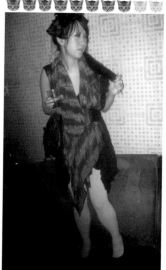

Colored tights say, "Look at my legs," which is kind of hard for us to do when we're crying tears of joy.

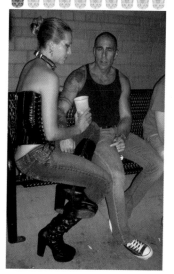

Did you know the average IQ in America is 100? Trust me, you don't know anyone with a 100 IQ. It's like what kids have.

If you want to get a great apartment in Manhattan with a beautiful view, buy some fancy wallpaper, rent some storage space, shower at your girlfriend's place, and shit in a bucket.

If Joan Jett was a J.A.P., I'd jack off and jizz on her jaw.

This girl is so classy I wouldn't be surprised if her queefs wear bow ties.

The problem with getting to the President of What-Ever is, when you finally meet him, the guy is so over your questions the whole quest is for naught.

He Japanese-maple-leafs New York.

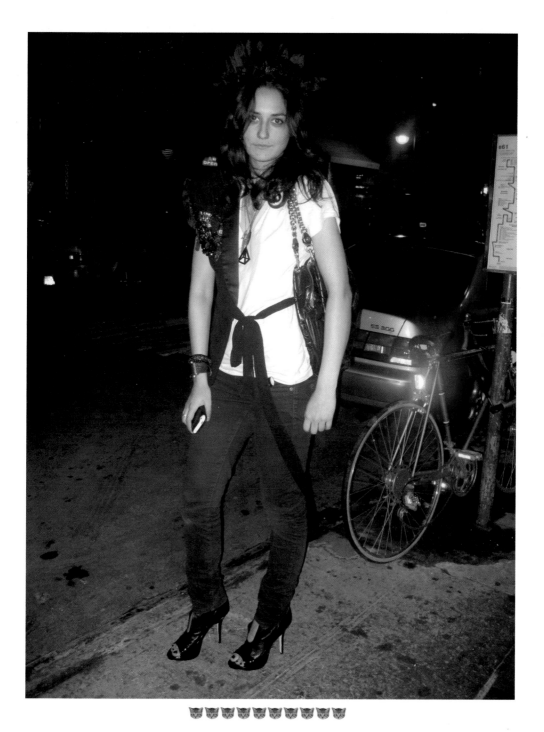

If you read this outfit in list form you'd say, "Sounds like a ceremonial chief from some tribe of cannibals," but when you actually see it with your own eyes you're like, "Eat me. Seriously. Fucking please eat me."

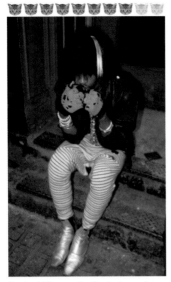

In about 11 years, the black glam rocker, Addams Family, aristocratic Warhol child in drop crotch pajama pants look is going to be so last year.

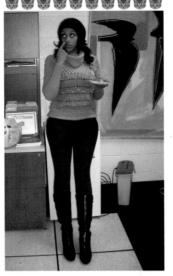

Petite girls are fun to fuck but when you're seen in public with them you feel like a small-dicked pedophile. For the long term, you have to go with a real deal Russ Meyers type, no matter how uncouth.

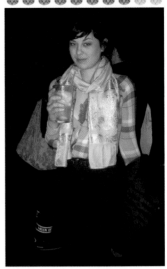

Tattoos on pretty girls' chests always reminds me of that Woody Allen movie where his sister goes, "He went to the bathroom on me."

This is a great way to avoid sexual harassment in the workplace.

I didn't know you could scream the answer to "Are you ready yet?" without opening your mouth.

Clothing store girls are some of the most all-dressed-up-with-no-place-to-go people you will ever meet.

If you don't have a chin and you're trying to make it in Hollywood, know that you will have to say yes to absolutely everything they suggest.

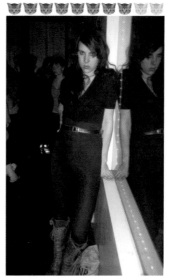

When you see a complete fucking mess, all you can think about is messing around with her, completely.

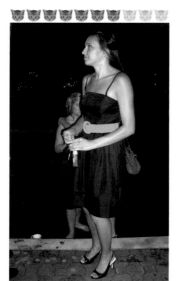

There is no creature who is more mysterious and alluring than the "Normal Girl." We know so little about them, and the little we do know has never been confirmed.

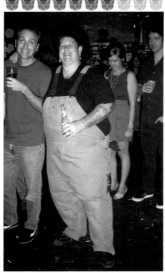

OK, maybe there is an exception to the "all women should wear heels" rule.

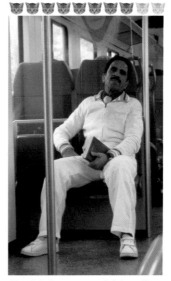

It's weird when you see a dad that still cares about how he looks. Not bad necessarily, just … weird.

When your neighbors are famous and they're making too much noise, you have to put your foot down and just go, "Look, either let me hang out with you or I'm calling the cops."

If you're going to do a lot of time travelling this summer, this look is as at home in 1949 as it is in 2049.

When you're nervous to meet your girlfriend's ex-boyfriend and he's this, you start to wonder if you're out of her league.

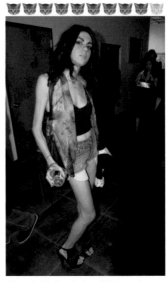

It's probably time to lay off the powder and straw when every girl you talk to starts staring back like this.

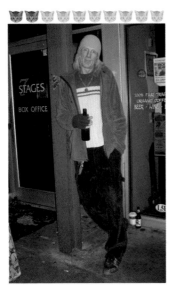

Few people know the first wave of grunge rave actually happened in the 60s.

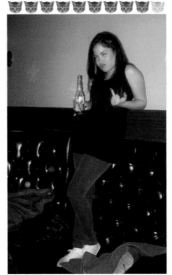

A cute bitch with a beer in her hand — I think that's what I'm going to order for my last meal.

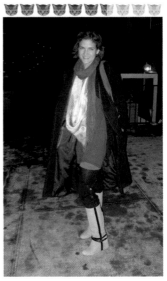

You can tell everything below the knees is the teacher's pet because she hasn't so much as looked at her upper half.

Wigs are as boiling as most big hats but that doesn't mean you have to stay bald. Just take your shirt off and air out your torso a bit.

Wealthy, clean ladies dressing up as L.E.S. dirtbags is like doing Oxy and Adderall instead of heroin and coke — that is to say, all the good without the bad.

When middle class kids get tons of tattoos, they end up attracting a level of blue collar scumbag they have nothing in common with and the end result is one guy trying to dumb down his vocabulary while the other wonders what the fuck *The Onion* is.

Metal geeks and gay geeks are hilarious but there's something extra special about seeing geeks invade the Devendra Banhart scene.

Hey, look! It's the ghost of bummers past.

"Pssst. You're over 30."

Before you let the person next to you "tsk" for buzzing the stewardess to ask for more booze, show them the icon that lights up every time you push the button.

As your guidance counselor, I have to say, you just might be boring enough to become a teacher.

Pink Chucks are to the party what Adderall is to the hangover.

It's sad to see all that "Kick Out the Jams" work presented in such a "Just Me" way.

These two are exactly like the paintings at the Louvre: beautiful and boring.

My taint turned green with envy when he saw the attention her Blackberry was getting.

I love catching inanimate objects right after they've been fucking, and they're all pretending I didn't see what I just saw, and she's got cake all over her elbows, and he's got that shit-eating grin on his plastic face because he thinks it's kind of funny.

The only thing harder than choosing between blondes and brunettes is getting the kind of life where you have to choose between blondes and brunettes.

Though their intellects are nothing to write home about and the accent is an unphrodisiac, New York chicks are some of the funnest, ballsiest, and horniest human beings ever to come out of an ethnically ambiguous cunt.

When grunge hit the Midwest, boners hit the deck.

Yet another guy going for the eccentric old-timey thing and forgetting he has on cyber sneakers from the future.

We always make fun of pretty boys but shit, if you have the face of a hot 15-year-old girl that just got fucked, what are you supposed to do, become a cop? Shut up and let this guy be beautiful. And leave his weird, sleepy, Mexican, black friend alone too.

People think Ewoks are cool but try being punk in that community. Even your closest family members will act like you don't exist and, within no time, you're asked to leave the forest.

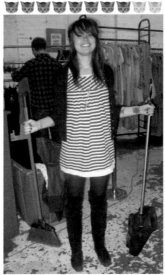

Is it just me, or did the name "Puss in Boots" always make you kind of horny?

Arranged marriages get a bad rap in Middle Eastern indie films but, sorry, it must fucking rule to be presented with a perfect eight who has to serve your every need for the rest of her life.

Tucking baggy jeans into your socks is like being a Marine because it's bold, proud, exciting, unique, innovative, daring, and shows independence.

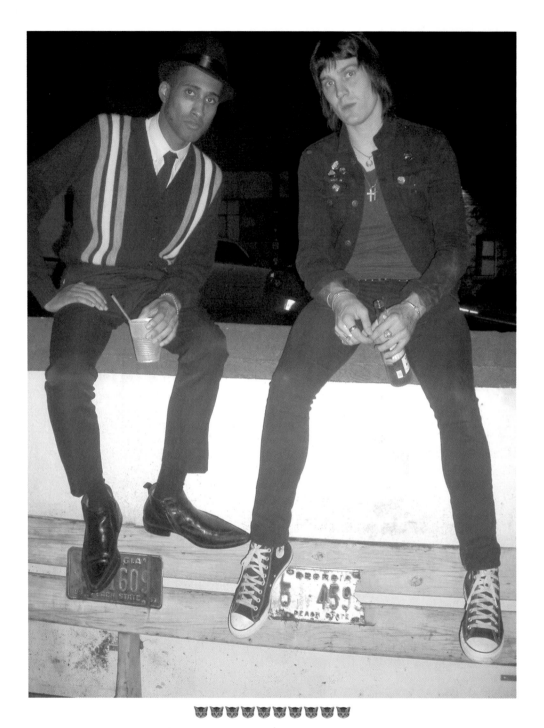

It took about half a century but now that mods and rockers are done fighting, we can finally see how breathtakingly gorgeous they are.

One of the reasons we didn't include t-shirt sizes in the Rules section is because even XL can be pulled off if the race is advanced enough.

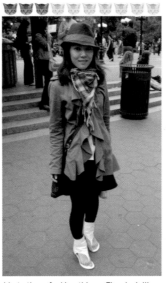

I hate these fucking things. They look like someone blew her socks off.

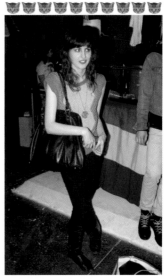

This girl gives being flaccid a bad name.

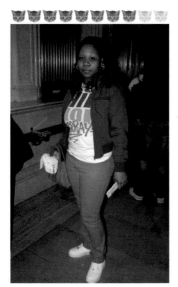

Hey serious face, why don't you take a page out of the rest of your book and cheer up a bit?

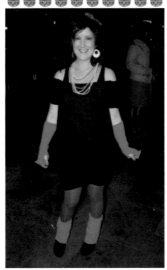

Whoa, whoa, not that much. Take it down a notch.

Two things I don't see here are: a bra and a problem with that.

This is the kind of thing you think is going to be way better than it actually turns out to be. Sort of like when teachers give inner city kids cameras and then have a photo show.

Most people have no clue how fucking exhausting it is to mince.

This is what grunge would look like if it was rich.

It's downright spooky how much pet owners end up looking like their pets.

I'm not sure how I feel about 18th century poetry slam swashbucklers but you have to admit she kind of nailed it.

The only thing scarier than running into a black guy on drugs in the middle of the night is running into a white guy on booze.

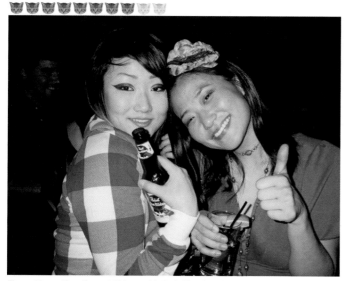

The problem with eating out Chinese girls is, half an hour later, you're horny again.

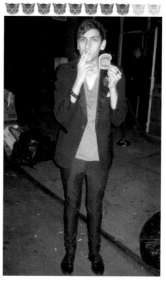

That suit is great but when you stick a wool hat on the top, you become a pallbearer at Jacques Cousteau's funeral.

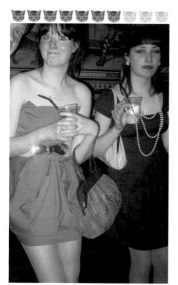

Dating a girl with a hot friend is sort of like having crabs: It annoys your dick.

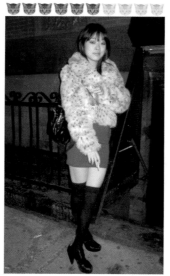

Hey lady, someone stuck your head on a Russian prostitute.

Very few women have the balls to go for the stoned-crying-allergies look.

If you hate eights and want to grow old without chicks all up in your grill, do not live in a party loft.

This was the last picture taken of Arnell before he relaxed himself to death.

Now I know why the French call candies Good Goods.

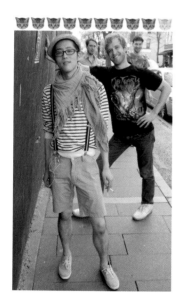

It sucks when you finally get the style recognition you deserve and some asshole steals your thunder at the last second.

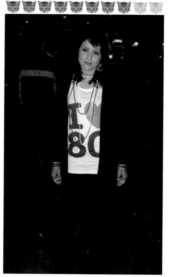

Me too. Especially those girls in the ZZ Top videos. That was the best women have ever been.

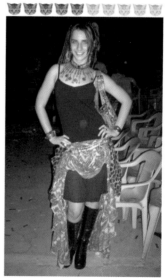

The only way this could work is if she was a militant Republican pro MMA fighter.

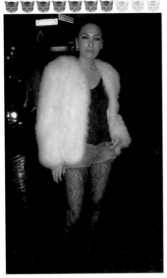

Dear women, please stop putting your hair up all the time. It's a facial TMI.

To wear a shirt without a collar is to go backwards in the evolution of the shirt. It's basically creationist.

Did you ever have a cool babysitter? She'd have a friend over, and they'd be listening to records, and you're like, "I cannot fucking WAIT to be older."

"Holy fuck, I just had the most brilliant idea."

You had me at black leather Mets hat but returning to the pit with broken legs has sealed the deal for life.

See how easy it is, bitches?

Are these fucking guys using party balloons to do nitrous!? That's like getting a unicorn to talk to teens about breast cancer.

After he killed someone in prison, they tried to cover it up and — just kidding! The only cover-up going on here is the star or the rose or whatever's beneath that ridiculous blob.

Do you want me this Asian, or should I tone it down a bit like this?

I don't mind if women get in shape by stretching (that's all yoga is, and you know it). That's kind of hot, actually. But dudes? Purple dudes?

Overalls are as hard to pull off as they are to pull off.

"How you gonna hate on a moustache, huh? Without it, I'm just a little guy standing here in a yellow shirt. Gimme a break."

As kids, we used to think saying, "Your mother wears army boots," meant she wasn't the kind of girl who turned your heart into a melted crayon someone left on the backseat of a car in July.

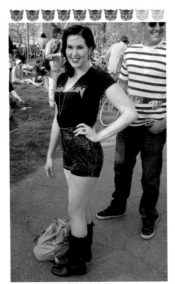

She looks like a professional groupie but without the pathetic, sad, fucked-by-my-dad part.

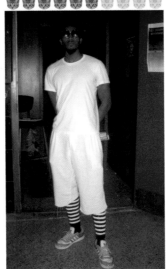

"When I grow up, I want to look like a rodeo clown who washes dishes."

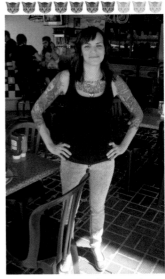

Thank God it's never too hot to wear long sleeves during Thanksgiving.

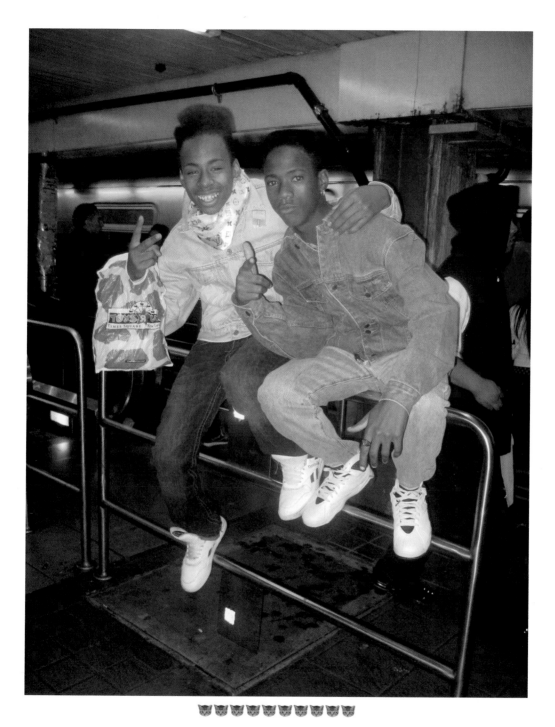

Once again, kids go back in time and redo something better than it was done in the first place.

Foie gras haggis is fancy and gross. Kind of like fucking Stella McCartney.

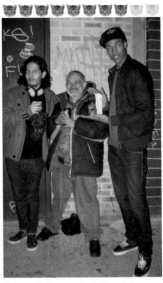

Only one in three males bothers to keep his foreskin clean though it's almost impossible to predict which one.

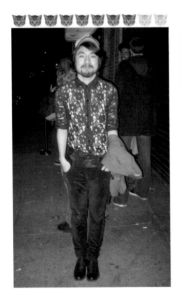

OK, so we're going to assume you don't care about the "less masculine" stereotype, and you're just owning it, right?

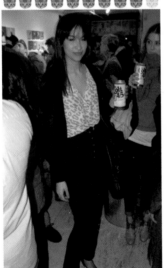

You know a girl's hot when all you want to do is get to know her mailman, so you can eventualy put her bills on your face and know a plastic window is all that separates your nose from her name.

I like how some pictures get mad at their captions but when I ask them to come up with something better they're like, "Ummm."

You know what really burns my ass? When you're jumping over a fire in the nude and some asshole thinks it would be funny to clothesline you in midair.

I've never wanted to smell potpourri more in my life.

Sneakers with a suit is for class clowns on prom night but somehow this guy did it.

Hey, are those high-heeled Doc Martens in the background? Move lady!

Enough with the fucking wool hats already. What is so great about being itchy?

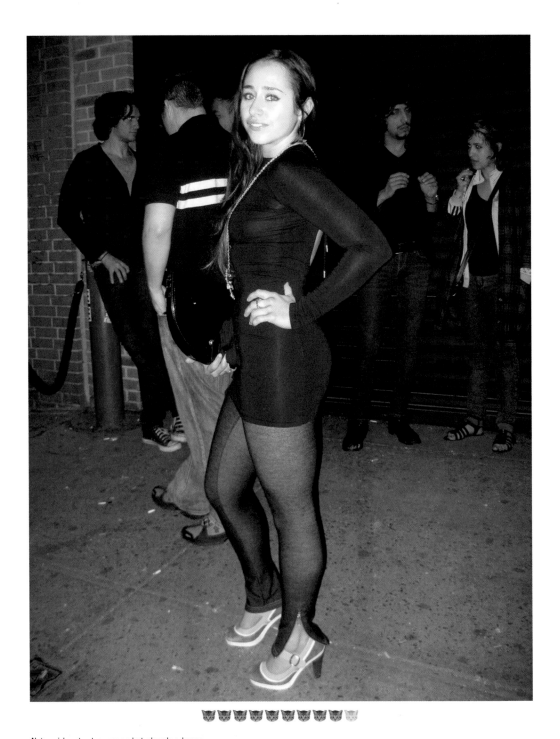

Not a girl, not yet a woman but already a boner.

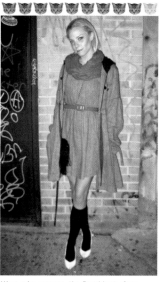

Nobody knows why black socks are such a fucking boner machine (especially when emphasized with white heels). Some think it's because you're taking something that's reserved for gross dads and flipping it. It's a dangerous game to play and one wrong move with the rest of her outfit could blow everything. Let's see if she did it ...

Wow, who are you, the President of my head?

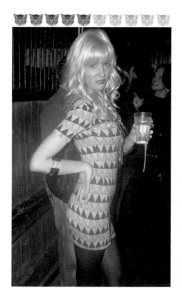

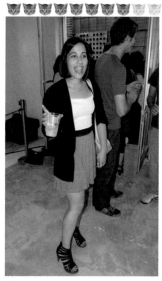

This is the kind of woman your dad gets mad at you for not being into.

Fun nights are magical fairies that will disappear if you try to capture them. They will come to you when you least expect it, so just close your eyes and let it happen.

After three drinks, a woman is pleasant. After four, she's annoying. And after five she's someone else's problem.

Photo by Last Night's Party. Text by Gavin McInnes

For the record, all of these pics were taken at the same party. You see what I've been screaming about?

WHAT ABOUT NEW YORK?
An Interview With Nightlife Blog Last Night's Party

New York, LA, London, or Montreal?
I love New York because it's non-stop action. Every city I go to people are always, "Hey, check us out. See? We have wild parties too" but it's usually a Friday or Saturday blowout. In NYC you can see the sunrise seven days in a row.

LA has some merit though, no? What's good about LA?
Some of my craziest times in LA happen during the day. I feel like the nightlife in LA is just one big casting call (in a good way, for me at least). I usually go to a party there at night and meet the people I will be doing stuff with during the next day. In NYC, I'm just waiting for the sun to drop before I do anything. Ideally, I'd spend my days in LA and my nights in New York, if I really didn't want to EVER sleep.

You're originally Canadian though, like me. What about the homeland? What about Montreal?
Montreal is filled with every remotely pretty girl in Quebec who thought she could be a model in "the big city." It's great when you're in the middle of it and it makes guys learn French real fast.

Is this your full-time job?
I work part-time in the Divided Red & Hennes Gold sections at H&M on 34th Street. Sometimes they station me in the fitting room. Come see me. I work Tuesday to Thursday.

I remember you said you hate fake party shots. That happens? People come up to you pretending they're having a wild time?
All the time. Especially when I leave New York. People have their "party face" looks everywhere I go. They'll be sitting there all sullen and depressed, then explode into life for the photo, then slump back down. It's so absurd that sometimes I actually break down laughing. I also get girls saying, "I wanna be naked in a bathroom. My boyfriend says it's OK" and even shit like, "My girlfriends are all between 18 and 21. Can we pose for photos in your hotel shower?"

Are you in a relationship? Is such a thing possible with a job like this?
I'm in many relationships, but the day I have a committed relationship, LNP is basically over. Then again, U2 said they'd stop when they started sucking.

What was with the wig?
I love that guys with tattoos all over their bodies or girls with piercings in all sorts of places, look at boys who wear wigs and say, "Hey, why do you do that?"

What's the worst popular fashion trend right now? Personally, I'd go with open-toed boots.
A girl can wear whatever she wants if she's really, really fun. One thing doing a lot of photo shoots taught me is every fashion mistake is always a tiny adjustment away from being a great look.

Is there a particular thing that girls wear that just kills you? High heels with short socks or dirty old t-shirts or something?
A tall, skinny, brunette with a beautiful face, wearing Marc Jacobs anything, big boobs, and an open schedule to hang out all night usually gets my attention.

What's the worst faux pas men make today?
Um, let's see. Fedoras, which I blame on Justin Timberlake, and talking about sneakers like anybody gives a shit. Oh yeah, and guys with girls who are way out of their league, yet treat them like accessories. You ain't fooling anybody.

You can usually tell how confident someone is by the number of trinkets they rely on.

Though punk rock and bikers may have had some influence, the real reason black leather is so popular in New York is everything is fucking filthy.

Photo by Last Night's Party. Text by Gavin McInnes

If this happens next to you, the best way to keep your cool is to bite huge holes into your lip and dig your fingers so hard into your leg that they come out the other side.

I was wondering what was going to come after all that boring feminist "No Means No" shit.

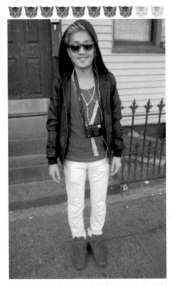

I *never* fantasize about fucking men but if I *did*, it would include spotlessly fashionable young ones like this.

Long hair says, "I was born with two X chromosomes and I love them both equally," where short hair just says, "Fuck this life."

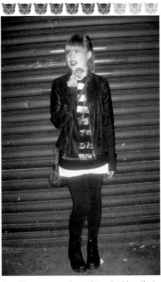

Doc Martens are about the only thing that look equally good on Nazi skinheads and tomboy tweens.

I swear to God people are going to look back on these boots the way they look back at the war in Vietnam.

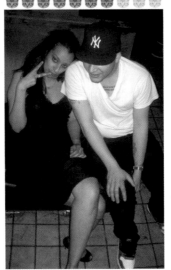

Did you ever meet up with an old college buddy and realize you must have been wasted the whole time you knew him because he's a total moron you have nothing in common with? I bet there are entire relationships like that.

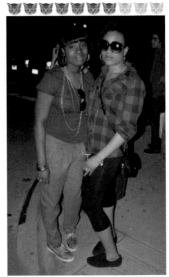

Am I the only one getting mad Tuesday night vibes off of this?

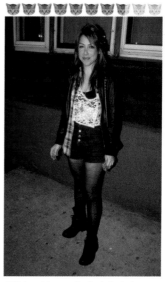

If there's one thing petty Brooklyn thieves care about, it's some stranger's faith in humanity. Is she going for a naïve world record?

A high waist converts short shorts from stupid video ho to libidinous film student.

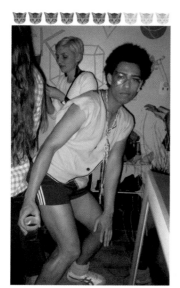

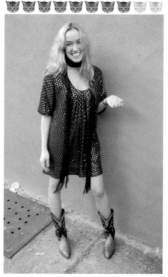

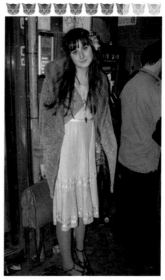

Awesome at a party. Not so fantastic going home alone, on the subway, at six in the morning.

When you see a girl's closet, it looks like a pile of useless shit stuffed to the ceiling. Then they stick their body into one of the things, and you go, "Oh."

She looks like a character in a children's story for Adults Only.

Why are so many comedians OK with the part where Charlie Chaplin killed six million Jews? Is it because he was funny?"

WHAT DOES BOB ODENKIRK HAVE TO SAY ABOUT IT?

TWO SAD CLOWNS. ONE FUNNY ONE.

All that "fuck the labels" and "fuck promoters" shit is for pussies. If you really want to be indie you need to take it to the next level and say, "FUCK THE VENUES."

Did you know the origin of the heart shape you see on cards and everything is based on a woman's bent over ass? Well, you do now.

He looks like he stuck his head in a junk drawer.

I've said it before and I'll say it again, there is no way any woman can stay single in this world if she wears these and goes out a lot.

Nothing conveys smart and fun like stupid and boring glasses.

I know, I know. She's really selling that short hair but just think how much better it would be if it was all messy and down to her shoulders. See?

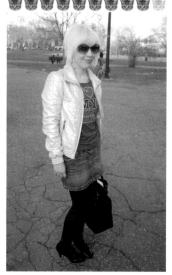

I realize your parents said you can't hang out with her but just lie and say you're sleeping at Jenny's house. They're not going to check.

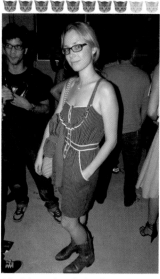

I don't know about Outlaw Country but there's about five days of the month I wish they'd outlaw cunty!

(Sorry lady, you look great. I just had to get that joke into this book.)

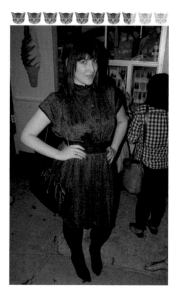

It's funny how you get over sweets right around the same time you start getting into chicks.

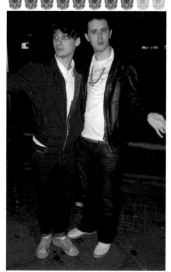

Hey, did either of you see two guys come through here amalgamating the best of about 30 years of British looks?

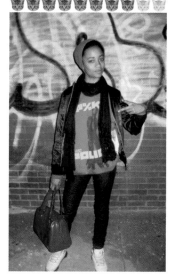

See? THIS is when it makes sense to wear a wool hat. I can't believe I have to tell you shit like this. I feel like your mother chasing you down the street with your snowpants.

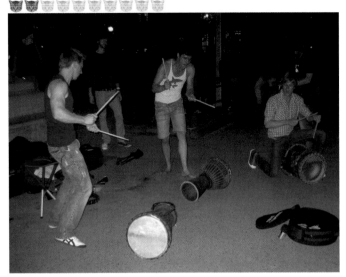

The really amazing thing about bongos is how surprised the guys are when you tell them to shut up and get the fuck out of here. What did they think was going to happen?

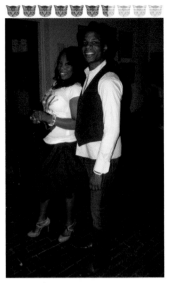

When Bill O'Reilly masturbates, he pretends every black person in America dresses like this.

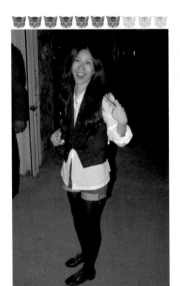

People hate on the pigeon toe pose but look what happens when you don't do that? You look like an action figure.

When you tally the number of potential tens that have been lost to brown nylons, it makes WWII look like the Falklands.

Men like skirts because it subliminally says "easy access." When a guy wears one however, all your subconscious can see is a hairy asshole stretched so wide it looks like a baby yawning.

Can you believe we sent some random black chick to the Middle East and she stopped all the wars there with one spontaneous pose?

It's weird how every single woman who works in fashion is dressed to the nines all day and surrounded by nothing but gays and other women. How is that even legal?

It's going to be kind of tricky getting those leggings off without disturbing your shoes and lace socks but where there's a will there's a way.

If you don't want to be mod or punk or whatever, why not make up your own thing? Like, "Space Boy."

"Hi, I'm a dart board."

If they've beefed up airport security as much as they say they have, why do we still see guys wearing their motherfucking pee pee jam jams on the plane?

I took this photo plastered out of my gourd and was convinced it would be the cover of the book. I guess drunk me is a six-aholic.

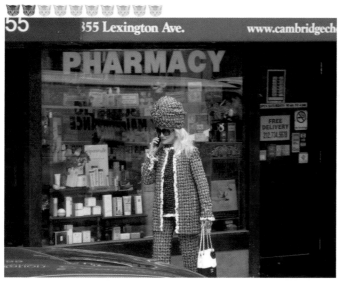

"Hello? Geppetto? Hey, sorry to bother you again but I really get the feeling people think I'm still a puppet. Are you positive this thing worked?"

How could something that sounds as barfy as "sheer leggings" be so totes 'triguing?

Are you a professor at Harvard who teaches Best Friendship?

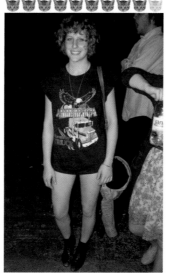

When David Caruso threatened to leave *NYPD Blue* unless they gave him more money they said, "Fine, we don't need you." The same thing is happening to pants.

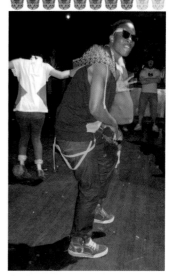

Careful dude, joke dancing is one of those things where if you do it too much, you forget how to real dance. Seriously, joke moves will keep popping up when you don't even want them too. It's like that old wives' tale about your face staying that way.

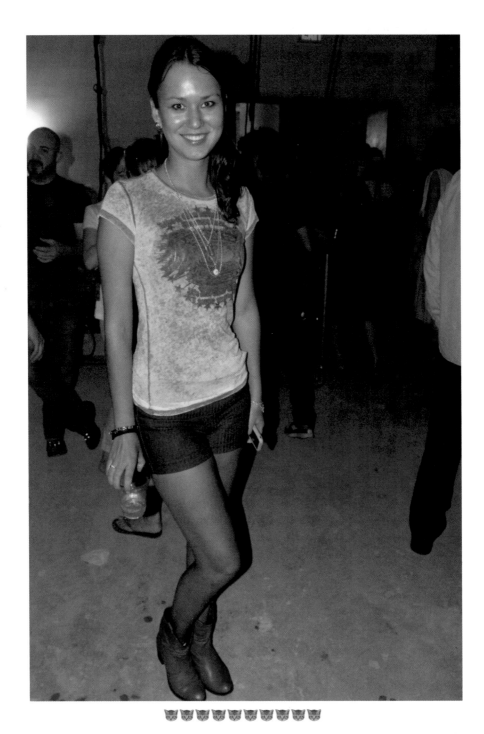

Man, when you put thrift store garbage on God, it really changes the context of the whole thing.

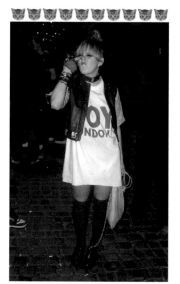



The day they decided all motorbikes had to be these stupid fucking aerodynamic Micronauts was the day douchebags moved in and took over that machine forever.

It's ironic because you need balls to pull off a shirt like this.

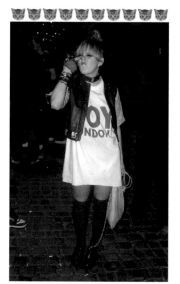

Once again, a kid born in the 80s doing the 80s better than the 80s.

White biker jackets are like white leather Chuck Taylors or albino alligators or white pro basketball players or pearls or the baseball that won the World Series or white gold.

See? You can still be a nine on a lazy Sunday. It doesn't have to be an ultimatum with your inauguration on one side and "break out the sweatpants" on the other.

I would but you can't tit fuck a dude. There isn't enough bun for the dog.

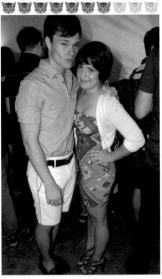

Is he trying to be gorgeous? Dude, men can't be gorgeous. Have you seen a bag?

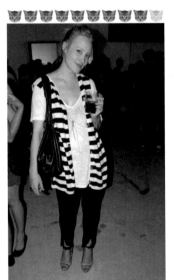

When my penis becomes president, all prison uniforms will look like this.

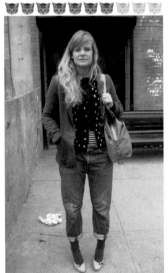

One pair of shoes and a frumpy bookstore clerk becomes a British aristocrat shopping for buildings.

An upturned brim leaves you no other choice but to party. You can't argue about politics or do your taxes with your hat like that.

If you're going to shop til you drop, you need to wear some third world army's military boots. They're used to it.

Canadian girls never wear leggings like this because they know they'll have to take off their shoes at the party and be slapping around the linoleum all floppy and barefoot like a sloppy bummer.

Can you get a bruise or a tattoo or some kind of stain or something? You're reminding me too much of that "nice girl" my grandmother won't shut up about.

What's your beef with this guy? Do you think he's trying to look badass or something? He's having fun and fucking around. You need to hop aboard the Crazy Train, learn how to love, and forget how to hate.

Fuck dude, you can't give us just a little less pant? That suit was almost on some Cassavetes shit but you ruined it.

Red lipstick is the new chastity belt. Not only does it tell you the second she made out with someone but it also identifies the fucking guy.

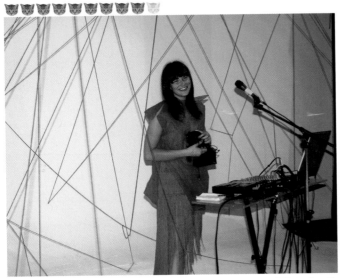

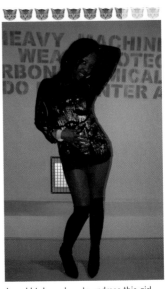

Doesn't every father want his daughter to be an artist when she grows up? She's all pretty and making neat stuff and having a good time stress-free. It's like the opposite of going to beauty school or marrying an alcoholic.

I would take so long to undress this girl, she'd get freaked out, put her socks back on and leave.

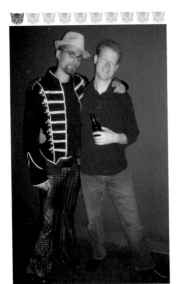

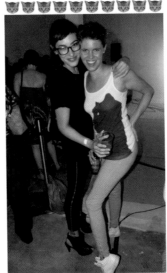

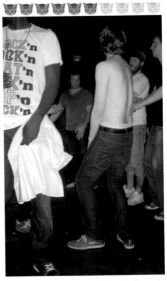

Facebook is great for seeing what your old high school buddies are up to now and saying, "Thank GOD I'm out of touch with those guys."

If you're wondering what you want to convey with your look, "the healthiest, smartest, and funnest two human beings on Earth" is a good place to start.

The shirt distribution at this party has got to be some of the most inequitable shit ever.

She is going to ruin you but you're not a man until you've: had your heart broken, broken a heart, had the shit beaten out of you, and beaten the shit out of someone, so you might as well get the first part over with.

No pedo but when adolescent girls walk around in heels like newborn fawns, it makes your soul exhale cum.

The best part of having a girl sleep over is you can finally look up and see what her face looks like.

Hipsters are always accused of having trust funds but I've met people with trust funds and they are way too busy being fabulous to even know what a hipster is.

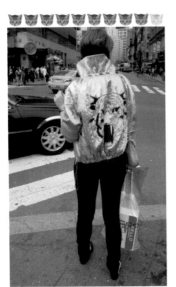

Hey mom, you accidentally rock.

If Puerto Rican girls stopped swearing all the time and moved to France, I would stick a beret on my dick so fast it would make its head spin.

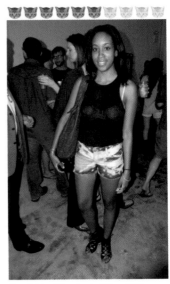

So outside of the shorts, this outfit is pretty lame but what are you supposed to do, give a 9 six kittens? Here goes.

Dogs are a great look if you like looking lonely.

This goes out to all the assholes that said James Taylor doesn't know any hot young black chicks.

The problem with joke shirts is they make you think of the ads for them on blogs, so it looks like you clicked on it.

This is like Nagasaki to the Girls With Short Hair camp.

When normal people try to dress kooky, it is so obvious they're lying, you feel like a parent being told the car dented itself.

If the clothes men like women to wear are so oppressive, why do they wear the shit out of them on Girls' Night Out?

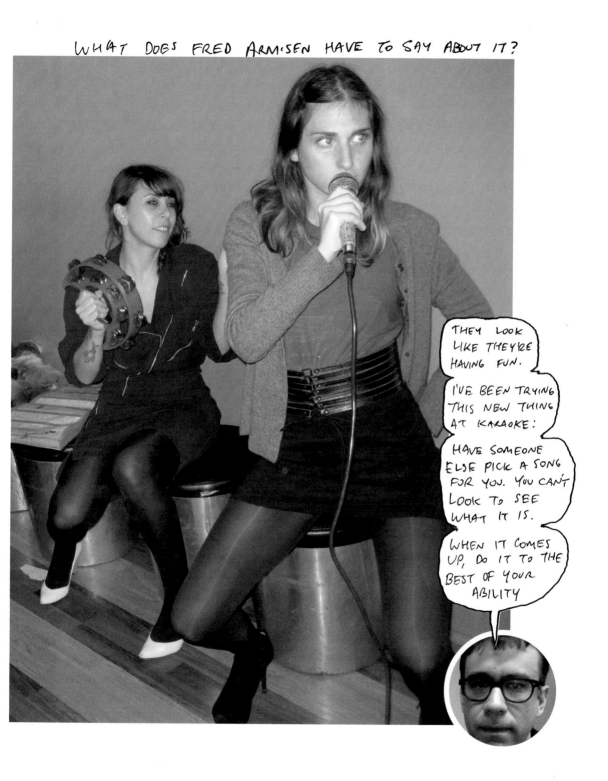

This is the perfect date if you still miss your grandpa like crazy.

You look fine but I think the girl behind you could do with some Preperation H.

She looks like the lawyer for a pajama party.

If this is some African despot's daughter and she's spending all their country's money on clothes, then both "shame on you" and "I love your purse."

Huh? What about your trust fund where your parents put aside several million dollars they didn't need — wait, who the fuck has several million dollars they don't need? Oh yeah, nobody. Where did this stupid trust fund myth even come from?

When I started removing five kittens from a nine because she combined old man shoes with an Erykah Badu shirt and a trench coat vest she said, "You're kidding right?" I feel like a traffic cop. Sorry lady, those are the rules.

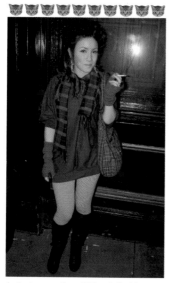

Just when you thought the whole thing couldn't get any better, she made her eyes skies.

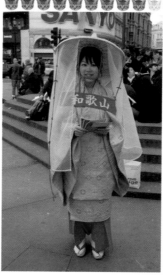

Japan, you are so different than us, it's fucking insane. I think we have more in common with trees or, like, a fish.

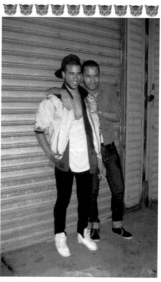

Sometimes it's bad for guys to get laid too much in high school. It makes them soft.

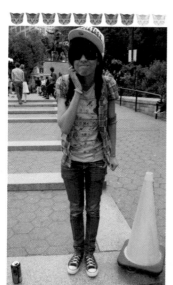

The kid sister look works but if you tell mom I have a BB gun, I am going to put your entire sticker collection in the toilet.

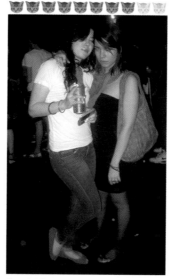

I'm glad Sparks took the caffeine out of their beer. That shit was crazy juice and girls with orange mouths were ticking time bombs.

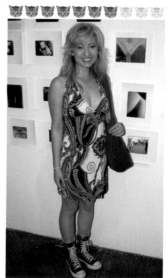

Surrounding yourself with pictures of gay porn is a great way to say, "Hi, what's your name?"

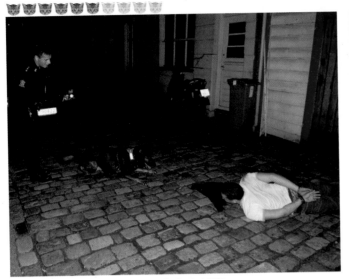

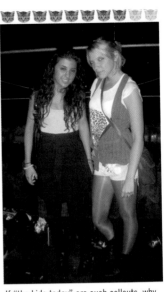

"What kind of dog is that? It's a German shepherd, right?"
Yeah.
"Are they good with kids?"
Well, as with all dogs it depends on the owner.
"Yeah. Makes sense. Hey, do you have a cigarette?"
Uh, hang on. I got so many fucking pockets on this fucking uniform. Gimme a sec.

If "the kids today" are such sellouts, why don't they have any logos on their clothes?

How about that feeling after finally getting out of a shitty relationsip and taking your shit out of her place? Each step feels like the opposite of gravity.

Sucks when you spend hours creating a whole new persona from scratch and nobody notices.

I like when someone orders "the corn" but they meant singular. Like, "One piece of corn, please."

Carrying a shirt around your waist may be a great way to prepare for chilly weather but it really bums us out when you don't have your bum out.

Remember those moms who would sit in the kitchen smoking and gossiping with the other kids? Even as a teenager, I knew that was fucked up.

I bet she wrote notes in school that were so funny you couldn't stop laughing, which really pissed off the teacher, which made you laugh even more because there's nothing funnier than not being allowed to laugh.

It's amazing how much a plaid shirt can make a woman look like John Goodman.

Art openings have nothing to do with art. It's way too packed to see anything, so why would you — oh shit!

Brooklyn girls are the best — until they open their mouths and a plumber comes out.

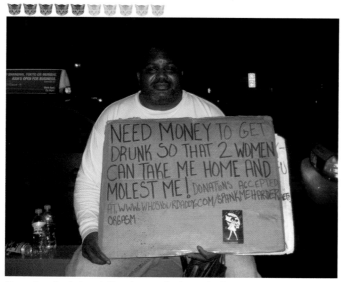

Um, you're going to have to throw in a couple of cases for them.

Bedhead gets pretty intense when your bed is your car.

At this age, women in Wisconsin are wearing track pants up to their necks, cutting their hair like lesbians, and watching the living shit out of daytime TV.

Some guys do the "you know you want to fuck me" thing so convincingly, you're like, "I do?"

Take it bitch. Take all three centimeters of my rock hard clit.

The only way you're going to get her is to go back in time, befriend her when you're both six, and then keep in touch for the next 20 years, sending thoughtful gifts every few months.

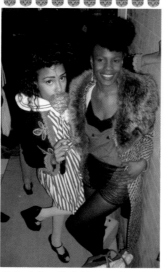

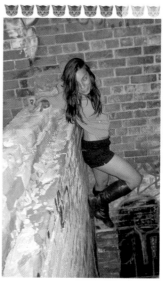

Why is Beyoncé's hair made from spending thousands of dollars stitching an Asian women's dyed blonde hair into her own already-straightened afro? What's wrong with an afro?

It's fun to be a big fish in a small pond but then you get to London and BOOM, you're plankton.

There are so many Boners who just managed to get into this book by the skin of their teeth and could fall out at any second.

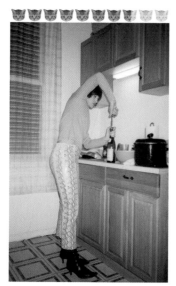

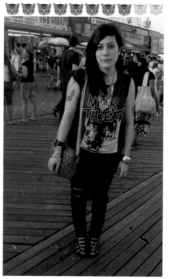

The suburbs are a great place to go on look tangents until you're so far out of your surroundings, you look like you've been Photoshopped in.

Want to know how to leave hardcore gracefully? Buy a purse, stick some expensive shoes on the bottom, and that's it. You're done.

Every red-blooded American girl knows France owns the copyright to cute.

Women go balls out about seven times a year. If you are lucky to get caught up in this tornado, here's a crucial tip: Don't suggest going somehwere else unless you're POSITIVE it's going to be more fun. If it ain't broke, don't fix it, and dragging them to a dead party will forever brand you as Captain Bringdown.

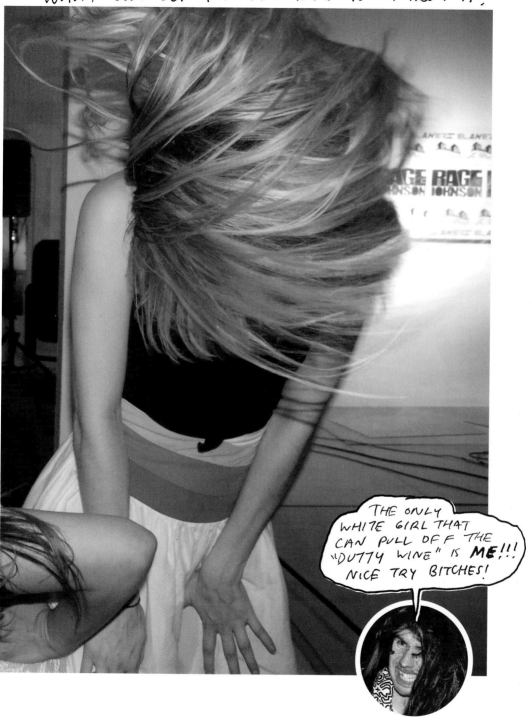

WHAT DOES JONNY MAKEUP HAVE TO SAY ABOUT IT?

THE ONLY WHITE GIRL THAT CAN PULL OFF THE "DUTTY WINE" IS **ME**!!! NICE TRY BITCHES!

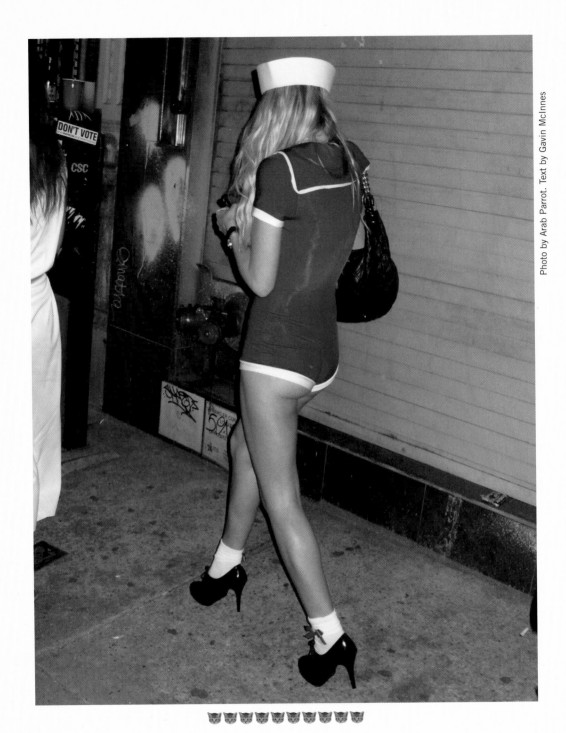

Ugh, this is so cheesy — wait, why does my left arm hurt? Oh my God! A heart attack? For this? You have GOT to be kidding me. Hnggh.

LONDON VS. MONTREAL VS. NEW YORK VS. LA
THE FINAL WORD
An Interview With the Arab Parrot

You are a New Yorker who's spent the last decade or so in LA, so you should be able to settle this debate once and for all: Who dresses better?
New York dude, come on.

Is it because New Yorkers are around people more so they get a better idea of what looks retarded?
The real question is: Who dresses better, Mexicans in LA or Puerto Ricans in NY?

What the fuck is with all the Ed Hardy in the world? If these people think old school tattoos are so cool, why don't they just go and get some? Having tattoos all over your sleeves is like having a tuxedo shirt.
I have no idea why people wear Ed Hardy, especially black people.

What about London and Montreal. Where do they fit in?
I lived in London for six years but that was so long ago. In the early 90s they dressed pretty cool. I've never been to Canada.

You pay your bills with this, right? Are you rich?
Ha, that's rich. I'm flat broke.

Could you basically get any girl you want? The blog helps though, right?
I'd do better if I wasn't homeless.

You kind of have a weird posture. Do you have spina bifida or some shit?
It's from years of practicing sucking my own dick.

Is there a particular look that girls wear that just kills you?
I love legs, so pantyhose, stockings, tights, whatever they call 'em. I'm feeling the rape look that's kind of trendy right now. You know, the pantyhose that's ripped with holes and runs in them? Shit turns me on. It's annoying when prude birds do it though. I like girls who dress grunge. Like, sleeveless denim jackets, leather jackets, skirts, boots. They shave the sides of their hair. Ummm, I like birds who dress like they're from the 60s, like flower child shit. I also like birds who dress rich, like they have a house in the Hamptons.

What's the worst faux pas men make today?
Other than dudes in Ed Hardy / Christian Audigay & head to toe streetwear clowns? I dunno. Dudes wearin' flip flops at the club? The Abercrombie & Fitch / Hollister look. How 'bout straight dudes who dress gay? Extra-small-size-wearing-Asian ravers? Punk rock posers? I dunno, there's too many. I'll tell you what is getting annoying is all these dudes growing their hair and beards. Fuckin gypsters.

Great. Hey the title of this thing implies there's going to be some kind of summary that sums up all the cities we've been talking about. Could you say something like, "London has the history to back shit up. When they do something they have hundreds of years of trial and error to give it context. America overrides that simply by having balls. They're the pioneers, so they'll come up with something way out of the box and London ends up jealous that they never thought of it (like punk). New York does this balls thing better than LA simply because it's more dangerous, so there're more daring people. Montreal is a curve ball because it's not on the radar and doesn't care to be. For them it's all about the party" — something like that?
What?

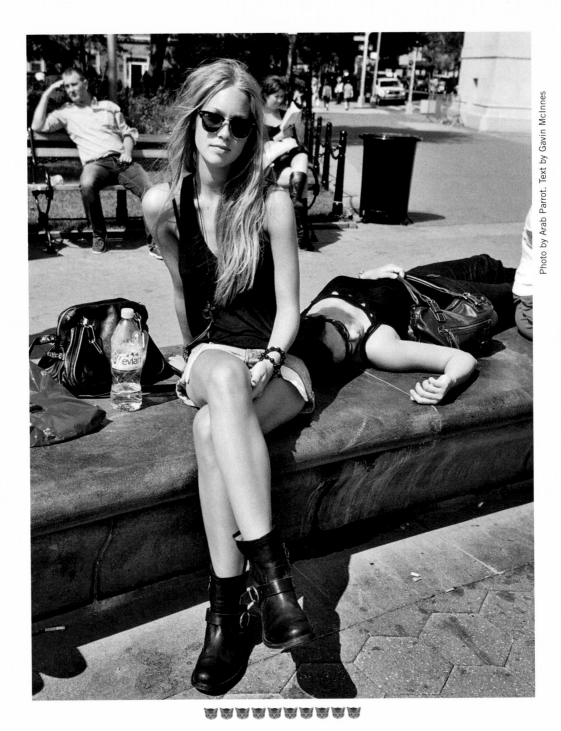

"Biker Casual" seems simple enough but I have seen women collapse with exhaustion trying to compete with it.

Photo by Arab Parrot. Text by Gavin McInnes

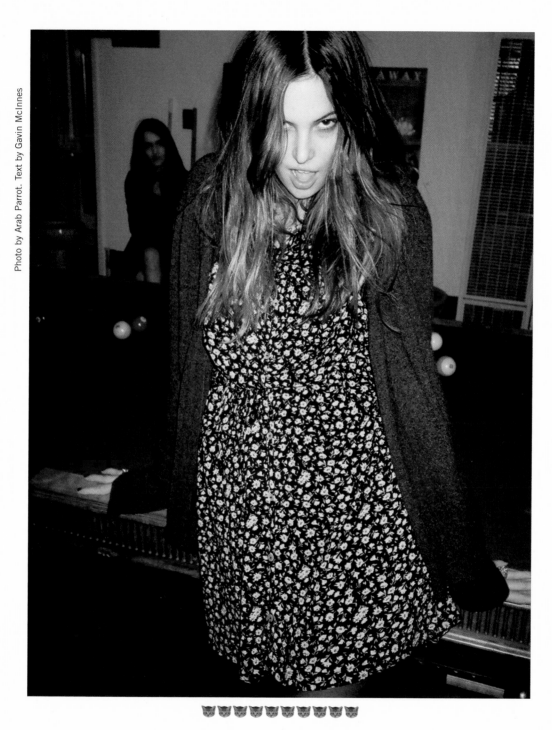

Malxom X hated liberals because he said they were "wolves in sheep's clothing" but he agreed that "bad girls in nice girls' clothing" was "on some whole other shit."

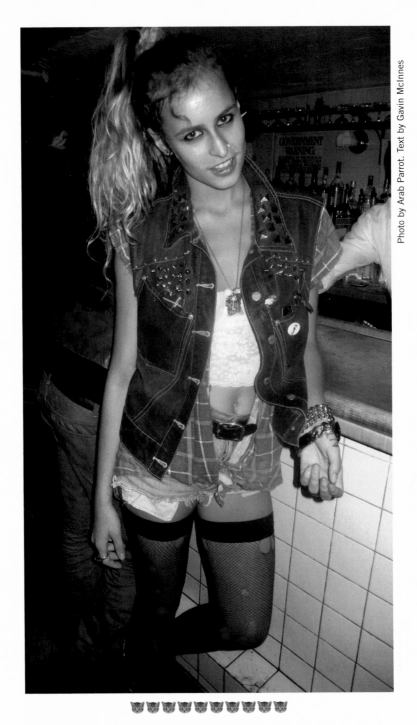

Photo by Arab Parrot. Text by Gavin McInnes

It sucks when you find out a girl you're into is a model because it turns your innermost desires into a duh.

Photo by Arab Parrot. Text by Gavin McInnes

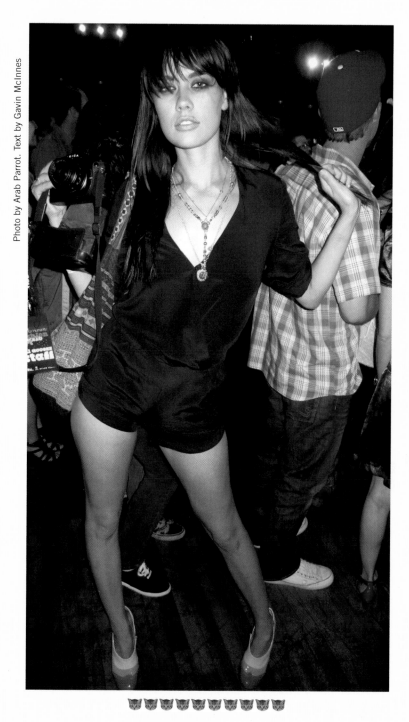

Girls would probably have something bad to say about her purse but girls are a bunch of fags.

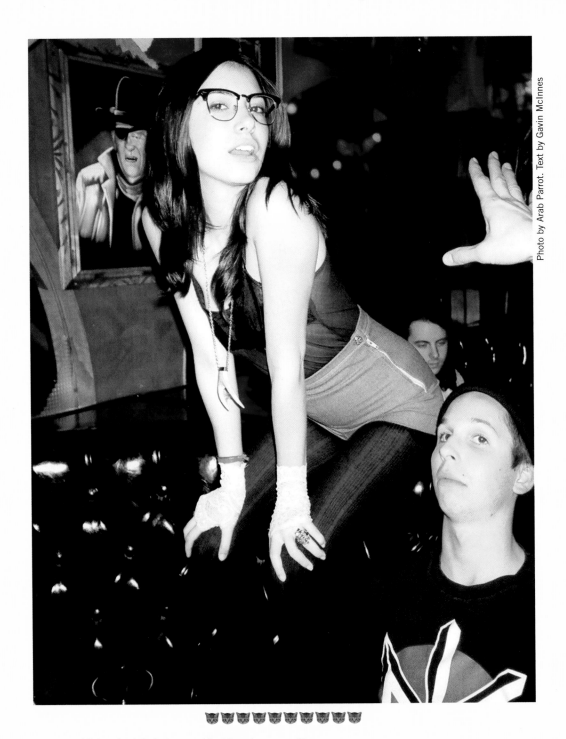

Photo by Arab Parrot. Text by Gavin McInnes

You know a girl's hot when both dead guys and Dead Kennedys are speechless.

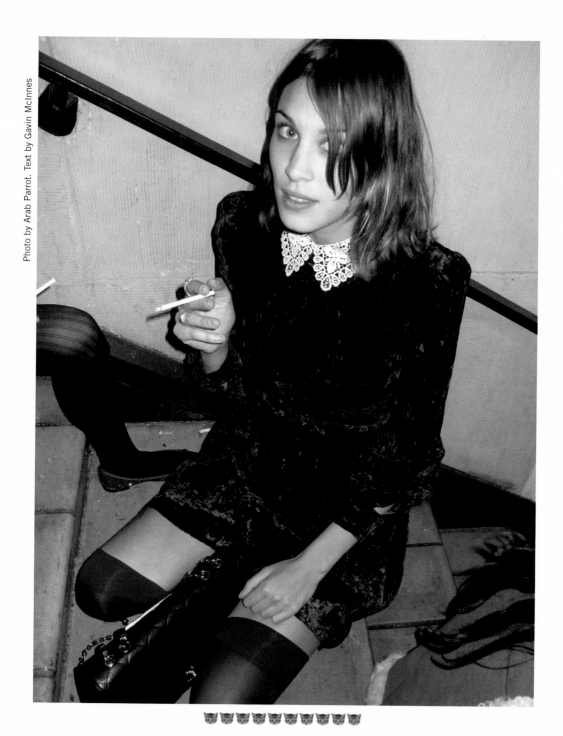

Photo by Arab Parrot. Text by Gavin McInnes

Yeah fine, Alexa Chung is hot if you're a heterosexual male or a lesbian over the age of eight. That's still 3,353,496.5 people she will never get no matter how hard she tries.

The firing range and the paint store are the only places diversity is as good as everyone says it is.

Interests include: being a nerd, being a Rasta, being a mountain climber, and being on your nerves.

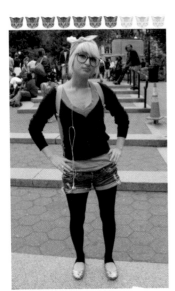

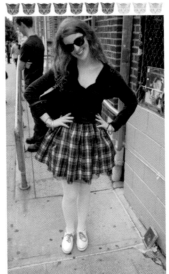

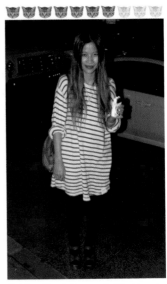

The hands-on-your-hip pose can say, "This is me, and if you don't like it, you're wrong."

Or it can be a little less authoritative and simply say, "This is me. Come on. You like it, right? How can you not?"

And then there's the pose that just braces itself and says, "This is me. I think I'm pretty good but I'll leave it up to you."

No matter what you do to a guy he will want to fuck you for the rest of his life. Once a girl is over you however, they never forget it. You didn't turn out to be a good potential mate and therefore you no longer exist.

If you've got a really bad sunburn, try to find someone who has no way of gauging how bad it is.

Take it easy lady, this is like a riot hose of adorableness. I hate vindicating Jack Nicholson but he's right: I can't handle the cute.

You know when a waitress is telling you the specials and it's so boring all you can hear is "and we bard blood bobaba bee the smoked boo bark ja ja bloo and a seared boo joo loo loo"? I don't think I've tuned into an entire specials list in my life.

The worst part of being alive in the Technological Age is seeing what the world looks like without wedgies.

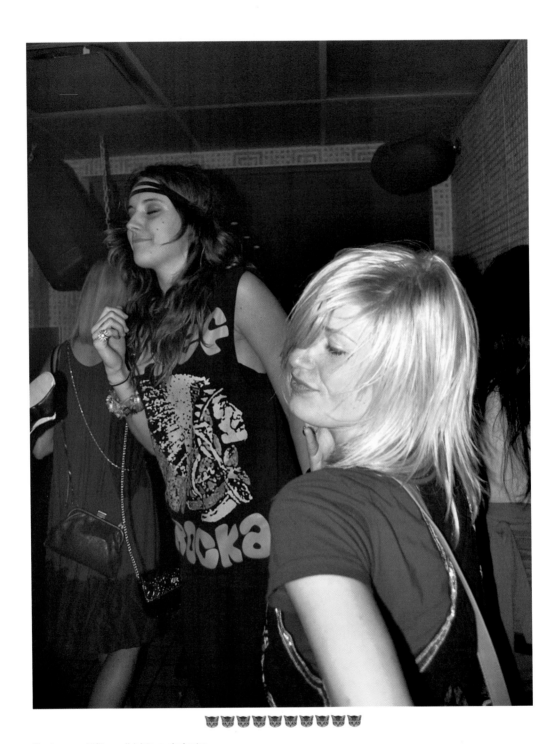

If only you could fit your dick into musical notes.

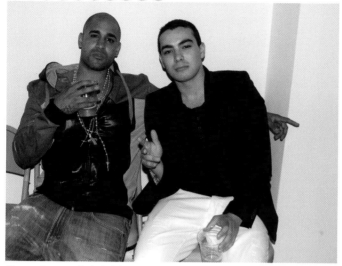

Wow, you know your jacket's rich when it gives you a boob job.

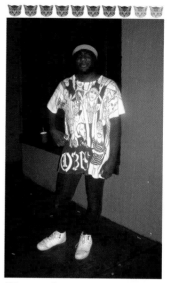

This guy needs to start a band called Chocolate Shuttlecock.

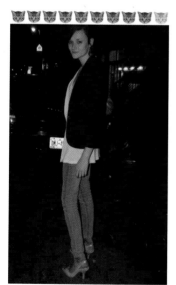

Those fucking things are like the Kiss boots of high-heeled shoes, which is fitting because they're made for loving you.

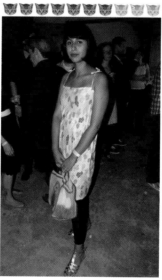

Dark toenail polish is a bummer because it makes girls' feet look like bear claws. Go pink or lighter than pink or nothing.

Nobody loves the New York summer uniform of cargos and flippies more than new dads with handbags.

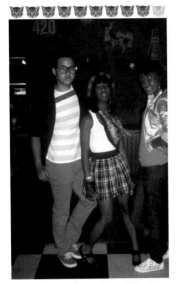

I hate when people use the word blipster because it implies they're as uninvited as wiggers.

The next time someone asks, "What's Kristen Schaal doing these days?" the answer should be, "Dancing to Britney Spears's 'Toxic' in a radiation suit in someone's basement."

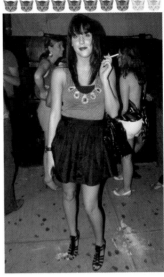

Lipstick is meant to simulate the way women's lips become flushed with blood when they're aroused but this is on some "Gael García Bernal is eating you out" shit.

There's a certain look girls get when they're wasted where you know you're either going to get punched in the face or sucked in the cock.

So the pigeon-toed stance got so much flak, you decided to start your own one by borrowing from the midgets? Your effort receives an A.

Dude, what are you doing? You look like ice cream-flavored gum.

Next time New Yorkers shit on you for living in LA, all you have to say is one word: In-N-Out.

Wow, I finaly found someone that knows less about rap than my mother-in-law.

Dads can get real creative when they're thinking of ways to punish you for leaving your clothes lying around the house.

You know a girl's got it going on when guys are checking out her farts.

The fact that pussy-eating carries none of the negative connotations cocksucking does is living proof that insults are created by heterosexual males.

Tits are awesome but sometimes you're like, "What should I do with these?" I mean, do you like it when we suck them? Do you want us to put oil or powder on them or some shit? What about a tit massage? Is there such a thing?

Why does she get to go backstage and I don't? What does she have that I don't have besides everything all five senses could ever ask for?

A transparent t-shirt is enough to make you forget sandals ever happened.

Man, those jeans are under more stress than my dad just before he lost his job.

Dude, I think you slept in WAY longer than you think.

In Sicily, a horse head in your bed means you sleep with the fishes but in Williamsburg it means you sleep with the art school girls.

If this guy's trying to be me for Halloween, I'd like him to know that hurts.

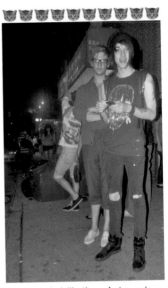

These guys look like the perfect gang to hang out with if you're going to be awake for three days straight.

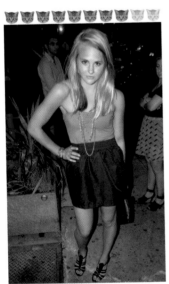

Trying to pick up a girl who doesn't get the cultural references in your jokes is like trying to fight a guy in the nude.

If you get circumsized at a late age, it's important you avoid all possible contact with females until the scabs heal over. I don't care what you have to do, just get them away from you.

Hey! Get back here. I'm trying to talk about the commodification of youth culture. Goddamnit, stop that!

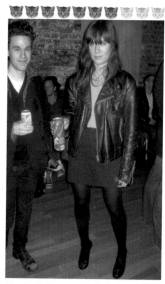

The only time sucking on lollipops doesn't make you look like a pussy is when the lollipop is a pussy.

Hey, that's the guy with the tattoo of himself from page 125! Are we running out of people? Let's see if we can't just shit three more out.

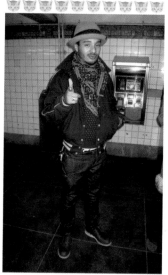

I don't know this guy, but to me he looks like he could secretly be a money-grubbing salesman that got so sick of paying for sexually harassing his secretaries, he decided to just marry the next one he got pregnant.

There's something about a little Italian man decked out in a funny hat that makes him look like the kind of guy who's someone else's puppet.

This Hawaiian Five-O in sheep fetus sandals looks like the kind of guy who thinks he's a mensch but is actually such a pussy he does more harm than most assholes.

THE END

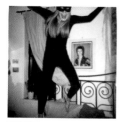

BETSY BLUNDELL
-is a talented New York photographer who is as easy on the eyes as she is on the ears. That means when she goes up to someone and asks for their photograph, it's about 100 times less creepy than when a wrinkly old moustache like myself does it.
betsyblundell.com

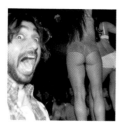

ARVIND DILAWAR
-is the editor of the website Street Boners and TV Carnage, which is where most of these Boners were born. He can't get a better job because he's just a kid and kids don't really know how to do anything but blog (no offense).
rough-draught.blogspot.com

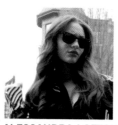

ALESSANDRA LOFTON
-is currently majoring in African American studies, if you can believe that.

VINCENT DERMODY
-is living in Asia or some shit now. He's from Chicago and says he grew up listening to hardcore but every pic of him back then looks pretty square to me.
2megapixels.com

LANCE KILBY
-is a weirdo from the South who will send you a 3,000 word email if you ask him where he was born or what his job is because you're writing up a blurb for the back of a book.
elkilby.wordpress.com

VALERIE ANG
-is an animator and musician that spends hours trolling the internet looking at gore. She parties like a redneck and smashes things, and we hope she never finds out she's actually a very tiny Asian woman.
valri.tumblr.com

JAMIE TAETE
-is a London homo that takes fucking amazing photographs and somehow manages to come across the most outrageously dressed British people every night. In fact, it's his photos that started us thinking London might be better at fashion than we are.
jamietaete.com

SAM METEER
-is a big-haired drunk from Northern Ontario who came to New York on a whim, took a ton of photos, and then said, "This sucks. I'm outta here."

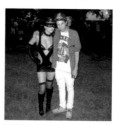

YODA
-is a sexy half Asian/half Jew who once told me his ethnic makeup means he is "the smartest person you will ever meet," but he changed his mind when he got older.

ABOUT THE AUTHOR

Gavin McInnes was born in England in 1970 but spent most of his time in Ottawa and Montreal, where he eventually received a BA in English from Carleton/Concordia University.

He sang for punk bands and did comic books in the early 90s and then started *Vice Magazine*, which he moved to New York City in 1999. In 2008, he sold his shares and left the company to start a new one called Street Boners and TV Carnage. He currently splits his time between his apartment in Williamsburg, Brooklyn, and his house upstate, where he writes for TV, film, and assholes like you. I think he does stand-up sometimes too. God knows. He has a wife, two kids, and a bear named Barry.

thegavinmcinnes.com
streetcarnage.com
mydadhomies.wordpress.com
en.wikipedia.org/wiki/Gavin_McInnes
youtube.com/user/thegavin2000
collegehumor.com/user:2037250
myspace.com/80hc

OH YEAH, I FORGOT TO THANK MY LIT. AGENT BYRD LEAVELL & MY EDITOR BENJAMIN GREENBERG.